'Whether we're at peak-zombie yet is anybody's guess, but anybody interested in the question of how we came to this point could do a lot worse than read Roger Luckhurst's intellectually agile and highly entertaining study of the walking dead, *Zombies: A Cultural History*, which traces their evolution from shadowy figures of myth and folklore to ubiquitous cultural presence . . . Like the rest of the book these latter sections are enlivened by Luckhurst's energetic prose, wit and finely balanced for his subject and critical distance.'
– *The Australian*

'A short review cannot do full justice to this book. I urge you to read it and, for those who have never read Roger Luckhurst before, seek out many of his other writings. What he does brilliantly is weave culture, politics and history into a singular tapestry that leaves scope for thought and discussion. The history of zombies is, in his hands, demonstrably worthy of our attention and time.' – *Hong Kong Review of Books*

'Roger Luckhurst's scholarly, entertaining, well-written book tells us that the zombie was born in the Caribbean, or in Western fantasies about the Caribbean.' – *Sydney Morning Herald*

'This enjoyable read sets out to understand the origin and the changing cultural meanings of the concept of the zombie in Western popular culture.'
– *Socialist Review*

'The narrative is always readable and accessible. Luckhurst is highly critical of most of the works he discusses, but he usually makes his case well . . . *Zombies: A Cultural History* can serve a constructive function by getting zombie fans to start thinking more critically about the creatures they've watched kill and be killed so many times before.' – *Psychobabble200*

'Entertaining and informative. It is more than worth having a read if you are a fan of the flesh eating, mindless killing machine that is the zombie.'
– *Impulse Gamer*

'The book is an engaging overall history for students and teachers of zombie culture generally.' – *Viewfinder*

'Delving into the rich tradition of zombie cinema, Luckhurst presents the reader with a well-researched and judiciously condensed history and socio-cultural analysis of everything . . . Luckhurst draws on prominent, respected researchers to back his well-considered, lucid overview of this culturally pervasive figure . . . For anyone seeking a definitive yet succinct history of the zombie, this book is an absorbing, accessible introduction.'
– Marianne de Pierres, author

ZOMBIES

A CULTURAL HISTORY

ROGER LUCKHURST

REAKTION BOOKS

'The blancs are blind,' he said, 'except for zombis.
You see them everywhere.'

Herard Simon in Wade Davis,
The Serpent and the Rainbow (1985)

Published by
Reaktion Books Ltd
Unit 32, Waterside
44–48 Wharf Road
London N1 7UX, UK

www.reaktionbooks.co.uk

First published 2015
First paperback edition published 2016, reprinted 2021

Printed and bound in India
by Replika Press Pvt. Ltd

A catalogue record for this book is available from the British Library

ISBN 978 1 78023 669 8

Contents

Note on Usage

This book explores how key terms are transformed by translation, so the spelling and usage of certain words vary throughout this book. All quotations preserve the original spelling, but I use *zombi* for the term that was used across the Caribbean in different local dialects and 'zombie' for the American concept, which first entered into popular usage in America in the 1920s. Similarly, the word Vodou is preferred for the complex religion and ritual practices in the Caribbean, while Vaudoux and later Voodoo refers to the Western fantasies about those practices.

Introduction

You know what a zombie is.

The zombie is that species of the undead that returns by some supernatural or pseudo-scientific sleight of hand. Zombies are speechless, gormless, without memory of prior life or attachments, sinking into an indifferent mass and growing exponentially. They are a contagion, driven by an empty but insatiable hunger to devour the last of the living and extend their domain until we reach the End of Days. Zombies are the Rapture with rot.

And you know how the zombie got here.

The zombie starts out as the decomposing poor relation of aristocratic vampires and mummies, the outlier undead of horror film. It shuffled out of the margins of empire, from Haiti and the French Antilles, making the leap from folklore to film in Victor Halperin's *White Zombie* (1932), a rewrite of *Dracula* set in a hallucinated Caribbean. This production, significantly enough, was a low-budget, independent shocker in the year that the Universal studio in Hollywood crowned Count Dracula, Frankenstein's Monster and Imhotep the Mummy as the unholy trinity of the undead. The zombie rotted a bit more from neglect, lurking unnoticed in graveyards, sinking into the shudder pulps and horror comics of the 1940s and '50s. Then another group of filmmakers completely outside the studio system in Pittsburgh clubbed together to fund George Romero's *Night of the Living Dead* (1968). After years on midnight movie and cult circuits, the reimagining of the zombie as a form of mass contagion began to seep into horror films in the

1980s. The remorseless zombie attack was bedded down as a familiar Gothic trope after Romero's *Dawn of the Dead* (1978) in a nasty outbreak of 'cannibal holocaust' films that chewed their way out of Italian grindhouses and reinfected American production. It leaped host again in 1996, when the Japanese computer giant CAPCOM released the video game *Resident Evil*, initially under the name *Biohazard*. This was conceived by designer Shinji Mikami, who coined a new term for the genre: 'survival horror'. Since the late 1990s over twenty different versions of the *Resident Evil* game have been released (along with an associated film franchise). These commodities have made billions of dollars of profit, and have been one of the main vectors ensuring that the zombie has become a truly global figure – and arguably the central Gothic figure for globalization itself. In 80 years, the zombie has ground down the bones of the opposition and lurched out of the shadows to become the dominant figure of the undead in the twenty-first century.

It is now impossible to move without stumbling over zombie apocalypse films, comics, novels, TV series, computer games and cosplay. Zombie parades began as a local phenomenon in Sacramento, California, in 2001, but have become an annual feature of many cities around the world. A television adaptation of *The Walking Dead*, an episodic, open-ended comic series, has become one of the most successful cable TV series ever made, surrounded by a host of imitators such as *Dead Set* and *In the Flesh* in Britain and (a little more dubiously) *The Returned* in France. The global reach of the zombie figure is represented not just by the colossal budget of Hollywood disaster films like *World War Z* (2013), but in the way it has fused with very local supernatural tales of the undead around the world, in Africa, Asia and Latin America.

'Zombie' has become a standard adjectival modifier, too: we are in a world of zombie computers, zombie stocks and shares, zombie corporations, zombie economics, zombie governments, zombie litigation, zombie consciousness, even zombie categories (concepts or terms that are dying out but still lingering on). These things all become zombified because they are marked by loss of agency, control or consciousness of their actual state of being: they are dead but

don't yet know it, living on as automata. They are the perfect emblem of decline coupled with denial: the zombie condition of the Western world unwilling to face itself after the peak of its power. It comes to something when an official government agency, the Office of Public Health Preparedness and Response of the American Center for Disease Control and Prevention, issues a 'Zombie Apocalypse Preparedness' kit (including posters and comics for schools), believing this was the most efficient way to educate the public in preparation for emergency. In 2011 the Wellcome Trust for medical research similarly funded the 'Zombie Institute for Theoretical Studies', a project to engage young people in Glasgow in 'zombie science', looking at risks of infection and treatments in a fictional disease outbreak. So extensive is this range of reference that the zombie is, as Jennifer Rutherford has observed, 'a mass metaphor', a metatrope, 'a figure that binds together other figures in a dense network of meanings'.[1]

Because of this ubiquitous presence, you also know what the zombie *means*. There are several basic interpretations of this creature that circulate in different registers, from the often highly informed but informal online discussion boards among fans to the arcane worlds of competing academic schools of thought. Zombies are what the anthropologist Victor Turner calls 'threshold people', those anomalies that straddle crucial cultural boundaries, 'necessarily ambiguous, since this condition and these persons elude or slip through the network of classifications that normally locate states and positions in cultural space'.[2] The most obvious boundary breach of the zombie is between the seemingly definitive states of life and death. Nearly every culture on the planet elaborates stories about the undead as a means of negotiating the perilous biological, cultural and symbolic passage between these two states. Like the North African *ghoul* or the Eastern European *vampyre*, zombies are also marginal folkloric creatures, clinging on in the uncertain zone between ancient belief and modern knowledge systems, who prey on those loved ones who hang around in cemeteries too long. They all act as a warning to observe the proper social protocols of mourning and avoid the risks of too much melancholic lingering of the living among the dead. These creatures transgress but in the end help uphold cultural

categories of purity and pollution, the sacred and the profane, the living and the dead. The zombie tests the limits of kinship and attachment where these are placed under severe pressure, as in systems of slavery or conditions of extreme economic dispossession and migration. The zombie is the loved one who has somehow catastrophically *turned*, in the same body yet a stranger to themselves and their kin. They can be (in Haiti) a pathetic figure of a long-dead relative who wonders forlornly into their home village years later, or (in Africa) a bewitched migrant whose labour destroys a fragile economic and social balance, or (in American and European horror films) the ravening wife, husband or child who has forgotten all emotional and social ties and is intent only on devouring their own kin(d).

The real question is why it is that this particular figure of the undead has become so all-pervasive. There are still large numbers of doomed aristocratic vamps around, of course, despite Buffy's repeated 'dustings', or operatic announcements of the exhaustion of genre, like Jim Jarmusch's enervated film *Only Lovers Left Alive* (2013). A good deal of North American real estate nowadays seems to be the subject of vengeful spectral returns (and not only from the enraged ghosts of long-dead mortgage providers). An occasional mummy, bad-tempered pagan elemental or even Old Nick himself still stirs his stumps once in a while. The unique twist the zombie offers, though, is massification: the undead as a multitude. Thus it is very common by now to interpret zombies as a distinctly modern contribution to the Gothic tradition, not archaic survivals from a ghastly past we thought we had superseded, but products of our industrial modernity, 'mirrors and images of modern mechanical processes'.[3] The zombie mass is a figure of the 'statistical society' that fully emerged in the late nineteenth century, in which government actuaries discard individuals for analysis of the peaks and flows, the appetites and risks, of abstracted populations. The zombies do not do the cultural work of monstrous others, slimy tentacular aliens or ancient cephalopodic gods raised from the deep. Instead, they are simply us reflected back, depersonalized, flat-lined by the alienating tedium of modern existence. They are the pressing problem of the

modern world's sheer number of people, the population explosion, bodies crammed into super-cities and suburban sprawls, demanding satiation beyond any plan for sustainable living. Survival horror is the crisis of the last representatives of rugged Western individualism trying to wrest themselves from the unregarded life of the anonymized mass.

It is then a short step to reading the zombie as the symbolic figure for contemporary capitalism. The zombie is 'the official monster of the recession', a relatively new addition to 'the capitalist grotesque', one shouty Marxist tome declares. 'What is striking about capitalist monstrosity', David McNally continues, 'is its elusive everydayness.'[4] Karl Marx didn't have the zombie metaphor to hand, but he did sometimes write of capital as vampiric, sucking dead labour from living bodies. Now that contemporary capitalism has become both massively more extensive (reaching around the globe) and intensive (penetrating and commodifying body and mind), this seems to make the zombie horde the privileged emblem of globalized hyper-capitalism, a runaway world always on the brink of apocalypse. Zombiedom as contagion, as sparking off exponential viral vectors through the communication networks of the global village, is only another figure for representing the risky interconnection of the world's economy. The zombie is the Gothic version of the catastrophe that haunts what sociologists call 'the risk society'. 'The deepest pleasure of the zombie story', another radical critic declares,

> lies always in its depiction of the break, that exhilarating moment of long hoped-for upheaval: the fulfilment of a sometimes avowed, sometimes disavowed, desire to see power at last unmade, laid finally to waste and torn limb from limb – and our structures of dominion and domination replaced finally and forever with Utopia, if only for the already dead.[5]

This hellish zombie 'utopia' is so deeply ambiguous for Marxists because, as Slavoj Žižek never tires of putting it, with neo-liberalism rampant after the collapse of the ideological blocs of the Cold War,

'it is easier to imagine a total catastrophe which ends all life on earth than it is to imagine a real change in capitalist relations.'[6]

Since the overt satire of George Romero's first sequel, *Dawn of the Dead*, in the late 1970s, where the zombies roam the world's first indoor shopping mall, ambling without purpose around the stores to jaunty muzak, this reading of zombie culture is less an allegory to be teased out, less subtext, than overt text. It is a blindingly obvious thing to say because it repeats what the zombie text itself already says so fulsomely. But through this reading, abject pulp fictions acquire the sheen of political critique. Even if it might only be a nihilistic gesture of refusal, the phantasmagoria of the zombie apocalypse reveals the deathly logic of contemporary capitalism. To the barricades! Occupy the Necropolis!

These things we know about the zombie. Indeed, so fixed is this understanding of the genre that some people get rather upset when there are slight changes or innovations in the zombie figure. Although it is perhaps hard to recall now, there was a shocked collective intake of breath among the first audiences of *28 Days Later* (dir. Danny Boyle, 2002) when Cillian Murphy finally encountered the undead in a church after wandering the empty London streets; they sniff out their prey with sudden predatory alertness and *begin to run*. Gone was the quintessential zombie shuffle, the lumbering remorselessness of the undead crowd. Uproar ensued: could Danny Boyle's victims of the 'rage virus' even be considered zombies at all? Even as this device was picked up and conventionalized (the zombies are *really* fast in the remake of *Dawn of the Dead* (2004) and there is a discussion of how to outsprint the undead with cardio training in *Zombieland* (dir. Ruben Fleischer, 2009)), traditionalists objected. Simon Pegg, co-writer and star of the 'rom-zom-com' *Shaun of the Dead* (dir. Edgar Wright, 2004), cried in agony:

> ZOMBIES DON'T RUN! I know it is absurd to debate the rules of a reality that does not exist, but this genuinely irks me. You cannot kill a vampire with an MDF stake; werewolves can't fly; zombies do not run. It's a misconception, a bastardisation that diminishes a classic movie monster.[7]

Since about 2010, some zombies have also been acquiring a flickering of consciousness, intelligence, halting speech and conflicted emotional lives, soliloquizing and even falling in love. Isaac Marion's novel and film *Warm Bodies* (2013) is a zombie rewrite of *Romeo and Juliet*; S. G. Browne's novel *Breathers: A Zombie's Lament* (2009) is an account of a dead man coming into possession of his true zombie state; M. R. Carey's *The Girl with All the Gifts* (2014) focuses on a child who seems to be a hybrid between human and zombie. In fact, this coming into consciousness is an old story, for zombies have been narrators since at least early 1950s comics: 'I cannot rebel, for I have *no* will!', Morto explains in the opening panel of the front story of *Adventures into the Unknown*. 'I can only obey for . . . I AM A ZOMBIE!'[8] Even so, people can get pretty cross about this contemporary trend, even those who understand that genres evolve in a spiral, repeating tropes but also constantly modifying them. Genres are unfolding processes in constant alluvial flow, not typologies with fixed categories to tick off like a game of bingo.

This becomes even more important when you realize that an answer to the question 'What is a zombie?' can be accurately answered with any of the following responses. A zombie is a noisy child; a three-legged horse; a homeless person; a wretched dog too weak to bark; a male spirit that haunts tree-lines; a potent rum cocktail invented in California in the 1930s and made famous at New York World's Fair in 1939; a female spirit with a broken neck; a Guédé god, Capitaine Zombi being part of the Vodou pantheon; the soul of a person caught in a bottle (this is a bodiless soul, a *zombi astral*, as opposed to a soulless body, a *zombi cadavre*); a person with catatonic schizophrenia expelled from their community or found wondering alone; a person poisoned by a sorcerer and left in a state of suspended animation, to be revived by an antidote; the outcast of the social justice exercised by the community's secret societies; a bewitched slave or indentured labourer or guest worker, forced to work on plantations away from home or in the gardens of large houses or the back rooms of bakeries (because bakers work late at night); a foreigner; a young, free and single urbanite; a coughing spectre that spreads tuberculosis; an entranced person easily returned to 'life' by

eating salt; a being easily recognized by a nasal tone of voice. You don't always know what a zombie is.

The point of this eclectic list is to emphasize that while there is a familiar history of the emergence of the zombie, this needs to be situated in a host of other cross-currents. The zombie is in fact one of the most unstable figures in the panoply of the undead, and has never stayed fixed for long. This is not surprising when you realize that 'zombie' is a word that emerges from the grim transports of populations between Africa, Europe and the plantations of the Caribbean and the American South. The word originates from a belief system that is a product of the slave trade plied between Africa, Europe and the Americas from the sixteenth century onwards. The zombie is rarely stable because it is a syncretic object, a product of interaction, of translation and mistranslation between cultures. Possible African linguistic candidates for the origin of the world include *ndzumbi* ('corpse' in the Mitsogo language of Gabon), *nzambi* ('spirit of dead person' in the Kongo language of the Congo) and *zumbi* (a fetish or ghost in the Kikongo and Bonda languages). In the Caribbean, speculations on the origins of *zombi* include sources in Arawak (*zemi* means spirit) or even a Kreyòl derivation from the French *les ombres*. It also bears some relationship to the words 'jumbee' and 'duppy', more familiar from Jamaican folklore as umbrella terms for a wide array of ghosts, spirits and changelings. The passage of the French Caribbean *zombi* to the North American pulp fiction zombie in the 1920s and '30s is also a complicated but crucial story to tell.[9] The American zombie is a mistranslation and weird creative elaboration of the Caribbean *zombi*, yet all the time it keeps an undertow of violent colonial history in plain sight.

The zombie, in other words, is a product of what has been called 'the circum-Atlantic world': 'Bounded by Europe, Africa, and the Americas, North and South, this economic and cultural system entailed vast movements of people and commodities to experimental destinations.' This created what the theatre historian Joseph Roach terms 'an oceanic interculture' marked by the hybridization of peoples and beliefs.[10] It also creates a *poétique de la relation*, a cross-cultural poetics.[11] A crucial part of the story, then, is that the zombie is a

result of the Black Atlantic, 'a webbed network, between the local and the global', a dynamic interaction of far-flung points on the map, brought into contact through centuries of maritime trade and colonization that produces unpredictable forms of cultural mixing or *métissage*.[12] The meaning of the zombie changes radically from point to point, time to time, twisting and turning, constantly subverting, reverting and inverting itself, sometimes a positive belief held in a magical or theological frame, just as often a negative projection of primitive superstition onto others.

If the zombie emerges in the slippage *between* cultures, all the same this is not a preface to celebrating the zombie as some kind of sliding signifier that can mean anything we want it to mean. Wherever it comes to stop, the zombie is still branded by the murderous history of slavery and colonial dispossession that underpins its origins. It remains connected to the meaning of Haiti and the islands of the Antilles to the modern world, and the systematic violence, expropriated labour, rebellion and revolution in those areas, however far it travels. What is complex about the figure is often the way this atrocious undertow is at once avowed and disavowed as the zombie stumbles through very different cultures.

This book is an attempt to reveal the very specific cultural history of a liminal Gothic monster and the path it has travelled from the speechless subaltern world of slavery into the heart of the American empire and the networks of globalized popular culture. It means sifting material from a diverse range of sources, from travel narratives to colonial histories, anthropology and folklore, legal and medical case studies, pulp fiction, anti-colonial political polemics, gaming culture, comics, high art and lowly modern horror film, in order to accumulate the proper range of resonances the term zombie now carries. I'll unfold this history in eight chapters, following the story chronologically from the first appearances of the elusive *zombi* in nineteenth-century travel narratives to its global pervasion 100 years later.

Let's start, then, with a bewildered traveller on Martinique in 1889, who turns to the daughter of his landlady and asks in some confusion: 'What is a *zombi*?'

Welcome to Zombieland! *Zombie Flesh Eaters* (aka *Zombi 2*, 1979).

I

From *Zombi* to Zombie: Lafcadio Hearn and William Seabrook

How the obscure and fragmentary superstitions about the *zombi* began their journey out of the local regions of the Caribbean and became the global zombie can be put down to the influence of two extraordinary travel writers who published books 40 years apart.

In 1887, the bohemian writer and journalist Lafcadio Hearn (1850–1904) was hired by *Harper's* magazine to write picturesque pieces on the French West Indies. Hearn, who was of mixed Irish-Greek parentage but had been educated in France and England, had travelled to America at nineteen in his first headlong flight from bourgeois European life. Hearn was a curious mix. He was a journalist in Cincinnati and New Orleans who reported on working-class and African American life in lurid terms, but he also spent his time translating the French decadent prose poetry of Théophile Gautier and Pierre Loti. His impressionistic reportage from New Orleans included records of the deaths of Marie Laveau, a Vodou queen, and Bayou John, 'the last of the Voudous', a Senegalese-born 'obi man', 'the last really important figure of a long line of wizards or witches'. 'Swarthy occultists will doubtless continue to elect their "queens" and high-priests through years to come', but Hearn mournfully reflected that 'the influence of public school is gradually dissipating all faith in witchcraft.'[1] This was a classic antiquarian's lament, trying to capture the fragility of the exotic as the modern world bulldozed every last enchantment. Hearn soon began producing books that focused on artfully retold folkloric tales, stories captured on the brink of dying out. He favoured ghost stories and superstitions transposed

into crystalline, decadent prose. He wrote to a friend: 'I have pledged me to the worship of the Odd, the Queer, the Strange, the Exotic, the Monstrous.'[2] He is most celebrated for his collections *Some Chinese Ghosts* and *In Ghostly Japan*, and his obsession with Far Eastern folklore led to life, marriage and assimilation in Japan, where he lived from 1890 and adopted the name Koizumi Yakumo.

His two-year stay in Martinique from 1887 was an escape from a brief sojourn in New York, which he hated: 'Civilisation is a hideous thing. Blessed is savagery!', he declared.[3] He wrote two books about Martinique, one a historical novel set during the slave rebellion of 1848, the other an episodic travel narrative titled *Martinique Sketches*. Martinique was known as *le pays de revenants*, meaning either the country so alluring it always compelled visitors to return or, more ominously, the country of ghosts. The place did seem to teem with stories of exactly the kind of 'weird beauty' Hearn loved to collect. Like a good folklorist, Hearn dutifully records the ephemeral superstitions of the country from his informants, racing to capture these wisps of oral culture in stylized written form before their vanishing.

'Night in all countries brings with it vaguenesses and illusions which terrify certain imaginations', Hearn reflects, 'but in the tropics it produces effects peculiarly impressive and sinister.'[4] Martinique was so superstitious, though, that the local Kreyòl has the common saying: '*I ni pè zombie mêmn gran'-jou* (he is afraid of ghosts even in broad daylight) . . . Among the people of colour there are many who believe that even at noon – when the boulevards behind the city are most deserted – the zombis will show themselves to solitary loiterers.'[5] These lofty reflections, however, get stuck on the word that Hearn has confidently translated as 'ghost', as if aware he has not quite caught all the local resonances of the term. And thus he starts a conversation with his landlady's daughter Adou, in which halting translation is at the core of the exchange.

'Adou,' I ask, 'what is a zombi?'
 The smile that showed Adou's beautiful white teeth has instantly disappeared; and she answers, very seriously, that she has never seen a zombi, and does not want to see one.

'*Moin pa té janmain ouè zombi, – pa' lè ouè ça, moin!*'

'But, Adou, child, I did not ask you whether you ever saw It; – I asked you only to tell me what It is like?'...

Adou hesitates a little, and answers:

'*Zombi? Mais ça fai désòde lanuitt, zombi!*'

'Ah! It is Something which "makes disorder at night." Still, that is not a satisfactory explanation. 'Is it the spectre of a dead person, Adou? It is *one who comes back?*'

'*Non, Missié, – non; cé pa ça.*'

'Not that? ... Then what was it you said the other night when you were afraid to pass the cemetery on an errand?'...

'*I said, "I do not want to go by that cemetery because of the dead folk; – the dead folk will bar the way, and I cannot get back again."*' 'And you believe that, Adou?'

'Yes, that is what they say ...'

'But are the dead folk zombis, Adou?

'No; the moun-mò are not zombis. The zombis go everywhere: the dead folk remain in the graveyard ... Except on the Night of All Souls: then they go to the houses of their people everywhere.'

'Adou, if after the doors and windows were locked and barred you were to see entering your room in the middle of the night, a Woman fourteen feet high?'...

'Why, yes: that would be a zombi. It is the zombis who make all those noises at night one cannot understand ... Or, again, if I were to see a dog that high [she holds her hand about five feet above the floor] coming into our house at night, I would scream: *Mi Zombi!*'[6]

Frustrated by this odd exchange in which *zombi* constantly slips away from definition, leaping from noun to noun, lost in translation, Hearn then returns to Adou's mother for clearer answers. Things only get worse, however:

'*I ni pé zombi*' – I find from old Théréza's explanations – is a phrase indefinite as our own vague expressions, 'afraid of

ghosts,' 'afraid of the dark.' But the word 'Zombi' also has strange special meanings . . . 'Ou passé nans grand chimin lanuitt, épi ou ka ouè gouôs difé, épi plis ou ka vini assou difé-à pli ou ka ouè difé-à ka màché: çé zombi ka fai ça . . . Encò, chouval ka passé, – chouval ka ni anni toua patt: ça zombi.' (You pass along the high-road at night, and you see a great fire, and the more you walk to get to it the more it moves away: it is the zombi makes that . . . Or a horse *with only three legs* passes you: that is a zombi.)[7]

Hearn makes it plain how he senses that there are 'strange special meanings' of the word which he cannot access without incorporating the act of translation into his very discussion. He cannot parse the difference between the *zombi* and the *moun-mò*, or keep the referent stable at any point. He might not have known that the 'three foot horse' also featured as an instance of Jamaican duppy lore, but here it is confidently called a *zombi*.[8] Hearn wants to incorporate this brand of supernaturalism into his appetite for global instances of the exotic and strange, but finds the *zombi* oddly resistant to his urge for definitional knowledge.

Much deeper into the *Sketches*, Hearn introduced another informant, Cyrillia, lovingly slotted into the libidinal economy of Martinician women built in the book. She also provides commentary on the supernatural, and again the meaning of *zombi* is a riot of confusion. Hearn declares:

> *Zombi!* – the word is perhaps full of mystery even for those who made it. The explanations of those who utter it most often are never quite lucid: it seems to convey ideas darkly impossible to define, – fancies belonging to the mind of another race and another era, – unspeakably old.[9]

This assertion is indebted to Victorian anthropological notions that superstitious beliefs are 'survivals', fragments of beliefs or customs that have failed to die out in the process of cultural evolution. 'Survival in Culture . . . sets up in our midst primaeval monuments

of barbaric thought and life', Edward Tylor declared in 1871.[10] Whereas Tylor regarded his function as an ethnographer 'to expose the remains of crude old culture which have passed into harmful superstition, and to mark these out for destruction', Hearn's quest for the weird and strange was exactly the reverse: to preserve its last traces.[11] He is happy to let his informants multiply senses of the word rather than providing any stable accumulation of meanings. This passage continues:

> One form of the *zombi*-belief – akin to certain ghostly super-stitions held by various primitive races – would seem to have been suggested by nightmare, – that form of nightmare in which familiar persons become slowly and hideously transformed into malevolent beings. The *zombi* deludes under the appearance of a travelling companion, an old comrade . . . or even under the form of an animal. Consequently the creole negro fears everything living which he meets after dark upon a lonely road, – a stray horse, a cow, even a dog.

Hearn then records Cyrillia's narrative of her regular encounters with *zombis* in her bedroom at their favoured hour in the dead of night, gently rocking in her rocking chair. This charming set of superstitions, transcribed by an indulgent Hearn, is given yet another kind of status in his last paragraph on the subject, however. There is a 'source and justification' for many peasant superstitions: the baneful influence of the 'negro sorceror', with his array of poisons and dark occult influences. Martinique has burned witches in the ignorant, pre-modern past, 'but even now things are done which would astonish the most sceptical and practical physician.'[12] This is typical of Hearn, who eroticizes the mixed races in exact proportion to the extent that he demonizes African blacks. It also oddly shifts the status of folkloric tales into a different order of reality, hinting at an objective truth behind the fragile splinters of local legends and lore. It is a final moment of hesitancy between the natural and the supernatural, scientific and folkloric explanations, that typifies writing on the *zombi* in the Caribbean.

Hearn was a pioneer in transporting words between languages: English owes him the word 'tsunami', for instance.[13] If he was one of the first travellers to name the 'zombi' in his travel narrative, then this first lesson is that it seems to defy the essence demanded of the question 'What is a zombi?'

Forty years later, a second traveller from America ventured not to Martinique but to Haiti. The self-mythologizing journalist, alcoholic, occultist, primitivist, sadomasochist and exotic traveller William Seabrook (1884–1945) bravely credited himself with porting the word from Kreyòl to English in his autobiography, *No Place to Hide*:

> Zombie is one of the African words. I didn't invent the word zombie, nor the concept of zombies. But I brought the word and concept to America from Haiti and gave it in print to the American public – for the first time. The word is now part of the American language. It flames in neon lights for names of bars, and drinks, is applied to starved surrendering soldiers, replaces robot, and runs the pulps ragged for new plots in which the principal zombie instead of being a black man is a white girl – preferably blond. The word had never appeared in English print before I wrote *The Magic Island*.[14]

There is no doubt that Seabrook's breathless account of his travels and initiation into the Voodoo cult in the mountains of Haiti, published in 1929, was hugely influential, although he was surfing the crest of a much larger trend, as we shall see.

Seabrook was an American writer who grew up in the South, among plantations and black servants. He claimed that his grandmother, nursed by a 'black Obeah slave-girl from Cuba', had passed on a few occult tricks. After a dissolute early life as newspaperman, advertising executive, tramp and ambulance volunteer in the Great War, Seabrook committed to the life of a travel writer of exotic locales and became – despite his alcoholism – one of the highest-paid feature journalists of the era. He moved among the Modernist, occult and bohemian circles of New York, Paris and London in the

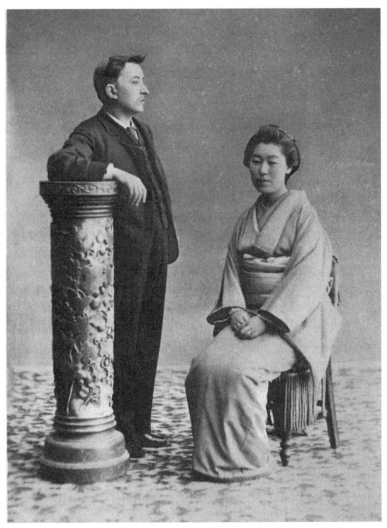

Lafcadio Hearn with his Japanese wife Koizumi Setsu, before 1904.

1920s and '30s. He spent time with the black magic 'Anti-Christ' Aleister Crowley, publishing a short piece about their 'experiments' together in 1921, and also knew the circle in Paris of Maria de Naglowska, a practitioner of ritualistic sex magic who wrote several books on the subject. Seabrook later collected his occultist adventures together in a book called *Witchcraft*. Seabrook himself had a

kink for tying up women, something he discusses openly in his Freudian autobiography. In France, he hung out on the fringes of Surrealism, and was published by Michel Leiris and Georges Bataille in their journal, *Documents*. Leiris was a great admirer of Seabrook's *The Magic Island*, a copy of which he carried with him during his own journey to Dakar, as he recorded in *Phantom Africa*. Seabrook's rubber fetish photos of his masked and bound wife appeared in *Documents*, while Man Ray photographed Seabrook doing various sadistic things to his lover, Lee Miller, herself a celebrated Surrealist and documentary photographer. Seabrook knew Jean Cocteau and Thomas Mann, and once travelled the length of France to meet the Modernist doyenne Gertrude Stein, convinced she could cure him of his alcoholism once he had realized 'I'd become like one of my own zombies.'[15]

Seabrook was immersed in that strand of Modernism that expressed its disgust of bourgeois civilization after the Great War by embracing what it perceived as the 'savage' vitality of the 'primitive' black world as an answer to Western decadence and decay. This 'negrophilia' stretched from Picasso's famous use of African masks in his seminal painting *Les Demoiselles d'Avignon* (1907) after visiting the ethnographic display in the Musée d'Ethnographie du Trocadéro, to the craze around *La Revue nègre* in Paris in 1925, which made a star of the near-naked black dancer Josephine Baker. Paris in the 1920s was a city 'in the grip of a *virus noir*'.[16] Michel Leiris delighted in another African American revue, *Black Birds*, declaring that it shattered the polite tedium of bourgeois art by reconnecting with 'our primitive ancestry', and exclaimed that the show was the perfect exemplum of 'why we have so little esteem left for anything that doesn't wipe out the succession of centuries in one stroke and put us, stripped of everything, naked, in a more immediate and newer world'.[17] Seabrook was the same: he wished to 'escape modernity through initiation into blackness'.[18]

This cult of black inversion culminated in Nancy Cunard's oddity, *Negro: An Anthology* (1934), a vast collection of images and essays on racial conditions around the world, denouncing America's Jim Crow laws and record of lynching, examining the state of Africa,

and including essays on 'Obeah: The Fetishism of the British West Indies' and a section on Haiti (with essays mostly translated from the French by Samuel Beckett). Cunard, daughter of the heir of the shipping family, had been disowned and disinherited by her father for her relationship with the black jazz musician Henry Crowder. Seabrook, who met Cunard, shared this problematic equation of black culture with virile primitivism to some extent. There is a very funny account of Cunard meeting Seabrook and his wife at the Café Select in Paris in 1929 just before he went to Africa, in which Cunard disdains their ignorance of actual blacks. Nevertheless, even Cunard thought the 'part about the dead Zombies rising from the grave . . . seems the most authentic – as a document has the priority over fiction'.[19] Seabrook travelled the world in search of the wild savagery that would shake the prison of his white identity. Most often, though, he found this in the bottom of a bottle, and he wrote a remarkable memoir of his treatment for alcoholism, *Asylum*.

In 1927 he published *Adventures in Arabia*, which included an account of his stay among the Yazidi 'devil-worshippers' (a 'cult' among the Kurds sometimes evoked in Lovecraft's horror stories). *Jungle Ways*, in 1931, was a book in which Seabrook recounted his attempts to find cannibal tribes and the 'panther men' of West Africa. The second part of the book was called 'Cannibals', and Seabrook claimed to 'have brought back, among other things, a number of recipes'.[20] The book was the result of the Paris-based writer Paul Morand commissioning Seabrook to find a cannibal cult, join it and eat human flesh. At the end of *Jungle Ways*, Seabrook does just this, explaining that human flesh tasted 'like good, fully developed veal, not young, but not yet beef'.[21]

The actual story was that the French colonial authorities so controlled native life on the Ivory Coast that Seabrook could only find monkey meat used in native rituals there. It was only in a Paris morgue that Seabrook could buy a hunk of fresh human flesh to fulfil his bargain with Morand. This reversal – the 'civilized' colony and 'savage' metropole – neatly illustrated the kind of inversions Seabrook perversely embraced. In his study *Witchcraft* of 1941 he delighted in claiming that London 'houses more strange cults, secret

societies, devil's altars, professional "sorcerors" and charlatans than any other metropolitan area on earth', including 'goat worship, cults of cruelty, tree cults, cults of the horrible, Rosicrucians, Thugs, ghost circles, Black Brothers and Grey Sisters, suicide societies and mummy-worshippers'.[22] He also recalled a case of belief in persecution through a Voodoo doll, a story shared over dinner with Jean Cocteau and Luigi Pirandello among the bohemians of the Côte d'Azur.

His journey to Haiti to penetrate the cloud of rumour and myth that had grown up around the Vodou cult was therefore part of a larger continuum of explorations into virile primitivism. Seabrook reported all these exotic encounters in a tone that deliberately suspended judgement, expounding rational and psychological explanations of the power of the supernatural, yet also allowing for the authentic reality of extreme experience. It leaves the savage supernatural resting on the cusp between folktale and objective knowledge, the perfect place for sensational reportage. Seabrook arrived in the capital of Haiti, Port-au-Prince, to the cliché of the Voodoo drums sounding in the hills and the thrill of his native informant (his servant Louis) telling him that 'we white strangers in this twentieth-century city, with our electric lights and motorcars . . . were surrounded by another world invisible, a world of marvels, miracles, and wonders – a world in which the dead rose from their graves and walked.'[23]

Much of *The Magic Island* involves Seabrook's attempts to find and gain entry into 'secret' Voodoo rituals, presented as if he is a fearless participant observer (rather than, as was most probable, experiencing a package set up for the wealthy adventurous tourist). Eventually he does work his way into a place where he can witness the sacrifice of a goat and the ritual drinking of blood. He graduates to his own 'blood baptism' and even a feeling of 'possession' by one of the local gods. He proclaims these savage rituals vastly superior to 'a frock-coated minister reducing Christ to a solar myth'. 'I believe in such ceremonies', Seabrook says: 'I believe that in some form or another they answer a deep need of the universal human soul . . . Let religion have its bloody sacrifices, yes, even human sacrifices, if thus our souls may be kept alive.'[24] Just like Hearn's decadent

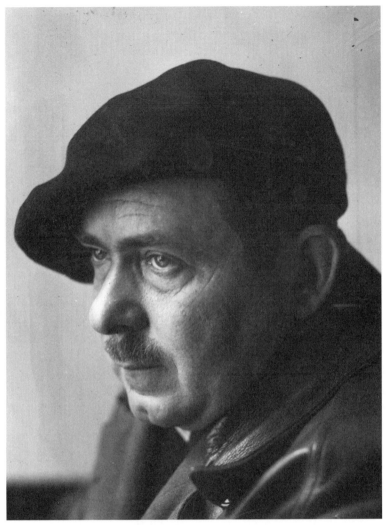

William Seabrook, author of *The Magic Island* (1929).

bohemianism, Seabrook's Modernist primitivism embraces precisely what Victorian anthropologists of superstition and colonial authorities had vocally condemned. Seabrook admires the 'dark depths no white psychology can ever plumb', although in the same sentence declares the Haitian peasants 'naïve, simple, harmless children' with conventional lazy racism.[25]

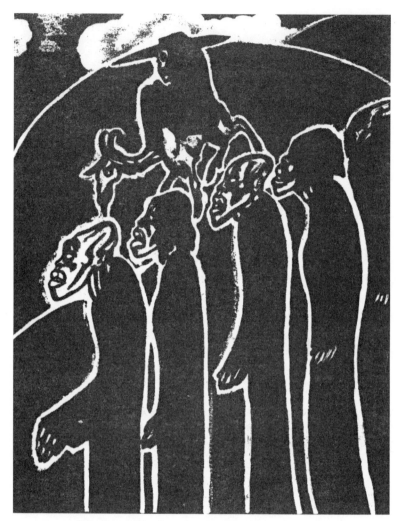

Woodcut of 'dead men working' by Alexander King,
from William Seabrook's *The Magic Island* (1929).

What follows is Seabrook's introduction to a magic that hides
behind Voodoo, a 'black sorcery' that is much harder to access.
Seabrook's fame rests on a short chapter called '. . . Dead Men
Working in the Cane Fields', which is mostly filled with second-
and third-hand reports of superstitions about 'a baffling category on
the ragged edge of things which are beyond either superstition or

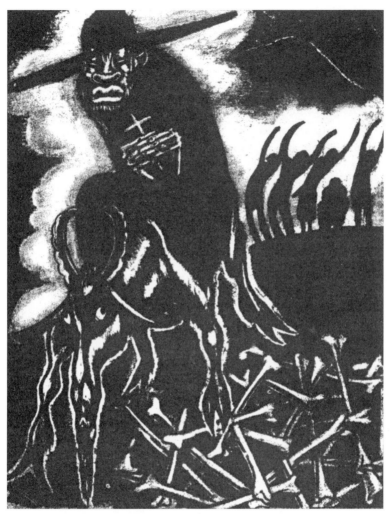

Alexander King woodcut from *The Magic Island* (1929).

reason'.[26] These relayed stories involve the vampire, the *loup-garou* or werewolf, and, most elusively, the *zombie*, a term that always appears in italics, as if resistant to incorporation into American English. In contrast to the slippery confusion of Lafcadio Hearn, Seabrook offers a precise definition:

The *zombie*, they say, is a soulless human corpse, still dead, but taken from the grave and endowed by sorcery with a mechanical semblance of life – it is a dead body which is made to walk and act and move as if it were alive. People who have the power to do this go to a fresh grave, dig up the body before it has had time to rot, galvanize it into movement, and then make of it a servant or slave, occasionally for the commission of some crime, more often simply as a drudge around the habitation or the farm, setting it dull heavy tasks, and beating it like a dumb beast if it slackens.[27]

Seabrook collects a number of folkloric tales about zombies, detailing how they can be brought back to a paradoxical consciousness of their 'true' dead state by eating salt. The awakening of a zombie to its true condition through the agency of salt is a constant in these early accounts. It is a superstition linked to the one in Europe, where spilled salt is thrown over the left shoulder in the Devil's face: salt is a preserver and purifier. Seabrook is then told that the zombie is not simply a marginal peasant belief, but has been enshrined in the Penal Code of Haiti, in a clause first added as early as 1864. Article 249 declares:

Also shall be qualified as attempted murder the employment which may be made against any person of substances which, without causing actual death, produce a lethargic coma more or less prolonged. If after the administering of such substances, the person has been buried, the act shall be considered murder no matter what result follows.[28]

This ambiguous legal formulation seems to confer the imprint of reality on zombification beyond merely folkloric whispers. The Penal Code was concerned to objectify and outlaw *sortilèges*, 'sorceries' exercised beyond, behind or in parallel to religious practices. Could the zombie be the product of a secret shamanic knowledge of a pharmacopeia used for inducing catatonic states? Could this be the material base for this elusive state?

It was precisely Seabrook's use of detail from the authority of medicine and law that was picked up in *White Zombie* in 1932, a film that leaned heavily on Seabrook as a source. This clause from the Penal Code is laboriously read out by the local doctor; Article 249 was also reproduced on posters for the film, as if it were a legal guarantor of 'true' horror. In 1936, the feverish pulp novel *Damballa Calls* by the German writer Hans Possendorf started and ended by quoting this same article of law, commenting: 'This gruesome paragraph, which is surely not to be found in the penal code of any other country, seems to be good evidence for the existence of "zombies".'[29]

Fifty years later, in the 1980s, the exotic adventurer and 'ethnobiologist' Wade Davis revived this old theory, claiming to have found both the poison that induced this catatonic state – derived from the puffer fish – and its antidote, thus finally 'solving' the mystery of the zombie once and for all. He published an academic paper, 'The Ethnobiology of the Haitian Zombi' in 1983, followed by a more sensational popular account of his adventures among the occultists of Haiti in *The Serpent and the Rainbow*. The book (and subsequent TV specials) presented 'actual' zombies created by the profound but secret skills of poisoners. They had proper names and case histories, these zombies. Clairvius Narcisse had 'died' in 1962, but was filmed by a BBC film crew in 1981. He later told Davis that he remembered being conscious but rendered completely immobile through his own funeral. Francina Illeus was being treated in a psychiatric institution for catatonic schizophrenia. Wade's theory was that these people had been poisoned with a potion used as a form of social policing by Haiti's secret societies. This theory created controversy and was largely dismissed by his fellow researchers.[30] In another echo of Seabrook, Davis's account, which wanted to claim a serious scientific basis, also became the source material for a sensationalist Gothic horror film, Wes Craven's *The Serpent and the Rainbow* (1988).

Seabrook starts collecting zombie stories as soon as his ear is attuned to this elusive being from the 'ragged edge'. These seem to be folkloric tales of the vengeance of these unquiet dead on the greed that drives their gangmasters or owners to extract unholy quantities

of labour. One story he is told refers to a gaggle of workers employed under a headman for HASCO, the Haitian American Sugar Company, an American enterprise then faltering at trying to reintroduce large-scale plantation farming back into Haiti. The rhetorical device is to link a native superstition to the machinery of modern American industrialism. Even more miraculously, his native source dismisses any hesitancy about the status of these stories by immediately offering to show Seabrook zombies actually at work in the fields. 'I did see these "walking dead men", and I did, in a sense, believe in them and pitied them, indeed, from the bottom of my heart', Seabrook declares with significant ambiguity at the opening of his description. He adds:

> My first impression of the three supposed *zombies*, who continued dumbly at work, was that there was something about them unnatural and strange. They were plodding like brutes, like automatons . . . The eyes were the worst. It was not my imagination. They were in truth like the eyes of a dead man, not blind, but staring, unfocused, unseeing. The whole face, for that matter, was bad enough. It was vacant, as if there was nothing behind it.[31]

Seabrook experiences a twist of 'mental panic' at this apparently incontestable empirical proof of the existence of the undead, only to rationalize what he sees as 'nothing but poor ordinary demented human beings, idiots, forced to toil in the fields'.[32] The chapter ends, however, in suspension between natural and supernatural explanations, with Seabrook quoting the authority of a respected Haitian scientist who reads out Article 249 of the Penal Code to hint at 'something in the nature of criminal sorcery' behind the zombie. A gripping yarn about the exotic uncanny must always be left unresolved, the zombie shuffling beyond any single frame of reference.

It is only in later chapters that Seabrook provides any proper context for his visit, when he travels to the island of La Gonave to meet its famous 'White King'. Faustin Wirkus was the American Marine Corps sergeant promoted to effective governor of this island

in the Gulf of Gonave, 30 miles from Port-au-Prince. Wirkus 'ruled' this territory as the lone white American representative on the island. After Seabrook's visit, Wirkus became something of a celebrity in America, published his own memoirs and went on the lecture circuit with his 'exotic' films of Haitian life. Seabrook praises the Marine for weaving himself into peasant structures of belief and justice, rather than trying to impose foreign values: this is how Wirkus is crowned 'King', symbolic companion to the native Queen.

The key point is that in visiting Wirkus, Seabrook's travelogue finally acknowledges that his whole trip is made possible by the occupation of Haiti by American forces in the period between 1915 and 1934. His impressions of Haiti are entirely dictated by this act of colonization, and this context is central to understanding how the Caribbean *zombi* made the leap to become the American zombie.

The occupation of Haiti was part of a larger series of American interventions in the Pacific and Caribbean in the early stages of America's imperial expansion into its sphere of influence from the 1890s: the annexation of Puerto Rico in 1898, the occupation of Cuba and Honduras, the creation of Panama, the troops sent into Mexico in 1914. Haiti occupied a unique position in the Caribbean in that it had been an independent republic since 1804, changing its name from Saint-Domingue to the indigenous Arawak name Haiti. It was the only state to be built from a successful slave rebellion at that time. This revolt began in 1791, started by a group of 'Black Jacobins' inspired by the rhetoric of universal liberty promised by the French Revolution; it had to defeat French, Spanish and English troops and a last Napoleonic attempt at reinvading the island before winning final independence.

Saint-Domingue had been the most profitable colony in the French empire, pouring vast wealth into French port cities like Brittany and Marseilles from rich harvests of sugar and coffee. The wealth of a substantial portion of the French bourgeoisie depended on the output of this single colony. Its profits were so vast because the plantations exercised a brutal system of slavery that slaughtered hundreds of thousands of African slaves throughout the eighteenth century in the relentless pursuit of maximum return.

The infamous newly independent black republic wrote a constitution outlawing foreign ownership of land. For this and other outrages, Haiti was demonized in white Europe and America for a century as an affront to benign accounts of the civilizing virtues of imperialism. The fledgling post-colonial state was virtually crippled from birth by the huge reparations of 150 million francs it was forced to pay in 1825 to foreign plantation owners for loss of income in return for limited trading deals. Haiti has been in debt dependency ever since.

In July 1915, the u.s. intervened in Haiti, ostensibly to restore political stability and avoid civil war following the murder of the president Guillaume Sam, who had been torn apart by his own citizens. The Americans depicted themselves in paternalist terms, and Haiti as its savage, childish 'ward' requiring benevolent guidance. American capitalists had actually been steadily securing control of Haiti's Banque Nationale over the previous decade, and the finances of the country had effectively been taken over by the New York City Bank before the u.s. Navy arrived. Haiti was again a pioneer, this time in experiencing the neo-imperialism of global finance at the start of the twentieth century.

American diplomats installed a new puppet president and forced the passage of a constitution which allowed for foreign ownership of land again. Much of the constitution was drafted by Assistant Secretary to the Navy Franklin D. Roosevelt. A $40 million loan secured from New York banks in 1919 further indebted Haiti. American capital then set about reconstituting large plantations. New business ventures, such as HASCO, were investment opportunities that promised large returns to their investors. Improvements in the infrastructure of the immiserated state of Haiti were funded by heavy taxes; most Haitians could not pay in cash and were forced to do so through the supply of their indentured labour. The return of the *corvée* gang within a year of American occupation, working on roads and railroads, was seen by many as the return of slavery.

The Americans fought a long-term insurrection by guerrilla rebels (known as *cacos*) and also, alongside the Catholic Church

and Protestant missionaries, a war against 'native superstition', which involved attempts to systematically dismantle any Vodou religious worship among the peasantry. This resulted only in a black-market trade in 'Voodoo drums' seized from *honforts* (ceremonial spaces) destroyed in police and army raids. In 1920, allegations about atrocities allegedly committed by Marines, reported by the black American journalist James Weldon Johnson in *The Nation*, resulted in an American Senate Committee inquiry that under-mined the discourse of paternalism. Haiti became a political focus for black civil rights and Negritude movements across the interwar period. By 1922, HASCO was in financial collapse and had to be recapitalized. During this slump, tens of thousands of Haitians travelled to neighbouring Dominica; up to 25,000 of them were later slaughtered in the ethnic massacres of 1937 known as *El Corte*, 'the cutting', thousands of macheted bodies of Haitian workers flung into the Massacre River. There was also mass migration to find work in Cuba, some estimating that nearly a quarter of the male population moved in this period. A shift in American foreign policy after the election of 1933 ensured the end of the occupation in the context of non-intervention. The U.S. withdrew from Haiti on 15 August 1934.

Seabrook's visit came towards the end of the occupation, at a time when the euphemistically named 'Hygiene Service' of the occupier was engaged in yet another major drive to disrupt an insurgency they closely associated with Vodou worship. They were being assisted by a very active Catholic Church campaign against peasant beliefs. The weirder and more sunk in superstition savage Haiti was, the more the language of Empire and Church as bringers of enlightenment justified intervention. Seabrook's Modernist primitivism clearly disliked any pious Christian interference with savage energies (his rejection of Christianity was wrapped up in his rejection of his father's evangelical ministry). This is why he approved of the king of Gonave's decision to merge with local customs rather than try to eradicate them, and why he embraced with typical colonial melancholy what he believed were the last traces of authentic rituals and customs before modernity swept them away.

But Seabrook was also blind to the conditions that created his 'dead men working in the cane fields'. The cultural resistance to slave plantations, from a century of building nationalist myths commemorating the violent refusal of the white masters, meant that the large HASCO plant in Cul-de-Sac found it very difficult to find labour for its revival of large-scale harvesting. Gang bosses brought in outsiders under duress; they were referred to locally as *zombis*. If slavery is, as Orlando Patterson has evocatively put it, a form of social death, to be returned to slavery by the American occupiers was an uncanny return after a century of freedom: no wonder the 'undead' roamed the HASCO fields. 'The essence of slavery is that the slave, in his social death, lives on the margin between community and chaos, life and death, the sacred and the secular. Already dead, he lives outside the mana of the gods and can cross the boundaries with social and supernatural impunity.'[33] So the imbecilic state Seabrook diagnosed could just as well have been the exhaustion of *corvée* work, and the shuffling gait might have come either from being in chains or from a distinctive way of moving that slaves developed to conserve energy. There is a reason why so many African American dances are based around ideas of 'the shuffle'. What Seabrook thinks he sees as a savage survival is actually a product of the very industrial modernity he believes he is leaving behind. 'Could there have been a more fitting image of and inclusive commentary on the proletarianization of the displaced Haitian peasant sharecropper than a crew of *zombies* toiling in the HASCO cane fields?' one historian asks.[34]

While Seabrook might have resisted many aspects of American modernity, his help in transferring the *zombi* into the zombie only retrenched a vision in the colonial centre of a series of immiserated margins creeping with supernatural beings set on vengeance. The malignant ancient Egyptian mummy starts awake in the British Museum with murder on its mind only after the British begin their military occupation in 1882. In the Roaring Twenties, American power is to be haunted by its own imperial revenant, one that will eventually bring full-scale and repeated apocalypse down on the American empire until it stands in imagined ruins – again and again and again.

What do these first brushes with the *zombi* in Hearn and Seabrook teach us? These books show us that it is important to grasp geo-political differences of emphasis as the *zombi* circulates around the circum-Atlantic world. The Martinician *zombi* is different from the Haitian *zombi*. They seem to have a different slant from the tales of *zombi* devilry collected in Dominica in the 1920s by folklorist Elise Clews Parsons, for instance, and different again from accounts of 'spirit thievery' associated with the Obeah tradition (Obeah being a term more familiar in Anglophone colonies in the Caribbean like Barbados and Jamaica, the word perhaps derived from the Igbo term *obia* for that figure that lies somewhere between doctor and priest).[35] In turn, these zombies vary from the American undead of Louisiana or, further north, from the zombies spewed out of New York pulp publishing houses in the 1920s and '30s.

The very different colonial histories of Caribbean islands contribute to these shifts of meaning. Lafcadio Hearn's elusive encounter with the meaning of *zombi* in Martinique anticipates a more expansive range of metaphorical resonances there. Unlike the revolutionary struggle for independence crucial to the identity of Haiti, Martinique, despite several slave rebellions since its colonization by the French in 1635, remains to the present day a 'department' of the French state, never having undergone full decolonization. This continued sense of dispossession in the native population has made Martinique a significant location for the emergence of anti-colonial theory that condemns this subjection in terms that often use the zombie as metaphor.

It was in Fort-de-France in Martinique that the revolutionary thinker Aimé Césaire, author of *Discourse on Colonialism*, taught Frantz Fanon, who went on to train in medicine and psychiatry and become a key intellectual in the struggle against French colonialism in the Algerian war of independence and elsewhere in North Africa. When Fanon published *The Wretched of the Earth*, the preface by Jean-Paul Sartre saw it as an epochal book in the reversal of power between white and black, colonizer and colonized. Sartre declared to his European readers of these 'wretched':

Their fathers, shadowy creatures, *your* creatures, were but dead souls; you it was who allowed them glimpses of light, to you only did they dare speak, and you did not bother to reply to such zombies . . . Turn and turn about; in these shadows from whence a new dawn will break, it is you who are the zombies.[36]

Fanon's book, as a manual for building revolutionary consciousness, actively denounced the 'terrifying myths' of 'leopard-men, serpent-men, six-legged dogs, [and] zombies', typical of what he called the 'occult sphere' of under-developed nations (he was not very careful in separating out the locality of these beliefs, either, as this mixed list attests). 'Believe me, the zombies are more terrifying than the settlers', Fanon said, arguing that these only reinforced the subjection of 'the native, bent double, more dead than alive', stuck in 'pseudo-petrification' under a 'death reflex'.[37] Even as Fanon urges revolutionary youth to 'pour scorn upon the zombies of his ancestors', the idea that settler colonialism can only create 'cultural lethargy and the petrification of the individual' very clearly borrows from the notion of the zombie, as if he cannot quite shake it himself.[38] In his psychiatric case studies of disorders produced by the violence of subjection and the traumas of his patients resulting from war, imprisonment and torture, the metaphorical zombie rears up again in his account of psychosomatic conversion hysterias, although he never uses the term:

It is an extended rigidity and walking is performed with small steps. The passive flexion of the lower limbs is almost impossible. No relaxation can be achieved. The patient seems to be made all of a piece, subjected as he is to a sudden contraction and incapable of the slightest voluntary relaxation. The face is rigid but expresses a marked degree of bewilderment.

The patient does not seem able to 'release his nervous tension'. He is constantly tense, waiting between life and death. Thus one of such patients said to us: 'You see, I'm already stiff like a dead man.'[39]

This description produces a very different undertow of meaning for the contemporary zombie.

Another significant Martinician writer and intellectual, Édouard Glissant, was also prone to use the zombie as a metaphor for the divided consciousness of the colonial subject. In his essay 'Dispossession', Glissant argued that Martinique suffered a very specific form of colonial melancholia, never having been in control of the economics of the plantations, even at the height of slavery, since the market was always determined elsewhere, by other islands or by the colonial centre. There was no density of island culture or identity. After centuries of colonialism and the neo-colonial assertion of Martinique as an Overseas Department of France in 1946, Martinician culture was marked only by pseudo-production, paralysis, 'technical automatism' and 'mental automatism'.[40] In a companion essay, Glissant reflected: 'Just as the Martinician seems to be simply passing through his world, a happy zombi, so our dead seem to us to be hardly more than confirmed zombis.'[41]

Subsequently, these intellectuals provide the basis for a generic portrait of the colonized self as a kind of zombification that extends to other Caribbean writers. Jean Rhys, the expatriate writer at the centre of Modernist Paris and London in the 1920s and '30s, was born in Dominica. At the end of her life, she rewrote the story of the first Mrs Rochester from *Jane Eyre*, a Caribbean Creole, in her novel *Wide Sargasso Sea* (1966). The story mixes the bewilderment and confusion of the last surviving rump of Creole planters after the end of slavery with Rochester's newcomer nightmares of being 'buried alive', 'the feeling of suffocation' and a dread of being poisoned by his servants. Early in his visit, Rochester looks up 'Obeah' in a travel book called *The Glittering Coronet of Isles*, reading: 'A zombi is a dead person who seems to be alive or a living person who is dead. A zombi can also be the spirit of a place, usually malignant but sometimes to be propitiated.' The same entry warns, however, that the Negroes 'confuse matters by telling lies', making this superstition difficult to pin down.[42] From these suggestive hints at native beliefs that exceed rational reduction, Rhys constructs a portrait of selves zombified by the weight of colonial

history and doomed expectation, and it spectacularly revises a reading of Brontë's Bertha Mason as a metaphorically zombified colonial subject.

Similarly, the Jamaican writer Erna Brodber, a scholar long interested in folklore and superstition, uses the notion of 'spirit thievery' in her novel *Myal* to depict the pressures on a young girl caught between her Irish father and Jamaican mother, between passing for white and being abjected as black, and between the allegedly enlightened values of her adoptive family of Protestant missionaries and the traditional beliefs of the peasant village steeped in Obeah lore. Her slow decline into 'vacant staring' and increasing phases of catatonic shutdown leaves a chorus of voices to diagnose her condition:

> – . . . He gives them no mind. He has . . . –
> – Zombified them. That's the word you need. –
> – Meaning –
> – Taken their knowledge of their original and natural world away from them and left them empty shells – duppies, zombies, living deads capable only of receiving orders from someone else and carrying them out . . .
> – Have you been zombified?[43]

This slippage around the zombie in generic post-colonial discourse 'creolizes' the *zombi* into a metaphor of colonial and post-colonial torpor. This is in distinct contrast to what happens in Haiti, however. The Haitian *zombi* has accrued a much more fixed set of cultural identifications and meanings. As my reading of William Seabrook's *The Magic Island* has begun to suggest, this is down to the very specific role that the black republic of Haiti has played in the colonial imagination of Europe and America since independence in 1804.

Seabrook's sensational story of the zombie needs to be understood as the story of a creature emerging from a long history of demonization of Haiti, which was focused for decades on overheated fantasies of Voodoo, cannibalism and black magic. Once this

sense of historical undertow is in place, we can begin to place Seabrook as merely one voice in the cacophony that unleashed the zombies that poured into American popular culture in the last years of the colonial occupation in the late 1920s and early 1930s.

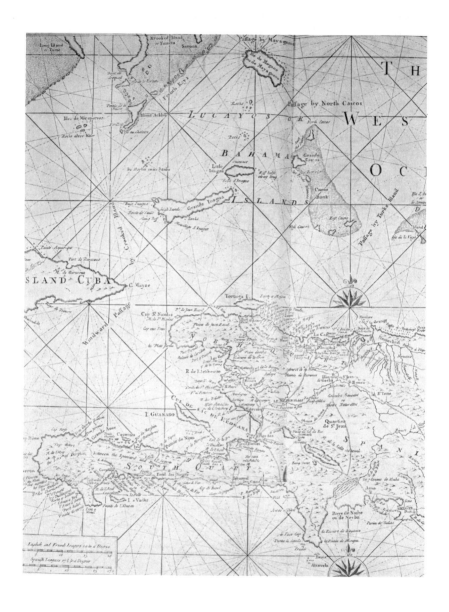

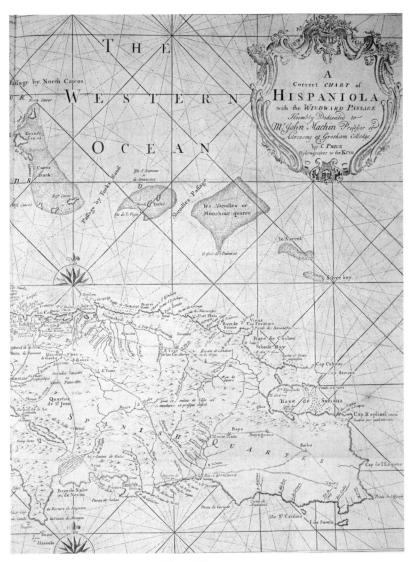

Map of Haiti, *c.* 1800.

2
Phantom Haiti

In 1685, Louis XIV signed into law the notorious Code Noir, the document that formed the official legal framework for slavery and the enforcement of order in the French colonies. The first article expelled all Jews from French colonies; the second article required all planters importing African slaves to baptize them as Catholic within a week of arrival or else face a fine; and the third edict forbade any other public exercise of religion, regarding all other congregations among the slaves as 'illicit and seditious'.[1] In the colony of Saint-Domingue, later to become Haiti, this produced a century of detailed elaborations of the Code, outlawing slave assembly first for dances, then for drumming ceremonies at night, then the practice of *sorciers*, the uses of magic charms and talismans, and, in 1758, all 'superstitious assemblies'. This followed a rebellion led by the maroon (fugitive slave) Makandral, rumoured to be a sorcerer who had poisoned French planters and exerted uncanny influence over his followers. In the 1780s, when Mesmerism became fashionable in Paris, it was immediately banned in Haiti. The law and the spirits are symbiotic: the Code's interdictions shaped and validated the very occult forces it was trying to eliminate.

The first European travel narrative about Saint-Domingue, Louis-Élie Moreau de Saint-Méry's *Description topographique, physique civile, politique et historique*, appeared in 1797, in the midst of the slave rebellion. The book spoke of 'disgusting' savage rituals and warned that 'nothing is more dangerous from all reports, than this cult of Vaudoux, founded on this extravagant idea, which can

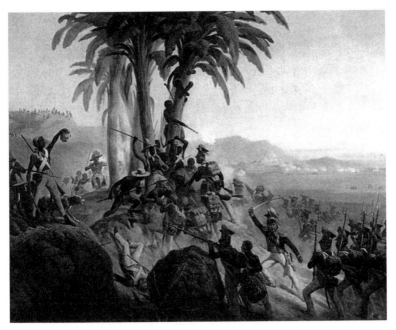

Haiti's interminable wars of independence: January Suchodolski's
The Battle at San Domingo, 1845.

be made into a very terrible weapon, that the ministers of the being
that is decorated with this name are omniscient and omnipotent.'[2]
It was strongly rumoured that the group that instigated the slave
rebellion of 1791 did so over a blood sacrifice. Boukman, the first
leader of the rebels, was widely believed to be a *papaloi* or Vaudoux
priest. Throughout the nineteenth century, Saint-Méry's fantastical
account of secret serpent worship in gatherings in the mountains
was rehashed as the authoritative truth that was hidden beneath
the surface of the black republic of Haiti. This is how the journey
from the French *Vaudoux* to the Louisiana Creole Voudou to the
modern American Voodoo begins.

The word *vodun* in the African Fon language loosely translates
as 'spirit', the invisible spiritual energy that entwines itself through
all human affairs, binding together past and present, mundane and
ultramundane spheres. Historians of Vodou religion speculate that
the French took slaves in such large numbers from the kingdom of

Dahomey (now Benin) that they transported much of their spiritual beliefs with them wholesale. Across the Caribbean, different slave ancestry produces slightly different local religions: hence Obeah in Anglophone colonies, Vaudoux in Saint-Domingue and Santería in Cuba. The French operated their most profitable colony with such brutality that the planters rarely bothered to 're-educate' their slaves, given the short life expectancy. Yet if Vodou is a partial link back to ancestral origins, it is also undoubtedly a syncretic set of beliefs, fusing with the official Catholic religion of the French colonists in Saint-Domingue in such intricate and ingenious ways that the Church authorities have found attempts to separate orthodox and unorthodox religious belief in Haiti impossibly self-defeating. Vodou is not a fixed doctrine, but a dynamic array of rituals and practices, so the Vodou *lwa* (or spirits) constantly mutate and transform in and beyond the Catholic panoply of saints. It also adapts very locally, often down to individual *honforts* (places of worship), and no two schematic descriptions of the cosmogony ever quite match up.

Under slavery, Vodou operated secretly in defiance of the Code Noir. But even after independence, the ruling elite in Port-au-Prince tended to regard Vodou practices as a peasant superstition that blocked progress and development towards modern statehood, adopting a European Enlightenment model of the nation. It was only in the 1920s that leftist political intellectuals like the anthropologist Jean Price-Mars suggested that Vodou could form the basis of a new indigenous national identity in Haiti. Most anti-colonial thinkers – like Fanon – continued to regard superstitious belief as a regressive force, a marker of subjection, not liberation.

Secret and disavowed before and after independence, Vodou steadily acquired a monstrous and phantasmal status in nineteenth-century travel writing. Vaudoux was an elusive cult mentioned only marginally before 1850 (and not at all in Thomas Madiou's four-volume history of the republic, published in 1848).[3] Yet it started to be the *defining* element of the Haitian republic in the 1850s, when the politics of race and slavery became incendiary during the American Civil War. In this context, an independent black state

only a little bit further away than the American slave states in the South required ideological demonization by the enemies of abolition. Black autonomy had to indicate depravity and credulity. When the ex-slave and soldier Faustin Souloque became president of Haiti in 1847 and ruled as Emperor Faustin I between 1849 and 1859, Haiti was portrayed as returning to a savage African state of bestial cruelty and superstition. It was emphasized that Souloque was a 'pure' black African who had massacred the mulatto ruling elite in Port-au-Prince on coming to power, eliminating the last traces of white influence. The scientific racism of Count Gobineau's notorious *Essay on the Inequality of the Human Races* (1853–5) used Haiti as the exemplar of race degeneration. A lurid depiction of this savage state, *Souloque and His Empire*, was published by Gustave d'Alaux in French in 1856 and translated into English in 1861. Towards the end of the American Civil War, there was also propagandistic use of the Bizoton Affair, a trial in a place near Port-au-Prince that appeared definitively to link Vaudoux with human sacrifice and cannibalism, the basest marker of savagery imaginable in Western thought. This was hugely important in further darkening the reputation of Haiti.

A detailed account of the Bizoton trial was published in English in Spenser St John's *Hayti; or, The Black Republic* in 1884, some twenty years after the fact, suggesting the story still carried a lot of cultural freight. St John was a career diplomat who had served as the British consul in Haiti from 1863 to 1875. Although when in the Far East he had scandalized his fellow colonial rulers by openly acknowledging his three children with his Malay mistress, his disdain for black Haitians was absolute. In his chapter 'Vaudoux Worship and Cannibalism', St John suggests that the arrival of Souloque made Vaudoux effectively the official religion of the rulers of the republic, and that this dark alliance was continued by Souloque's successors after he was deposed. St John detailed rituals that included 'the adoration of the snake', sacrifices of animals and the 'goat without horns' (which St John understands as meaning the sacrifice of human children). The ceremony of the snake, St John asserts, using second- and third-hand accounts, 'is accompanied by everything

horrible which delirium could imagine to render it more imposing',[4] a formulation that has no content but positively invites the reader to fantasize horrific things.

The Bizoton trial develops directly from these stories; the record of the law is again supposed to provide objective truth value of an horrific tale. In December 1863, the court heard, the labourer Congo Pellé had sought intercession from a Vaudoux *papaloi*, who had demanded a human sacrifice. Congo's niece was delivered; she was strangled, decapitated, her head cooked for soup and her flesh for a stew, with some body parts eaten raw, participants later confessed in court. The disappearance of another child in the area for a second sacrificial ritual had exposed the horrific plot.

St John is contemptuous of the process of the court (modelled on the French, not British, system), where the fatal confession had obviously been beaten out of the defendants and testimony was whispered to the judge by those too terrified to attest in open court. Yet he points out with dogged empiricism that 'there, on the table before the judge, was the skull of the murdered girl, and in the jar the remains of the soup and the calcined bones.'[5] Eight members of the *honfort* were condemned to death, and St John's account contains an intriguing last detail:

> The Vaudoux priests gave out that although the deity would permit the execution, he would only do it to prove to his votaries his power by raising them all again from the dead. To prevent their bodies being carried away during the night (they had been buried near the place of execution), picquets of troops were placed round the spot; but in the morning three of the graves were found empty and the body of the two priests and the priestess had disappeared.[6]

Presumably, if the word had been available to him, St John would have said something about the *zombi* at this point, but his account never uses the term. St John rationally dismisses the story as an act of collusion with the gendarmerie, a further indication of how sunk in superstition Haiti has become. A few pages later,

however, St John quotes from an official French report of 1867 about a disturbed grave and the occupant found 'killed' a second time, stabbed through the heart. The report hints at 'a sleeping potion' used to place victims in a drugged state that doctors mistake for death. After the funeral, the bodies are disinterred, killed and their body parts used in rituals. St John picks up the phrase *li gagné chagrin*, local Kreyòl for 'a sort of anaemia of the mind' that is affected by this drug. This is tantalizing, but St John offers no further details.[7]

This was still the case as late as 1913, when a tale can be told about Haiti in Stephen Bonsal's *The American Mediterranean* about the poisoning, burial and snatching from the grave, without having the word *zombi* available. Bonsal, in rampantly racist terms, relates a story personally known to him from his time in the Black Republic of a man declared dead and buried, but found semi-conscious and bound to a tree in the midst of a hastily abandoned Voodoo rite. 'The unfortunate victim of Voodoo barbarity recognised no one, and his days and nights were spent in moaning and groaning and in uttering inarticulate words which no one could understand.' The 'unfortunate wretch' never recovered from his 'mental decay': the authorities colluded by refusing to admit his actual identity, and he was left in this half-life hidden away on a prison farm.[8] Bonsal believes poisoning by the Voodoo cannibal priests who secretly run Haiti is the truth of the case. The outline of a narrative is slowly emerging, although this case is framed as proof of the prevalence of human sacrifice in Haitian Voodoo.

These anecdotes suggest the beginnings of the Haitian *zombi* that crystallized in Seabrook's account 50 years later, but the elements have not yet found their arrangement in the modern form. Instead, both the St John and Bonsal accounts are dominated by the scandal of cannibalism, a trope central to defining Europe's savage Others. This association was of course invented in the Caribbean. On his famous voyage that entirely misread the terrain of the West Indies, Christopher Columbus was told in November 1492 by his Arawak informants of a land of 'people who had one eye in the forehead, and others whom they called "canibals." Of these last, they showed

great fear, and when they saw this course was being taken, they were speechless, he says, because these people ate them and because they are very warlike.'⁹ This was the first use of the word 'cannibal' in a European language. Columbus later landed on Hispaniola (the first name for Haiti) and had a very brief exchange with a profoundly 'ugly' native that the admiral judged, without any material evidence, 'must be one of the Caribs who eat men'.¹⁰ Peter Hulme's analysis of this invention of the cannibal suggests that Columbus's crew merely slotted the man-eating Caribs into the phantasmatic place of the savage 'Anthropophagi' race that Herodotus imagined to lie somewhere beyond the edge of ancient Greece. Barbarians always devour human flesh.

As the maritime British Empire expanded, cannibalism became a particular obsession in English colonial discourse. 'Cannibalism is for the British something that defines the Savage as such, an atavistic tendency that even middling civilization cannot overcome.'¹¹ British explorers were obsessed with finding proof of cannibalism, whether among the Maoris in New Zealand and the aborigines in Australia or in the tribes of Hawaii (who were alleged to have eaten the morcellated body of Captain Cook). Later, West Africa, particularly Dahomey, was regarded as teeming with cannibal cults. By the 1890s, the spectacle of Dahomey cannibal tribesmen was one of the biggest draws of the 'human zoos' that were built for world's fairs and expositions around the world.¹² Since Haitians were descended from West African slaves, Vodou was bound up in this feverish set of associations. In each region, an obsessive prosecution by colonial authorities means that, as one legal historian puts it, 'law and cannibalism produce each other', because legitimation for colonial rule comes through the attempt 'to correct the excesses of atavism by applying the restraint of law'.¹³ It is therefore no surprise that an English consul would refract savage Haiti almost entirely through the lens of cannibalism. Meanwhile, the American Stephen Bonsal says of Haiti that 'there is no place in the world where you could so easily satisfy a cannibalistic craving as this land' and believes that child sacrifice is at the core of all Vodou ritual.¹⁴ The book, published just a few years before the American

occupation, justifies intervention because without 'supervision and control' of the black population, 'the task of civilisation has only been half accomplished.'[15]

The critic Gananath Obeyesekere has argued that the British spent so much time anxiously inquiring at first contact about cannibalism that natives began to reflect back in various ways the act that so clearly terrified their invaders. And if the cannibal can be understood as a paranoid projection outwards onto the Other, that is because acts of cannibalism among shipwrecked and stranded sailors at the very limits of empire were common. The notorious 'raft of the *Medusa*' incident, which took place off the coast of Senegal in 1816, in which the desperate survivors were known to have eaten men as they died, haunted the nineteenth-century imagination, as did the suspected fate of Sir John Franklin's disastrous expedition to find the Northwest Passage in the 1840s (Charles Dickens was particularly enraged by speculation that Franklin's noble crew must have got stuck in the ice and resorted to cannibalism). And in the very year that Spenser St John published his account of savage Haiti's Vodou cannibalistic cult, 1884, three English sailors were prosecuted for the act of eating a fellow survivor following the shipwreck of the *Mignonette*.[16] The outrage about this case was rather more concerned with the fact that a code among British mariners *in extremis* had been brought to court in the first place; this was a formalized act of survival, and although the perpetrators admitted their guilt, they were pardoned shortly after imprisonment. The cannibals, in fact, were us, not them.

Three years after St John's *Hayti*, the journalist and fiction writer Grant Allen published 'The Beckoning Hand', a lurid Gothic short story about an Englishman's fatal obsession with a mixed-race actress, soon revealed after their marriage as a Haitian quadroon whose matrilineal African inheritance pulls her back to Haiti and to Vaudoux, 'the hideous African cannibalistic witchcraft of the relapsing half-heathen Haitian negroes'.[17] This biological taint cannot be superseded: black blood and its savagery will out. This new kind of 'colonial Gothic' used the spurs of imperial travel to reinvigorate a notable revival in supernatural fiction: Allen had been

embittered by his failure at an idealistic university experiment to educate the natives in Jamaica and returned to his home in England to write fiction that harped instead on biological determinism and racial degeneracy.

Haiti was evidently part of this Gothic palette. In 1899, the big-game hunter, explorer and novelist Hesketh Hesketh-Prichard was commissioned by the *Daily Express* to travel into the interior of Haiti, a place that he claimed had been a 'sealed land' to whites since the last massacre of planters in 1804. His book of this trip, *Where Black Rules White* (1900), was written, he said sarcastically, 'in the hope of seeing with my own eyes those hidden things which the negroes had accomplished in their hundred years of opportunity.'[18] What it consolidated was only St John's demonic portrait of Haiti and Vaudoux. 'Vaudoux, Juju, Obi, or some analogous superstition seems to belong to the bottom stratum of black nature', Hesketh-Prichard authoritatively explained.[19] He continued: 'Vaudoux is cannibalism in the second stage. In the first instance a savage eats human flesh as an extreme form of triumph over an enemy . . . The next stage follows naturally. The man, wishing to propitiate his god, offers him that which he himself most prizes.'[20] The *papaloi* dominate civil society not with magic but with poisons: 'secret poisoning pervades the scheme of Haytian life.'[21] These poisons – 'which seems at present to lie outside the white man's range' – include one that 'can produce a sleep which is death's twin brother' and is often used to procure the bodies of children from graveyards for ritual sacrifice.[22] Again, Haiti is portrayed as a land 'netted over with fear, fear of vague and occult potencies', but the *zombi* has not quite yet emerged.[23] Hesketh-Prichard concludes his journey by remarking that Haiti provides only evidence that the Negro is quite incapable of self-rule, just four years before the Americans landed in Port-au-Prince and took command of the state machinery.

This paranoid vision of savage Haiti as a den of conniving cannibals was reproduced wholesale during the American occupation. Richard Loederer's *Voodoo Fire in Haiti*, for instance, published in New York in 1935, is breathless about 'secret cults, black magic, and human sacrifices'. These have been woven into the thread of the

black republic from the beginning, Loederer claims, explaining that
'from out of these sexual orgies grew the atavistic impulse towards
cannibalism.'[24] A native informant has told him the story of the
Bizoton Affair, now sensationally retitled 'the "Congo Bean Stew"
trial'. This material is clearly just lifted from St John's 50-year-old
book. Another invented informant is given the words of William
Seabrook, which shows how quickly the older cannibal fantasy
started to incorporate zombies in the 1930s where they had been
entirely absent before: 'Voodoo is strong; stronger even than death.
The Papaloi can raise the dead. He breathes life into corpses who
get up and behave like men. These creatures are bound forever to
their master's will. They are called "zombies."'[25] From very early on
in America's engagement, the depiction of Haiti is largely a
palimpsest of recycled textual fantasy.

Another example of this American view was John Houston
Craige, a U.S. Marine who was transferred to train the Haitian police
force for three years and published *Cannibal Cousins* in 1935. Rebel-
lion and Vodou are as usual tied together in Craige's sketch of the
republic, and Vodou is routinely associated with cannibalism from
the earliest days of independence. Craige records a general disbelief
of these stories among American Marines, but cites the legal case
against Papa Cadeus, who had been an important figure in the Cacos
Rebellion against the American occupiers, and a Vodou *papaloi* long
rumoured to use cannibalistic rituals involving the 'Goat without
Horns'. Craige reports (second hand) that human bones had been
found buried around the Cadeus *honfort*, and that the priest had
been sentenced to death by the court in the early 1920s, a judge-
ment foolishly commuted at a time when the Americans were under
scrutiny for their own alleged atrocities. In a later chapter titled
'Doctor Faustus, Cannibal', Craige charts the 'marvellous tale' of a
lowly black peasant from Marbeuf who rises to become the chief of
police in Port-au-Prince by virtue of his deal with a Vodou priest.[26]
It is said, Craige reports, that his rise came at the cost of the sacrifice
of one baby a year for over 40 years. This is recirculated gossip: a
patina of savagery rubs off, and even if untrue it serves to abject
Haitians as credulous fools for believing such a story. It also deflected

any critical attention from the organized political and guerrilla opposition to the occupation.[27]

This demonization continued long into the post-occupation era, particularly under the dictatorship of François 'Papa Doc' Duvalier (who came to power in 1957), in part because this brutal regime carefully cultivated fear and obedience among the population by associating Duvalier with Vodou and occult secret societies. Duvalier, who trained in medicine, was closely associated with the scholar of Vodou Lorimer Denis and they co-wrote the study *The Gradual Evolution of Vodou*. In the 1960s, when gruesome news of Duvalier's atrocities began to circulate (helpful material in an era of violent anti-colonial wars against Western powers), the details mixed atrocity, Vodou and supernatural doings in the presidential palace. After a failed rebellion in 1963, Duvalier was alleged to have ordered the leader's 'head to be cut off, packed in ice and brought to the palace in an Air Force plane. News spread around Port au Prince that Papa Doc was having long sessions with the head; that he had induced it to disclose the exiles' plans.'[28] Through stories of sorcery, Duvalier became associated with the Guédé *lwa*, the Vodou spirits who preside over death and the cemetery, and he deliberately dressed to echo the signature style of Baron Samedi in a black hat, dark glasses and funeral suit: a figure to preside over a funeral. In an odd feedback loop, Duvalier survived by exploiting American fantasies of Haitian cannibalism and supernaturalism, reimporting them to terrorize his own population.

Meanwhile, familiar tropes of travel narratives about Haiti continued into the 1960s. Graham Greene had first travelled to Haiti in 1954, and seen his first Vodou rituals as a tourist. Once Duvalier came to power, Greene returned to report on his 'reign of terror'. 'Some strange curse descended on the liberated slaves of Hispaniola', Greene reported. 'The unconscious of this people is filled with nightmares; they live in the world of Heironymus Bosch.'[29] In his novel *The Comedians* (1966), Greene used the Haiti of Papa Doc's regime of murder squads superficially as an exotic objective correlative for his usual wearisome dramatization of Catholic angst among expats. Zombies are mentioned in passing,

but simply as part of a black culture paralysed by fear and superstition: they are now reference points for the Haitian exotic.

For the anthropologist Francis Huxley (great-grandson of the Victorian man of science), Haiti in the 1960s was summed up in this way: 'Notorious for its voodoo and its zombis, it can indeed be fascinating and beautiful: but its poverty is disgusting, its politics horrible, its black magic a matter for dismay.'[30] An obligatory search for zombies takes him directly to the Psychiatric Centre, where many patients suffer 'voodooistic hallucinations'. Many patients offer him sincere accounts of (un)dead girls returned from the grave: 'Such stories are endemic', Huxley explains. 'The girl is always recognized by her bent neck – because her coffin was too small, and her head had to be jammed down to fit her in – and a scar on her foot, where a candle had overturned and burnt her when she was laid out.'[31] Huxley considered *zombi* stories 'an epiphenomenon of possession', psychologizing the folklore as a subset of Vodou's practice of ecstatic dancing and the ritualistic loss of self.

The Vodou context might have fallen away to a large extent from the cinema depictions of the zombie since the 1970s, except here and there in the framings of films like the blaxploitation horror Paul Maslansky's *Sugar Hill* (1974) or Lucio Fulci's Louisiana-set *The Beyond* (1981). Yet the trace of this long history of fantasies about savage Haiti survives in the mindless drive of the modern zombie to devour living human flesh. The cannibalistic act remains the index of savage otherness to Western civilization, just as it has since the ancient Greeks, and survivors of the zombie apocalypse can slaughter the undead hordes in such massive numbers because they are modern representatives of the subhuman barbarians at the gates. In the zombie TV series *The Walking Dead*, the worst imaginable menace is less the undead than the other groups of survivors who have resorted to cannibalism, thus severing the last connection to pre-disaster American values.

In the 1980s, cannibalistic fantasies specifically about Haiti returned again, this time with catastrophic humanitarian consequences. In the very early years of the AIDS pandemic, it was a common speculation that the syndrome was invading American

shores through African or Caribbean carriers. Signs of the syndrome were particularly rife in the immigrant Haitian population in New York. In 1982, AIDS was considered 'an epidemic Haitian virus' and a year later the association with 'Voodoo practices' was first made.[32] In 1986, the august *Journal of the American Medical Association* published a letter from a doctor voicing the hypothesis that those attending Vodou rituals 'may be unsuspectingly infected with AIDS by ingestion, inhalation or dermal contact with contaminated ritual substances, as well as by sexual activity', citing Wade Davis as the sole authority. The journal titled the contribution 'Night of the Living Dead II'.[33] The drinking of blood invoked four centuries of an association with the eating of flesh, cannibalism and magic. The high incidence of AIDS among Haitians, one reporter declared, was 'a clue from the grave, as though a zombie, leaving a trail of unwinding gauze bandages and rotting flesh' had appeared at the doors of the hospital.[34] There was no recognition that it was sexual tourism between America and the Caribbean that was the most obvious source of infection.

For the historian Laënnec Hurbon, Haiti and its Vodou practices have long been sites of American projection, places where travellers 'find in Vodou their own fantasies'.[35] It is generally agreed that while ritual anthropophagy (the eating of human flesh) can occur in highly ritualized circumstances, the 'cannibal' is an invention of colonial discourse. What testimonies of Vodou rituals involving the eating of flesh are most likely to be are literalizations of highly metaphorical practices. Vodou is, after all, a practice of possession and dispossession, of roles and masks, where one thing stands in for or displaces another and the metaphysical transposition of identities is at the core of events (just as the transubstantiation of the 'body of Christ' is at the heart of Christian ritual). In a discussion of the Kreyòl term *mangé moun* ('eating man'), Erika Bourguignon noted its extremely flexible metaphorical range in Haiti, where greed and envy, domination and control were translated into talk of oral aggression or acts of devouring, and the metaphorical transpositions of animal and human flesh.[36] Deftness in both language and ritual practice outwits leaden visitors, particularly if they filter what is

witnessed through a pre-prepared grid of interpretations about 'savages', witch-doctors or cannibals.

This longer historical perspective on Haiti in the Western imagination offers the broader context for now concentrating on the crucial years in which the Caribbean *zombi* translated and transformed into the zombie in American culture.

3
The Pulp Zombie Emerges

The zombie was invented in the vast surge of anonymous discourse that poured out of the printing presses of America's pulp printing houses. The pulps – so-called because of the cheap untreated wood-pulp paper they were printed on, in contrast to the upscale 'slicks' – established a format of short melodramatic fictions breathlessly told with the arrival of Frank Munsey's monthly magazine *The Argosy* in 1894. The golden era of the pulps was the 1930s, when it is estimated that over 30 million Americans were reading nearly 150 titles per year by the outbreak of the Second World War. Differentiation in a crammed market produced many of the commercial genre distinctions we still use to categorize popular fiction. It was in this era that the magazine entrepreneur Hugo Gernsback invented the term 'science fiction' in *Science Wonder Stories* in 1929, for instance. The pulps also twisted traditional Gothic into modern horror fiction in magazine, like *Terror Tales*, *Horror Stories* and *Unknown*. There were also strange fusions between horror, science fiction and mystery, creating odd hybrids such as *Weird Tales*, from 1923, and whole genres like the weird menace stories that thrilled readers in the 'shudder pulps' of the 1930s.

Pulp fiction was an unashamedly commercial mass culture industry, driven by the mechanical production of sensation. It was designed to jolt tired nerves, always pushing at the boundaries of acceptable taste by toying with taboos around sex, race and death. The editorial in the first issue of *Terror Tales* justified itself somewhat disingenuously by arguing: 'today, in a generation protected

and coddled by the artificial safeguards of civilization, the average citizen finds scant play for those tonic bodily reflexes which are so largely caused by primitive fear. Thrills, we believe, fill an important, necessary function in any normal, healthy human life.'[1] The exotic zombie was an exemplary creature to shuffle out of this context.

I want to trace how the zombie emerged in the pulps, sampling a few crucial representative writers and tales. These are the stories that, alongside Seabrook's *The Magic Island*, directly underpin the more familiar story of the arrival of the zombie in American cinema just as the category of 'horror film' was emerging in *White Zombie* in 1932.

Pulp fiction seeks to stimulate the reader through extreme physiological reactions: the thrill of excitement, the tears of sentiment,

Original film poster for *Voodoo Devil Drums* (1944).

the prickling of fear, the shudder of revulsion. The ambition to produce unmediated bodily reaction is the reason why it is rarely considered proper art. Gothic fiction was condemned from the start as a dangerous stimulant, generating 'the shocks', as Coleridge said of the scandal about Matthew Lewis's blasphemous romance *The Monk* in 1797, that 'always betrays a low and vulgar taste'.[2] The Gothic began in graveyard elegies, melancholy over mouldering remains, and soon mined a rich seam for its horrific effects by continually transgressing the boundary taboo that separates the living and the dead.

That later American Gothic scoundrel, Edgar Allan Poe, was in no doubt that '*no* event is so terribly well adapted to inspire the supremeness of bodily and of mental distress, as is burial before death.' In relishing the ghastly anecdotes that make up the first part of his short fiction 'The Premature Burial', Poe's narrator argues that 'We know of nothing so agonizing upon Earth.' To come round and find oneself alive yet trapped in the grave evokes 'a degree of appalling and intolerable horror from which the most daring imagination must recoil'.[3] In 'The Facts in the Case of M. Valdemar', Poe would cross the border from the other direction in a tale where a man suspended in a Mesmeric trance at the moment of dying is held there for seven months to then speak from beyond death: '*I say to you that I am dead*', that entirely impossible utterance. He is released from his trance and disintegrates into 'a nearly liquid mass of loathsome and detestable putrescence'.[4]

Throughout the nineteenth century, Gothic fiction continued to toy with this taboo, breaching it in every abject way. There were tales of body snatchers who haunted cemeteries for low-rent anatomists. Varney the Vampire launched a penny dreadful serial of unending undead returns. Victorian newspapers obsessed about every true-life incident of premature burial. Many of these obsessions recurred in the twentieth-century horror pulps. In H. P. Lovecraft's lurid early serial fiction 'Herbert West – Reanimator', a pulp Victor Frankenstein rootles around in graves, morgues and abattoirs for his vivisections, and so sets the tone for the obsession with unruly corpses in *Weird Tales*. A later example was Henry Kuttner's story 'The

Graveyard Rats' (1936), featuring the gruesome yet fully deserved end of a gravedigger who pilfers valuables and body parts from graves; he is eventually trapped in a system of tunnels in the cemetery dug by giant rats only to confront 'the passionless, death's head skull of a long-dead corpse, instinct with hellish life', which eats him alive.[5]

Weird Tales was established by J. C. Henneberger in 1923 out of an admiration for Lovecraft's brand of pulp horror. It nearly collapsed by sailing close to censorship with the necrophiliac tendency of C. M. Eddy's story 'The Loved Dead' a year later, a crisis that brought the influential editor Farnsworth Wright to the journal. Wright fostered the mighty weird trio of Lovecraft, Robert E. Howard and Clark Ashton Smith, although just as famously turned down some of their strongest works: he was a quixotic editor.

The influence of *Weird Tales* on the other horror pulps set up a nexus of concerns that produced the perfect conditions for Seabrook's 'dead men working in the cane fields' to flourish instantly in American popular culture. *Weird Tales* was generically slippery, hovering between supernatural and science fiction, a magazine that early on carried on its cover the promise of stories of 'the bizarre and unusual' or 'startling thrill-tales', but also 'pseudo-scientific tales'. Early editions mixed up pulp horror with reprints of Charles Baudelaire, Théophile Gautier and Percy Bysshe Shelley, as if seeking to invent its own literary tradition of decadence and outrage. Lovecraft himself came to define the weird tale as something beyond the clanking chains of mere Gothic sensation, a striving to convey 'a certain atmosphere of breathless and unexplainable dread of outer, unknown forces' and 'a subtle attitude of awed listening, as if for the beating of black wings or the scratching of outside shapes and entities on the known universe's utmost rim'.[6]

The weird tale therefore often used far-flung, exotic settings and Orientalist colouring. The stories were suffused with paranoia about foreign menace and fears of invasion or subversion. This was the era of the 'Yellow Peril' from China and the 'Red Scare' from the immigrants pouring into America from Eastern Europe, bringing socialism or Bolshevism (or – almost as bad – Catholicism) with them. White Puritan America, from the solid, reliable stock of

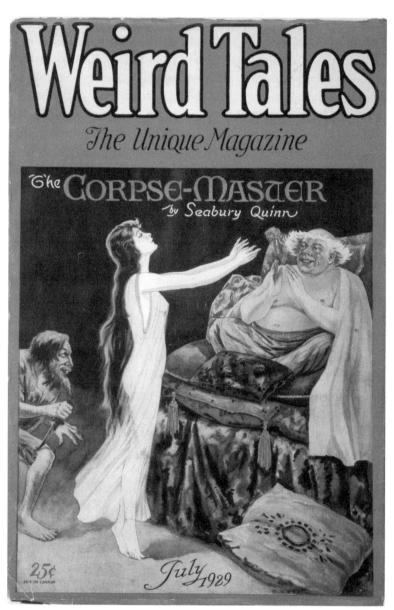

A quintessential pulp cover: *Weird Tales* (July 1929).

Northern Europe, faced 'a racial abyss' or the prospect of 'race suicide' as the blood of the nation was diluted by these weaker races, conservatives argued.[7] Lynchings continued in the South as tolerated forms of social policing, and the Ku Klux Klan reinvented itself and peaked as a national mass organization in the 1920s. Meanwhile, groups like the National Association for the Advancement of Colored People pushed harder for equality of civil rights. American colonial ambitions in the Caribbean and Pacific brought a military dimension to these speculations, one which carried an undertow of anxiety about reverse colonization and fantasies of race revenge.

Pulp fiction often reflected back these racial anxieties, seeking populist approval. Sax Rohmer sold millions of his Fu Manchu stories, moving from England to America to be closer to his market. The 'Yellow Peril' – the fear of the Chinese masses – had become a Western obsession by the late nineteenth century, stoked by writers like Rohmer and the Caribbean-born pulp author M. P. Shiel. American pulp science fiction was obsessed with lost races in the last unexplored interiors of Africa or the Amazon, or else imagining futures in explicitly racial terms (Buck Rogers fighting Ming the Merciless, or the race wars on Mars depicted by Edgar Rice Burroughs). In the *Weird Tales* roster, both Lovecraft and Howard were pathological racists, directly linking the Gothic form they embraced to the biological inheritance of the white, Nordic north. These pulp writers wrote hypnotic race fantasies, dripping with the weird menaces threatening to undo the last scions of white manhood in a delirium of miscegenation and monstrosity.[8]

The Caribbean *zombi* knotted together these elements into a single pulp figure. It was a being that hovered between life and death, the natural and the supernatural, and toyed with the gruesome prospect of being buried alive by nefarious native conspirators. It rose up in that indeterminate zone of rumour in the colonial margin, and when the threat was transposed to the imperial centre it offered a shivery instance of infiltration and exotic menace. The Master of the *zombis*, exercising a demonic hypnotic power over the weak-willed, was fused with a long-established melodramatic narrative about foreign mesmerists and their threat to white

women, and therefore to the purity of the race. The Haitian *bokor* (or 'witch-doctor'), was but a new version of the threat represented by Count Dracula or Svengali in the 1890s. If the Gothic romance shadows geopolitical shifts, and mocks the discourse of bringing light and enlightenment with its countervailing dark fantasies, then America's occupation of Haiti after 1915 only reinforced the allure of this Caribbean inflection of the supernatural. Its force in the Gothic imagination was redoubled after America's withdrawal in 1934.

There are several anthologies of fiction that can be used to trace the history of the emergence of the pulp zombie, before and after the publication of Seabrook's *The Magic Island*. Otto Penzler's soberly titled compendium *Zombies! Zombies! Zombies!* collects classics from Poe, Lovecraft and Kuttner, and doubtful borderline cases like Sheridan Le Fanu's 'Schalken the Painter' and Thomas Burke's often anthologized 'The Hollow Man', about a murdered man reanimated by African cultists and returning to London to seek out his murderer.[9] The first cluster of recognizable pulp zombie stories is in the late 1920s and early 1930s, from magazines like *Weird Tales* and *Thrilling Mystery*. They follow Seabrook very closely. Seabury Quinn, inexhaustible author of Jules de Grandin detective stories for *Weird Tales,* actually dramatizes the shift in 'The Corpse-Master' (1929), when his Fu Manchu-like Chinese villain, who presides over a harem of transfixed, languorous women, proves to have 'resided long in Haiti, and that there he mingled with the *Culte de Morts*'.[10] De Grandin efficiently educates the reader in the conventions they need to know about this dastardly new enemy: 'In Port-au-Prince and in the backlands of the jungle they will tell you of the *zombie* – who is neither ghost nor yet a living person resurrected, but only the spiritless corpse ravished from its grave, endowed with pseudo-life by black magic and made to serve the whim of the magician who has animated it.'[11]

Ten years later, in Thorp McClusky's 'While Zombies Walked', the narrator sees men with severe head wounds labouring in a cotton plantation 'like soldiers suffering from shell-shock', but comes to a belated understanding (much later than the reader) when 'there

flashed across Tony's brain a confusion of mental images that he had acquired through the years – an illustration from a book on jungle rites – a paragraph from a voodoo thriller – scenes from one or two fantastic motion pictures he had witnessed.'[12] By 1939, the zombie is recognized by its embedded references in American popular culture, rather than through obscure colonial folklore.

The early stories in this cluster start by repeating the same folkloric elements about a Voodoo spell that holds the zombie in thrall to its master, but which can be broken if the victim is given salt. This traces back to G. W. Hutter's story 'Salt is Not for Slaves', first published in *Ghost Stories* in 1931, which reads like the transcription of a folklore story from Haiti, which it essentially is. The substance of the story is narrated by an ancient servant, Marie, who tells of a French plantation owner who controlled slaves in the fields with witchcraft up to the eventual triumph of the 1804 revolution. The story never uses the word *zombi* or *zombie*, as if it is not quite yet secure in the language. Marie seems to recall vividly scenes from over a hundred years before, explaining how these abject slaves are deliberately fed salt to awake them in revolutionary times to their (un)dead state. The tale ends with Marie's own horrifying dissolution, for she too has been in this suspended state for over a century: 'That face! The flesh melted away under my terrified gaze. Nothing was left but the grim bones of the dead.'[13] Perhaps because the framing has a certain ethnographic tone of authority, the elements of the story were recycled by others: salt wakes the enslaved undead of a visiting Haitian revue in London in Charles Birkin's 'Ballet Nègre', for instance. G. W. Hutter's influence was far more substantial in another way, though. Presumably because of the authority of 'Salt is Not for Slaves', Hutter, the pseudonym of Garnett Wilson, became the scriptwriter for *White Zombie* the following year, in 1932.

Once the film had further lodged 'zombie' in the language, the pulps rapidly absorbed it. By 1933 it had already crossed the Atlantic. Vivian Meik's short story 'White Zombie' of 1933, published in his collection *Devil's Drums*, is set in the English colonial context of West Africa, centred on a plantation on the edge of the terrain where administrative authority begins to run out and something

has gone very wrong after the death of the white owner. Aylett, sent to investigate, realizes that the 'pitiful automatons' who still work the fields labour unto and beyond death at the command of a sinister gangmaster: 'zombies, the natives called them in hushed voices'. The story finishes off the zombified white owner with a crucifix that reduces him to 'greyish powder', suggesting a rapid fusion of Seabrook's Haitian zombie with European vampire conventions.[14]

Some pulp writers did not merely exploit the tropes of the latest horror trend, but relied on more detailed knowledge of Haiti. One of the most celebrated pulp writers of the 1930s was Theodore Roscoe, who wrote serials for *Argosy* and later sensational crime journalism for Hearst's *American Weekly* (he only published two stories in *Weird Tales*, because their hack rates were too low for one of the most successful pulp writers of the day). Roscoe added authentic grit to his exotic pulp fictions by travelling in the late 1920s and '30s to far-flung places, journeying across the Caribbean islands for several years, including Haiti. His travel notes from 1930 mention: 'But five days down from New York lies an island where the law was only recently passed that a man must wear pants in town. Black Haiti.'[15] The stench of Port-au-Prince ruins its picturesque poverty. He hears the drums at night, listens to stevedores steeped in Voodoo belief, and implies that savagery is only just kept at bay by the presence of 500 American Marines. This was the first of several trips to Haiti before Roscoe went further afield to research the French Foreign Legion at war in Morocco and Algeria, and later to explore the Leopard Man cults of West Africa.

In 1931, Roscoe published *The Voodoo Express: A Haiti Novelette*, the cover story in *Argosy*, about the myth of a phantom train that hurtles through the Haitian jungle, said to be full of Spanish gold protected by the undead. It is full of melodramatic clichés, of the jungle as a 'weird' primordial space, of secret Voodoo gatherings that are a 'blood ritual dating from the dawn of time', of a witch-doctor who 'was a high priest of the dreaded Cultes des Mortes; master of Petro and Legba rituals – the weirdest of all Haitian creole voodoo'.[16] The place is also a tumble of superstitions, including the zombie, somewhat confusingly presented:

While our early Pennsylvania Dutch believed in *hex* and the backwoods Gumbo Ya-Ya Cajuns of Louisiana have all kinds of fetishes and charms, the Caribbean creoles have this black-magic witchcraft called *obeah*. Haiti reeks with that sort of business. Ghosts. Haunts. The Haitians have their own special version. You know about *zombies*. The 'undead dead' they call them. Corpses who've been dug up and set to work like mechanical slaves.[17]

The breathless action seethes with anxiety that Haiti 'will bring out what's already in a fellow's blood', pulling the rational visitor down into primitive superstition: 'If it's born in a man he'll revert to type in the tropics.'[18] It is set in 1915, significantly right at the start of the period of American occupation. Although much of the mystery is rationally (if improbably) explained in the end, preserving the American protagonist from this reversion, the zombies that ride the train are left deeply ambiguous, suspended between natural and supernatural explanation.

During a lengthy trip through Haiti in 1934, Roscoe also wrote the serial *A Grave Must Be Deep: A Chilling Mystery of Haitian Black Magic*, composed, he said, on his travel typewriter partly in Cap Haitien, Gonaives, and by candlelight in a cemetery near Léogâne. Roscoe's plot transports a Greenwich Village bohemian to a plantation on Haiti, as she is declared one of the heirs to the recently murdered white planter owner, her Uncle Eli. The shenanigans at his funeral – deep burial in a hardwood coffin beneath a heavy stone, completed by a metal stake through the heart – suggest that knowledge of these superstitions have some purchase. 'He is afraid they would get him for a *zombie*', one Haitian nevertheless helpfully explains.[19] The plot kills off the heirs one by one, maintaining a vaguely spooky air before the book reaches a truly delirious finale. Uncle Eli rises from the grave to announce himself the White King of the Zombies and agitates to revive the Caco insurrection against the fragile grip of the authorities. The chief of police refuses to believe in the zombie, yet anxiously explains: 'the mountain blacks are of the most fanatic. This story spreads like the disease.'[20] The ploy is all unsubtly telegraphed and laboriously explicated in the last

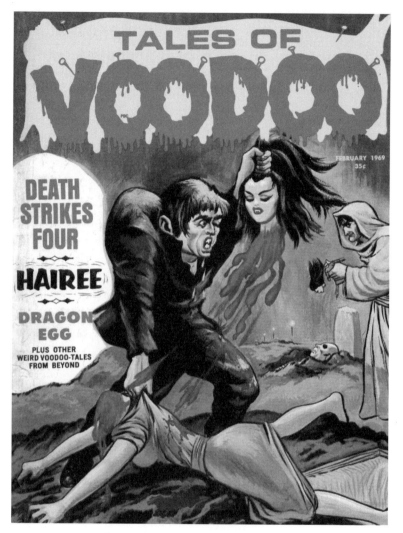

Cover of *Tales of Voodoo* (February 1969).

chapter. This is an exercise in the 'explained supernatural': Uncle Eli's death was staged and the zombie trappings used manipulated the credulous natives, of course.

Roscoe's follow-up serial adventure for *Argosy* was called *Z is for Zombie* (1937), a title that neatly suggests how soon 'zombie' entered the pulp ABC of horror. The story is another detective fiction, starting

out in Port-au-Prince before heading into the superstitious hills beyond the town. By the late 1930s, Roscoe is able to toy with the knowledge his readers have of zombies, although the term is still written in italics as if it remains an unassimilated loan word. The plot includes corpses vanishing from graveyards, apparent medical experiments in resuscitating the dead conducted by suspect German scientists in remote hospitals in the jungle, and even the possibility of undead German spies left over from the Great War. Roscoe also indirectly evokes the details of Seabrook's description of dead men in cane fields, as his hero reflects:

> It was no time, either, to recall the story a French consul in Port-au-Prince had once told him about the dead men they'd found working at the Hasco plant . . . Hasco stands for Haitian American Sugar Company, and you can buy Hasco Rum today in any good liquor store in the United States. You wouldn't expect the un-dead in a modern industrial plant under Yankee capital, but the rumour persisted that *zombies* had been seen there.[21]

For a serial adventure that requires constant convulsions in plot development, these instances of reflection – which cost his editor two cents a word – are telling. At another moment, the protagonist Ranier reflects on the ghosts of atrocious history that haunt Haiti and personify its uncanny night as 'a ghost, fuming and blowing, trailing its gauzy veils across field and road, stalking in moist white cerements through the jungle'. This purple patch ends very oddly: 'The ghosts here were American. Ghosts from the days of Benoit Batraville and Guillaume Sam and the Caco insurrections. Shades of Smedley Butler! . . . Ranier almost listened for a faint bugle echo to summon phantom stalwarts of the Corps . . . charging the fog with reckless bayonets.'[22] The spectres conjured are of the beginning of the American occupation and the war conducted by the American Marine Corps against the Caco insurgents from 1915. Smedley Butler had been awarded the Medal of Honor for his assault on a Caco stronghold in November 1915, making him the most decorated soldier in American history. Yet Roscoe, who wrote

extensively on American naval history after the decline of the pulps, must have known that by the early 1930s, Butler had become, in his retirement, a prominent peace campaigner and ardent critic of American warmongering and colonial profiteering in its sphere of influence. Although Roscoe's zombies again all turn out to be explicable ruses in *Z is for Zombie*, the hesitation expressed in the plot is not just about the explanatory power of the supernatural, but a register of the ambiguous legacy of American foreign policy.

The most sustained engagement with the Caribbean supernatural in the pulps can be found in the short stories of Henry St Clair Whitehead. Whitehead published consistently in *Weird Tales* throughout the 1920s, but also in other pulp venues like *Black Mask* and *Strange Tales*. He became a friend of H. P. Lovecraft, who long admired his contributions to *Weird Tales*. Lovecraft corresponded with him, assisted him with rewriting rejected stories and eventually visited him for a fortnight in 1931. He came away admiring 'one of the most fascinating personalities I have ever encountered'.[23] When Whitehead died quite suddenly in 1932 before publishing a collection, Lovecraft mourned a writer whose 'best work is among the finest weird writing of the present time'. Whitehead was the exemplary weird writer because he stuck to rigorous rules: 'avoid all extravagance, freakish or capricious motivation, redundancy of marvels, and the like, and to follow absolute realism except for the *single* violation of natural law.'[24] In deference to Lovecraft's high opinion, Arkham House, which was set up in 1939 to publish the fiction of H. P. Lovecraft and his circle, published two Whitehead collections, *Jumbee and Other Uncanny Tales* (1944) and *West India Lights* (1946).

Whitehead could evoke an authority about the world of the Caribbean supernatural because many of these tales were written, rather extraordinarily, while he was the Protestant Episcopal Church's archdeacon of the Virgin Isles, living on the island of St Croix between 1921 and 1929. He had a PhD in philosophy from Harvard and contributed ethnographic commentary on the local dialect to American academic journals. Whitehead was a senior cleric at a time when both Catholic and Protestant churches from North

America were waging war against superstition in their colonial holdings in the South, and he was in St Croix soon after it had been sold to America for $25 million by the Danish government. St Croix had been Spanish, then French, and was held by the Danes from 1733 to 1917. This was a place of extensive migration where English was spoken with a Dutch accent and 'Crucian Creole' had been invented by Moravian missionaries to communicate with their slaves. Whitehead said he was bringing news from what he called 'the newest colonial possession of The United States'.[25]

Whitehead's stories have the studious, diffident air of M. R. James. Their melodrama is often effectively distanced because they are framed as stories of local superstitions collected as exotic ethnography by a scholarly alter ego, Gerald Canevin. This collector of supernatural tales has a clubbable air, listening to stories coaxed out of informants, their tongues loosened by generous rum swizzles. An early story for *Weird Tales* called 'Jumbee', published in 1926, indicates that we are in the matrix of Anglophone Caribbean superstitions. An American Southern gentleman, wintering in St Croix because of lung damage from mustard gas in the Great War, is determined to get an authoritative fix on the meaning of 'jumbee'. Like a latterday Lafcadio Hearn (who is mentioned in the opening paragraphs), Mr Lee interrogates the local populace, but they determinedly displace the belief, all offering the united front 'that the Danes had invented Jumbees, to keep their estate-labourers indoors after nightfall'. Dissatisfied, Mr Lee 'had been reading a book about Martinique and Guadeloupe . . . and he had not read far before he met the word "Zombi". After that, he knew, at least, that the Danes had not "invented" the Jumbee.'[26] This implies that jumbee and zombi are identical forms, although the story that unfolds demonstrates that they are rather different.

Mr Lee finds his native informant, Jaffray Da Silva, a man 'educated in the continental European manner' but who is 'one-eighth African' and who speculates 'that everybody with even a small amount of African blood possesses that streak of belief in magic and the like'.[27] His story of the jumbee starts out as a tale of 'crisis apparitions' – a theory among psychical researchers at the time that

ghosts are projections of psychic energy released in moments of crisis, often said to be broadcast during the death throes. Da Silva 'sees' his Danish neighbour, Mr Iversen, but knows it is an apparition and an announcement of the man's death in a house a mile or so away. And so it proves to be. As Da Silva journeys to Iversen's house, he runs across 'the "Hanging Jumbee"' on the road: three black ghosts suspended in the air, like sentinels marking death. This appearance is described in an oddly casual manner, the discussion first framed by noting that the apparition conforms to their appearance in another textual account of the Hanging Jumbee. This is not a melodramatic ghost, but evidential confirmation that jumbees are associated with recent deaths. The way in which the spirits are described inevitably recalls the fate of slaves hanged from branches: 'They are always black, you know. Their feet . . . are always hidden in a kind of mist along the ground whenever one sees them.'[28] Another species of vengeful ghost, this time an old black woman, sits on the steps of Iversen's house, who turns into a *sheen* – a dog (*chien*) or werewolf. Whitehead's tale ends abruptly with the refusal to explain much of what has just happened, never clarifying the causal relationships between Iversen's death and these native spirits. It is enough, for Canevin, to have merely collected the testimony. This is a storytelling device that enhances the sense of immersion in a set of local supernatural beliefs that shapeshift beyond your limited grasp. Just to be even more bewildering, another jumbee tale, 'The Projection of Armand Dubois', is offered as 'a gem, a perfect example', 'typically, utterly West Indian', yet the manifestations here bear no resemblance to those in 'Jumbee'.[29]

In 'Black Terror', Whitehead's narrator Canevin notes that 'here in Santa Cruz the magic of our Blacks is neither so clear-cut nor (as some imagine) quite so deadly as the magickings of the *papalois* and the *hougans* in Haiti's infested hills with their thousands of *vodu* altars.'[30] Whitehead's expert local knowledge thus picks the careful path of the ethnographer through local island variations. 'Black Terror' is one of his most overt stagings of the spiritual battle undertaken in the colonies, of Christian belief against the 'primitive barbarism' and psychological pressure exerted on the

population by black *papaloi*. If the Christian priest wins this local battle against sympathetic magic, it is only because of the greater institutional power behind the padre's particular account of the ultramundane world. The same priest recurs in 'The Black Beast', called in to counter a vengeful haunting on a white planter's family home. Father Richardson, Canevin comments, 'had spent a priestly lifetime combating the "stupidness" of the blacks', and Christian exorcism wins out over Damballa, the 'Guinea Snake' God.[31]

The specific supernatural world of Haiti appears in 'The Passing of a God', first published in *Weird Tales* in 1931 (and claimed by Lovecraft to be Whitehead's best work). It is a narrative communicated by Dr Pelletier, lately arrived in St Croix from Haiti. It is significant that it begins with a lengthy discussion about the impact of William Seabrook's *The Magic Island*, the doctor noting 'that there have been a lot of story-writers using his terms lately.'[32] The exchange continues:

'Have you read Seabrook's book, *The Magic Island*, Canevin?' asked Pelletier suddenly.

'Yes,' I answered. 'What about it?'

'Then I suppose from your own experience knocking around the West Indies and your study of it all, a good bit of that stuff of Seabrook's is familiar to you, isn't it? – the *vodu*, and the hill customs, and all the rest of it, especially over in Haiti – you could check up on a writer like Seabrook, couldn't you, more or less?'

'Yes,' said I, 'practically all of it was an old story to me.'[33]

Precisely because of this familiarity, Whitehead eschews the world of Seabrook's zombies to pick up instead on the account of spirit possession by one of the Vodou gods, delivering a bizarre tale of an American businessman whose cancerous tumour is worshipped by the local Haitian population as the earthly incarnation of one of the Vodou gods. The doctor who excises the growth sees two eyes staring back up at him on the operating table, 'something incredibly evil, something vastly old, sophisticated, cold, immune'.[34] Again, a

story ostensibly about black credulity is read more compellingly as an account of the literal incorporation of native superstitions by occupying settlers, including those professional agents of colonial enlightenment, doctors and priests.

Another remarkable story of incorporation, 'The Lips', is set in 1833, significantly just after a slave uprising on St Jan had been violently suppressed (although the text does not mention that 1833 was also the year the British parliament passed the Slavery Abolition Act). It concerns a slave-ship captain bitten by a female slave as she is sold. The suppurating wound will not heal and develops into 'blackish-purple, perfectly formed, blubbery lips' which open to reveal 'great shining African teeth' that bite at his fingers and whisper to him relentlessly until the captain kills himself.[35] It is written for the bravura pulp horror of this denouement, but the story also presents an unconscious registration that colonial violence will burrow under the skin of the perpetrator and lead to self-destruction. And isn't this what happens when the *zombi* leaps from local Caribbean traditions to become the American zombie? The transition is an act of cultural incorporation, which makes the zombie less a spectacle of black abjection than a measure of the deathliness that comes with imperial power.

Whitehead published in the pulps, yet the ethnographic authority of his stories derived partly from his refusal of the generic tropes that popular fiction relied upon (Canevin proves equally dismissive of high art, taking aim at the inaccuracies in Ronald Firbank's decadent fantasy compounded of Cuba and Haiti, *Prancing Nigger*, which came out in 1924). There is no standard zombie business in Whitehead's work; he conveys instead a certain complexity of local superstitions across the Caribbean. Whitehead might have had more influence on how this world was portrayed had he not died in 1932, the year in which the Halperin brothers brought the zombie to cinema.

4
The First Movie Cycle:
White Zombie to *Zombies on Broadway*

White Zombie (1932) was scripted by pulp writer Garnett Wilson and took its main inspiration from Seabrook's *The Magic Island*. It was an independent production by the Halperin brothers, experienced Poverty Row filmmakers in the 1920s, who made it in eleven days for $100,000. It was a typical piece of opportunism. In 1931, the son of the Universal Studio head, Carl Laemmle Jr, had produced Tod Browning's *Dracula*, followed nine months later by James Whale's *Frankenstein*. The sensational impact of these films prompted a boom in 'weird' pictures that in the course of 1932 began to be described as horror – the British Board of Film Censorship introduced the classification 'H for Horrific' that year. The Halperins somehow persuaded the star of *Dracula*, Bela Lugosi, to effectively repeat the role of Count Dracula as the mesmerist Murder Legendre in *White Zombie*. He received a pitiful fee, which Lugosi himself later claimed was only $500. The plot also essentially followed the Browning *Dracula*: a young white couple due to be married, the woman imperilled by a foreign desire exercised through super-natural means, her fiancé temporarily unmanned but aided by a Van Helsing type to vanquish the un-Christian foe. The sense of déjà vu was intensified by the recycling of sets in *White Zombie*, which were hired at night from Universal Studio, from scenes leftover from *Dracula*, *Frankenstein*, *The Hunchback of Notre Dame* and *The Cat and the Canary*. The film was released in New York to critical ridicule yet much ballyhoo at the Rivoli Theater, where hired zombies shuffled across the awning above the entrance to illustrate 'THE LEGION OF

The first cinematic glimpse of 'dead men walking'.

SOULLESS MEN' (as the posters explained) at the horrifying core of the film, causing mobs to gather on Broadway. Although only modestly successful, the crowds falling away after its first couple of weeks, *White Zombie* made a twenty-fold return on the initial investment. Unusually for an independent production, it had been picked up for distribution by United Artists. So began the shuffling, disreputable B-movie life of the zombie.

In fact, Seabrook's 'dead men working in the cane fields' had already appeared in a short section of *Walter Futter's Curiosities* in 1930, a compendium of exotic documentary footage that claimed to catch visual evidence which confirmed Seabrook's account. This was another crucial context for embedding the heady mix of horror and erotic allure associated with Haiti, Vodou and zombies in early sound cinema. There was a craze for sensational expeditionary films that brought back footage from far-flung savage lands. Martin and Osa Johnson did this entirely legitimately, releasing titles including *Jungle Adventures* (1921) and *Head Hunters of the South Seas* (1922). However, *Africa Speaks!* (dir. Walter Futter, 1930) and the scandalous

The white woman, zombified.

Congo film *Ingagi* (dir. William Campbell, 1930) were soon exposed as frauds, lurid fictions largely composed of stock material and footage shot on Hollywood lots and at Los Angeles Zoo. By the time Seabrook's old friend the White King of La Gonave, u.s. Marine Faustin Wirkus, returned from Haiti to tour his documentary film, *Voodo* (1933), it was presumably rather difficult to tell the difference between fact and fiction. Wirkus's *Voodo* happily mixed both in its 36-minute running time, including footage gathered at Voodoo ceremonies on La Gonave, but it ended with an entirely fictional rescue of a young girl from ritual sacrifice, to conform to melodramatic structures.

Ingagi claimed to be about the kidnap of a woman by gorillas, with that spicy blurring of black sexuality with animal bestiality that was soon to be explicitly staged on Skull Island in *King Kong* (1933). *Ingagi* was an exploitation film: early viewers soon spotted that the topless girl in the arms of a gorilla was an aspiring actress in Los Angeles, not an African native, and the actor playing the gorilla, Charlie Genora, was quickly found by the press, as were several

of the black kids from Los Angeles who had been drafted in as African pygmies. The film's documentary truth claims prompted the wonderfully named American Society of Mammalologists to issue a formal complaint, declaring their members 'unanimous in deploring its numerous fictitious features'.[1] There is an ironic echo of all this in Josef von Sternberg's *Blonde Venus* (1932), when Marlene Dietrich climbs out of a gorilla suit in front of some nubile Nubians singing 'Hot Voodoo – black as mud / Hot Voodoo – in my blood / That African tempo makes me a slave / I'd follow a caveman right into his cave.'[2] There were many other exotic exploitation films circulating in the early 1930s, from *Blonde Capture* (1932) to *Wild Women of Borneo* (1932), *Jungle Virgins* (1932) and *Gow* (1932), the last of which promised its audience 'SAVAGE ORGIES OF MAN-EATING HUMANS'. The spuriously educational premise of showing naked Balinese young women was entirely about stoking desire, but the darker the skin of the natives and the closer one got to Africa, the more menacing the plots became.[3]

The horror cycle constantly used the promise and threat of inter-racial sex, most notoriously in *The Island of Lost Souls* (1932), an adaptation of H. G. Wells's *The Island of Doctor Moreau*, with Charles Laughton playing the mad scientist vivisecting animals into beast men as a lascivious pervert intent on engineering a sexual liaison between beast and man. This, in addition to the depiction of a successful insurrection on the island against the white master (the beasts led by Bela Lugosi, again), caused the film to be banned for many decades.

The erotic allure of miscegenation was all the more transgressive because of the arrival of the Production Administration Code in 1930. Also known as the Hays Code, this was meant to hold Hollywood cinema to strict moral guidelines, banning the representation of vices, 'impure love' and (explicitly) mixed-race relationships. Amendments had to catch up with the emergence of the horror film, putting vague limits on the representation of 'gruesomeness'. The Code, written by a Jesuit priest and Catholic editor, was constantly invoked by purity campaigners but unenforced by the studios, until the extensive nudity in *Tarzan and His Mate* (1934) caused panic and

ushered in a regime of strict enforcement. The zombie film therefore also emerged in this strange 'pre-Code' era, in which the law was marked out precisely by the extent to which it was ignored.

In this early context, then, *White Zombie* is obviously tilted towards the transgressive erotics of the encounter between white and black, living and dead. It also needs to be placed in a wider array of films about Haiti and the Caribbean than zombie film histories usually allow. What followed were heady melodramas where Voodoo and magic (but not necessarily zombies) feature strongly, such as *Black Moon* (1934), *Chloe, Love is Calling You* (1934) or *Drums O' Voodoo* (1934). *Black Moon* was a Columbia Studio feature set on the island of San Christopher – an island declared to be somewhere off Haiti, perhaps meant to be St Kitts – where a recently married white French Creole woman feels compelled to return to her family plantation; away from her modern New York life. There, she is secretly pulled into a sacrificial Voodoo cult as its queen, happily plotting to kill her own child for a culminating magical ritual. The racial ambiguity of the Creole is her death sentence: she is shot by her own stricken husband, who fortunately has the pure white Fay Wray on hand to marry instead (the film has exactly the same plot as Grant Allen's 'The Beckoning Hand'). *Chloe, Love is Calling You* and *Drums O' Voodoo* were both based in Louisiana, and staged the struggle to modernize the belief of local black populations against the last traces of Voodoo.

Ouanga (1936), though, also marketed as *The Love Wanga*, was set in Haiti. It had the strap-line 'Dramatic Dynamite for ADULTS ONLY' and involves the mixed-race star Fredi Washington playing a Haitian plantation owner, Cleli, a light-skinned octoroon who tempts her pure white neighbour Adam across the colour bar, something he steadfastly refuses ('Your white skin doesn't change what's inside you. You're black'). Washington had started out as a dancer in the same revues as Josephine Baker; her light skin seemed to intensify the temptation to transgress in the racial logic of the time. Adam's refusal (he has his pure white Eve as a fiancée, after all) prompts Cleli to revert to native 'wanga' (the generic American term for African-inflected witchcraft in these films) for her revenge. Cleli's

love charms fail, so she moves to raising a couple of black zombies to menace her rival, along lines borrowed from Seabrook.

The production of *Ouanga* was somewhat doomed, with an over-optimistic plan to take the whole production crew down to Haiti to recruit authentic dancers and drummers. This was hastily abandoned when local *papaloi* forcefully objected, and the filming moved to Jamaica where a cyclone destroyed sets and killed two of the crew. *Obeah*, an independent production from 1935 and presumably set in Jamaica, featured an explorer and his daughter imprisoned by a cult and scheduled for ritual sacrifice, but the film has not survived.

These films ensured the steady accumulation of depictions of savage witchcraft and sexual abandon that fixed the representation of the notorious Black Republic in early Hollywood cinema. 'Haiti entered the dominant, twentieth century imagination by way of B-horror', one film critic has argued.[4]

White Zombie wears its debts to the European Gothic heavily. Lugosi plays Legendre as a sardonic monster able to dominate the wills of others by natural and supernatural hypnotic powers, exerting his own implacable will at a distance with luminous eyes and a weird 'zombie grip'. He is of indeterminate race and portrayed as a *bokor*, a witch-doctor and master of subtle poisons and mental powers. Legendre is a pitiless victor over his enemies on the island; he has transformed into lifeless zombies his old master of the dark arts, a captain of the gendarmerie, the Minister of the Interior and even the High Executioner with a touch of poison and an imperious command. This feeds the American view that Haiti cannot govern itself, with every element of society corrupted by superstition.

Legendre's desire is all-encompassing too: not only does he long for the white beauty Madeline, but he openly expresses his desire for the white plantation owner Beaumont. 'I have taken a fancy to *you*, monsieur' – Lugosi delivers the line with his typically odd emphasis, perhaps making it sound camper than it was intended to be. *White Zombie* repeats much of the perverse threats in the *Dracula* plot. It borrows the unholy lust and penetrating eyes of the foreign Mesmerist from John Barrymore's depiction of the Mesmeric

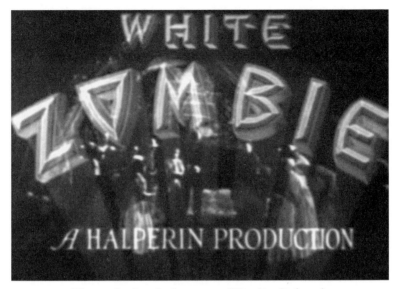

The zombie hits the big screen: *White Zombie* (1932).

monster *Svengali* (1931), a film based on George du Maurier's sensational romance *Trilby*, in which a white girl singer is the puppet of a swarthy European Jew. Indeed, *Variety* magazine called *White Zombie* 'the Trilby of the Tropics', suggesting how carefully the Halperins worked to fuse the film with established conventions.

Yet *White Zombie* also goes to some lengths to establish for the audience precisely what a zombie is. The opening titles launch the word across the screen a letter at a time: Z-O-M-B-I-E, over the monotonous chanting of a group of blacks at a graveside. In this opening scene, a beatific white couple, Madeline and Neil, recently arrived in Haiti and on their way to marry, witness a burial at a crossroads and soon after encounter Legendre with his shuffling group of workers behind him, a gang that terrifies the driver and prompts him to shout out: 'Zombies!' The driver is played by eminent African American actor Clarence Muse, a writer, composer and actor who wrote Louis Armstrong's signature song 'Sleepy Time Down South' and later worked with Langston Hughes on the film *Way Down South* (1939). Here, he plays the credulous native, who laboriously explains: 'They are not men, monsieur. They are

Bela Lugosi as the hypnotic Voodoo master Murder Legendre.

dead bodies. The living dead. Corpses taken from their graves and made to work.'

The iconography of the line of undead workers descending the hill is directly borrowed from the woodcuts that accompanied Seabrook's text in *The Magic Island*. The pressbook for the film, given as an aid to journalists, also directly quoted Seabrook in a contextual section called 'What Writers Found', although it leaves him uncredited.[5] This hillside scene begins to establish the filmic conventions of the zombie: blank eyes, slow pace, stiff limbs and a deathly white pallor (even on black faces). Further direct debts to Seabrook come in Doctor Bruner's lengthy explanation, delivered in a cod-German accent and in a sinuous single take, that zombies must be real to the extent that they are present in Haiti's Penal Code. The clause, number 249, transcribed by Seabrook and spoken by Bruner, was also reproduced in some of the advertising for *White Zombie*, designed to place the film in a zone of uncertainty between the exotic expeditionary documentary and the horror film.

The scenes of the zombies in the mill are highly evocative, as the workers are portrayed in a deathly silence, adopting the slave

shuffle of the socially dead. Even the gangmaster looks zombified, indifferent as one of the workers topples into the millstones relentlessly being fed the cane. Legendre's cynical indifference to their fate – 'they work faithfully and are not worried about long hours' – evokes Seabrook's description of the HASCO workers, yet also entirely displaces the context of the new labour laws installed by the American occupation. At the end of the film, Legendre's mountaintop retreat is surely meant to evoke the Citadel built above Cap Haitien by 'King Christophe' at the cost of thousands of lives between 1805 and 1820. Christophe was the 'savage' dictator continuously evoked in the first years of the American occupation, the Citadel called by one history 'the most impressive structure ever conceived by a negro's brain or executed by black hands', although its construction was soaked in blood.[6] The Citadel was the place where, legend has it, the emperor ordered his soldiers to march off the edge of the cliff when they displeased him, in a manner echoed in the final scenes of *White Zombie*, as Legendre's band of walking dead men tumble off the parapets and onto the rocks below. The film is torn about acknowledging the American presence – the hapless groom is an

Zombified factory workers, *White Zombie* (1932).

American banker down from New York, after all – but ultimately works hard to displace all the violence and cruelty onto Haiti itself, erasing the American 'modernizing' presence on the island.

In the end, *White Zombie* is significant mainly for dropping the paraphernalia of Voodoo to focus on the body of the zombie itself. The emphasis in Legendre's band of undead slaves is on physiological transformation into empty husks indifferent to pain or bullets – as in the memorable last scene. They are relentless agents of a demonic will, and so are little different from vengeful reanimated mummies (Karloff as *The Mummy* also appeared in 1932) or Count Dracula's abject servant, Renfield. The transformation of Madeline is somewhat different. Hers is a purely hypnotic enslavement that renders her catatonic, like someone suffering from tropical 'sleepy sickness', but easily returned to life (she is a *zombi astral* as opposed to the *zombi cadavre*). Madeline, her name perhaps an echo of Poe's Madeline Usher, was played by silent-era star Madge Bellamy, struggling to keep her place in cinema in the transition to sound. Her voice is thin and reedy, her gestures in the silent pantomimic mode

The Citadel, Haiti, Murder Legendre's fortress in *White Zombie* (1932).

Zombies plummet from the Citadel, *White Zombie* (1932).

already old-fashioned, although the film reverts to silence for much of the running time. Some critics unkindly suggest that Bellamy is so poor 'that the audience is unable to differentiate between her acting living and dead'.[7] Oddly enough, I think this works in the film's favour. Zombification is a kind of fatal return to the dumbshow of the silent era, the victim deprived of language and reduced to fumbling, exaggerated gesture. The technology of cinema itself, in the transition to sound between 1929 and 1932, contributes another level to *White Zombie*'s commentary on modernity and the supersession of the old.

On announcing their plans to shoot *White Zombie*, the Halperins were unsuccessfully sued by the playwright Kenneth Webb, whose play *Zombie* appeared on Broadway for only 21 performances in February 1932. No transcript of the play survives, but it was presumably also reliant on Seabrook's *The Magic Island*. When the Halperins decided to return to the zombie theme for *Revolt of the Zombies* in 1936, they avoided Haiti to set the story in Indochina, playing on the legends associated with the tyrant who built the

Angkor Wat temple with an army of slaves in the twelfth century. Still, they were sued again, this time over the copyright of the term 'zombie'. *White Zombie* was reissued in 1936, and one of the original investors, Amusement Securities Corporation, claimed proprietary rights on the word to protect their first film. In a written ruling, one of the judges stated:

> It seems that the term 'zombie', though the term be considered descriptive, is subject to exclusive appropriation as a trade name. A word which is not in common use, and is unintelligible and nondescriptive to the general public, though it may be known to linguists and scientists, may be properly regarded as arbitrary and fanciful and capable of being used as a trade mark or trade name.[8]

In their appeal, the Halperins tried to show that the word 'zombie' was in prior use before *White Zombie* and had entered *Webster's Dictionary* in 1935. Nevertheless, they were forced to pay damages and legal costs, resulting in the odd situation that Amusement Securities Corporation appeared to own the word 'zombie' in the 1930s.

The judge was presumably not a reader of pulp magazines or a drinker of zombie cocktails, and although the Halperins were asked to pay damages, the ruling was otherwise unenforced. Zombies were in fact already being folded back into Haitian melodramas, becoming the central horrifying detail where they had been almost absent only a decade before. In Hans Possendorf's *Damballa Calls: A Love Story of Haiti* (published in English in 1936), for instance, someone tries to dismiss the zombie as 'a fairy-tale created by some crazy newspaper man', only to be corrected: 'On the contrary, they are the most terrible fact in all the world.' Yet, just to keep the perspective realistic, this authority adds: 'This devilish art is, thank God, practised only on very rare occasions. So far as I am aware, no white man has ever yet had to endure this terrible fate.'[9]

The Halperins almost killed off the zombie with the poor melodrama of *The Revolt of the Zombies*, in which the 'Secret of the

Zombies' is held by Cambodian priests at Angkor Wat. A battalion of undead soldiers is seen advancing on a European front, indifferent to bullets, followed by a hasty gathering of Europe's generals determined to destroy this new weapon, which surely threatens the survival of the White Race if the dastardly Orientals rediscover it. In Cambodia, the secret is put to use not in the service of such a grand plan, but rather to further a dreary love triangle. Those superimposed hypnotic eyes that create a zombie army, the only memorable sections from the film, are recycled directly from *White Zombie*.

Lugosi himself, meanwhile, was condemned to repeat the witch-doctor role to the end of his career. He kidnapped American women off back roads and turned them into a bevy of *zombis astrals* in the rudimentary B-movie *Voodoo Man* (1944). Lugosi wears a cape embroidered with magical symbols, typical of a magus of ritual magic, and Haiti has dropped entirely from the context. The film is far keener to evoke the fantasies of sexual abandon that swirled around the world of ritual magic, which was being practised in Southern California at that time by the bizarre circle of science fiction writers, rocket scientists and occultists gathered around Jack Parsons.[10] In *Voodoo Man*, the kidnapped women are dressed in the white robes of initiates and shuffle around the basement with absolute compliance while Lugosi experiments with transferring their minds into the body of his undead wife, who has been in a zombified trance state for twenty years. Rescue comes in the midst of a culminating magical ceremony. Lugosi appears again as a voodoo man in *Zombies on Broadway* (1945), although by this time he is merely a cameo to mark out a certain frame of supernatural reference. 'Those voodoo drums – that's the death beat you know', he reflects, but he remains almost entirely marginal to the comic plot. Lugosi's last role, notoriously, was in Ed Wood Jr's *Plan 9 from Outer Space* (1959), often given the plaudit of being the worst film ever made. The plot involved aliens reviving the human dead as their agents on Earth. Almost as soon as filming began, Lugosi died, only to live on in the film, replaced by a hopeless stand-in. Even in death, he was held by the zombie grip.

After the failure of *Revolt of the Zombies*, the figure was doomed for a rapid revival for comic effect, as in the Bob Hope and Paulette Goddard vehicle *The Ghost Breakers* of 1940. In the film, Goddard inherits a Gothic pile that looms on 'Black Island' off the coast of Cuba and is said to be haunted down the generations by the slaves who once laboured there. Bob Hope tags along as a self-declared 'ghost-breaker' (a less catchy job title than ghostbuster) with his comic black sidekick. They are warned off by the threat of various malignant ghosts and zombies. These still require some explanation: 'It's worse than horrible because a zombie has no will of his own', explains a local expert. 'You see them sometimes, walking around blindly with blank eyes, not knowing what they do.' 'You mean like Democrats?' Hope asks. In fact, Hope's character knows the pulp origins of the zombie. When he arrives at the spooky mansion, his opening gambit with the old woman caretaker is to ask: 'Could we interest you in a subscription to *Weird Stories* magazine?' The zombie that features in *Ghost Breakers* is actually a figure of pity rather than fear, which prefers its ghosts old-school Gothic and Spanish. Once again, it is Hollywood history rather than the film itself that provides the telling detail. The zombie is played by Noble Johnson, one of the first African American film producers and actors, who ran his own film company in the 1910s. He acted consistently through the 1920s, playing a range of exotics, but was also able to pass as white. Johnson led the tribesmen of Skull Island in *King Kong*. In *Ghost Breakers* he is reduced to a mute shambler, barely featuring in a plot that superimposes the European Gothic onto a Caribbean context.

Ghost Breakers produced a cluster that further embedded the zombie as one element in American supernatural conventions. *King of the Zombies* (1941) was a Monogram Pictures vehicle for the successful black vaudeville comic Mantan Moreland to play up his stereotype of the mouthy manservant spooked in a haunted house. 'What's a zombie?' someone asks. 'Dead folks what's too lazy to lay down', he replies. When he is zombified by the disdainful lead Nazi, he continues his quicksilver backchat. 'Zombies can't talk!' the kitchen maid objects. 'I can't help it if I is loquacious',

A pitiful zombie in *The Ghost Breakers* (1940).

Moreland snaps back. In a dim echo of the old folklore, as soon as Moreland eats salt he recovers his senses, such as they are. Set on an indeterminate West Indian island and involving a dastardly German plot to use hypnotism and Voodoo to torture war secrets out of a kidnapped American admiral, the plot continually digs at German racism while fully demonstrating Hollywood's own rigid racial logics.

Mantan Moreland was back again in another Monogram film, *Revenge of the Zombies* (1943), an anti-German B-movie in which a mad scientist played by John Carradine thinks he has succeeded in creating 'an army of the living dead' amid the swamps of Louisiana to ensure German mastery (quite what he's doing there is left unclear). He has achieved this by indifferently experimenting on his wife Lila, all in the service of the greater glory of the Fatherland. Moreland plays another black servant who keeps running into zombies long before his white boss grasps the true story. In the end, Carradine's evil Nazi cannot control the will of his zombies and he sinks beneath the swamps in the clutches of his vengeful undead

Darby Jones as Carrefour, *I Walked with a Zombie* (1943).

wife. These films underline the link of Nazi Germany and zombies, established early in the pulps by Theodore Roscoe, which continues up to the present day in films like *Dead Snow* (2009). The roots of this connection lie partly in American finance capital's attempt to keep German interests out of Haiti just prior to the occupation and the start of the Great War.

Nothing in these comic films quite prepares the way for the extraordinary lyrical masterpiece of Jacques Tourneur's *I Walked with a Zombie* (1943). The film was a product of Tourneur's collaboration with Val Lewton, who had just shot *Cat People* (1942) as the first production in RKO's justly admired 'horror' film unit, B-movies given strict $150,000 budgets and usually developed, shot and delivered in a three-month cycle. The indirection and oneiric oddity of *Cat People* had been disliked by the studio, for Lewton was a suspiciously high-cultural type, but it proved immensely popular. Lewton told an interviewer early on that his team had 'tossed away the horror formula right from the beginning. No grisly stuff for us. No mask-like faces hardly human, with gnashing teeth and hair standing

on end. No creaking physical manifestations. No horror piled on horror.'[11] This seemed to refuse every element of the physical horror that had been established for the zombie film.

Just as *White Zombie* had relied on Seabrook, the scriptwriters for *I Walked with a Zombie* were given a piece of sensational journalism written by Inez Wallace in *American Weekly* which had been optioned by the studio: 'I have come to look upon the weird legend of the zombie – those dead men and women taken from their graves and made to work by humans – as more than a legend.'[12] The story that Wallace relates, about a recently married white woman zombified (with secret poisons) by a spurned Haitian rival, advances Seabrook's sensational account considerably, although this report is clearly filtered through a decade of American shudder pulp fictions. Lewton was compelled to work with this optioned essay and was forced to use the lurid title by the boss of RKO, Charles Koerner. He initially despaired before coming up with the idea of using the suggestive West Indian backstory from *Jane Eyre* to transform the material. Lewton then added a detailed file of research cuttings he had mined on Haiti and Vodou ceremonies to the writing process, such as Rex Hardy's photographs in *Life Magazine* published in 1937, the year of the Massacre River genocide.[13] From this material, the scriptwriters Ardel Wray and Curt Siodmak, along with Tourneur, transformed their pulp sources into something wholly different.

I Walked with a Zombie rewrites *Jane Eyre* (as Jean Rhys would do in *Wide Sargasso Sea*), in this case sending a naive nurse to the Caribbean island of San Sebastian to look after Jessica, the catatonic wife of the plantation owner. Precisely what occurs on the island is elliptical and odd, the narrative never coherently settling for natural or supernatural explanation. Is Jessica suffering from the after-effects of a fever, mental illness, the guilt of betraying one brother for another, or something stranger? If she is a zombie, then who is her master? Is Jessica actually the zombie of the title, or not? The film radically fractures any settled point of view and the narrative is studded with sequences intent only on evoking haunting atmospheres, the sinuous camerawork providing a confounding

chiaroscuro. The first encounter with the entranced Jessica is when she glides away from her room, out from under a reproduction of Arnold Böcklin's *Isle of the Dead* that hangs over her bed. She stalks through the shadows of the plantation, evoking uncanny dread, as does the long night-walk of Betsy and Jessica to the *honfort*, traversing a sequence of liminal spaces in a series of lateral moves and dissolves conducted in virtual silence to the hypnotic rhythm of the drums.

Voodoo superstition on the island is demystified by the Western rationalism of Mrs Rand, the doctor who is the hidden hand behind the native witch-doctoring, which she manipulates for ostensibly benign medical effects. Her authority is undercut by her unresolved Oedipal jealousy of her son's wife, however. The destructive mesh of desire at the heart of the Holland family plantation is subject to the ironic commentary of the calypso singer Sir Lancelot, who acts as the black chorus to a colonial family tragedy. Lancelot is half in and half out of the fictional frame of the film, being a famous Trinidadian calypso star in the States, well known for his radical left politics (Sir Lancelot also helped Lewton source the Haitian musicians who play the ritual drums on the soundtrack). The film ends with an unattributed black voiceover, almost the communal voice of

Zombie shadows, *I Walked with a Zombie* (1943).

the blacks on the island, the former slaves, which entirely displaces nurse Betsy's initial framing of the story. It is hard to think of another Hollywood film of the era that cedes narrative authority in this way, and the film's formal oddity acts perfectly to convey how narrative authority slips from white command. The audience is left bewildered by the film's puzzling dream logic: *I Walked with a Zombie* has been called a 'sustained exercise in uncompromising ambiguity'.[14]

Tourneur later claimed that the film's sympathetic portrayal of the former black slaves on San Sebastian got him placed on an unofficial Hollywood 'grey list' that blocked his career. The Office of War Information, the wartime censor, certainly took an interest in seeing the film, worrying that the depiction of the racial divide on the plantation undercut their request for images of integration – however fictive.[15] RKO certainly made it difficult for Lewton and Tourneur to collaborate again.

The most memorable figure in the film is Carrefour, the towering and silent black man with blank eyes who stands as sentinel and stalks the margins of the film (his name means 'crossroads', and is a deeply symbolic locale for the meeting of worlds in Vodou theology). It is this figure we see in the opening shots of the film, with Betsy, on the edge of the water, the liminal space where sea meets sand. His ambiguity – is he living or dead, agent of civilization or savagery, protection or threat, a zombie or not? – contributes again to the persistence of *I Walked with a Zombie* in the memory, a film that lingers like the after-image of a fever dream.

Almost as if to pull the zombie down from these heights of weird menace, *Zombies on Broadway* brings the figure crashing back to the B-movie gutter. This crass comedy from the same studio returns to San Sebastian and features Sir Lancelot's calypsos and Darby Jones reprising the role of Carrefour, but this time played for laughs. The plot features a gangster Ace Miller opening a nightclub, The Zombie Hut, in New York, and for the hullaballoo of the opening night Ace sends two saps down south to the islands to grab a 'real' zombie. This is the excuse for the vaudeville double act of Alan Carney and Wally Brown (RKO's low-rent Abbott and Costello) to indulge in some comic turns. Zombification is openly about *becoming*

black, about minstrelsy, as Carney is inadvertently blacked up in the jungle ('You're so scared, you've turned black!') and then subject to one of Lugosi's injections, which thickens his lips, bulges his eyes and renders him a passive mute. Becoming black is, fortunately, an entirely reversible condition – for Carney at least. Abbott and Costello killed off every Universal horror monster in their dire horror comedies starting in the late 1940s, but Carney and Brown had already terminated the place of the zombie in the RKO cycle by 1945.

Zombies on Broadway signals the complete passage from *zombi* to zombie in American popular culture. The nightclub in the film, 'The Zombie Hut', suggests the craze for tiki bars in the 1930s, selling cocktails in exotic, vaguely South Pacific settings. Don Beach, who started the revolution with his Beachcomber Café in Hollywood in 1934, was also the inventor of the Zombie cocktail, a fruit punch so heavily laced with various Caribbean rums that it 'zombified' the drinker. Just like the composition of the *bokor* poisons in Haiti, the recipe for the first Beachcomber Zombie was kept strictly secret. The chain of bars became known as 'The Home of the Zombie: The World's Most Potent Potion'. The drink became world-famous when nightclub impresario Monte Proser opened a tiki bar that sold the Zombie at the New York World's Fair in 1939. Famously, the Beachcomber restricted customers to a maximum of two Zombies per night (although on at least one occasion Val Lewton claimed to have drunk three or four in a desperate attempt to find inspiration to appease his Hollywood bosses). In the comedian Billy Connolly's famous routine 40 years later, the Zombie results in the drinker getting drunk from the legs up before the effect seizes and entirely disables the brain.

The Zombie cocktail retains a direct tie back to its Caribbean origins: rum, from the word *rumbullion*, meaning 'great tumult' among the West Country settlers in Barbados, emerged on the sugar plantations of the Caribbean because it was distilled by slaves from the 'spillings' of sugar-cane processing for which the planters initially had no use. Known also as 'Kill Devil', these improvisations of consolation for the intolerable conditions of slavery have since

Carioca Rum marketed the first bottled Zombie drink in the 1940s.

become a multibillion dollar industry owned by large multinational corporations.[16]

'Do do / that Voodoo / that you do / so well', the Cole Porter song went – first composed in 1929 before becoming a standard. Within ten years, the zombie shuffled out of whispered folkloric beliefs on the colonial margin of the American empire and into the sensational newspapers, pulp magazines, songs, nightclubs, lurid B-movies and radio serials like *The Shadow* that were at the brash

heart of the American popular culture industry. But if the zombie seems to have been thoroughly decoupled from its Caribbean *zombi* by this point, at the same time a different cultural stream was pulling it back firmly to the Caribbean.

The 1920s and '30s was the peak of Modernist experiment, and among the writers of the Harlem Renaissance – the flowering of black writers in New York – Haiti and its culture were key reference points. To get a full picture of the zombie in 1930s American culture, we need to recognize how crucial Haiti was in avant-garde circles too. It was Theodor Adorno, the most trenchant critic of the arrival of mass culture in the early twentieth century, who recognised that this kind of lowly pulp fiction had to be seen in relation to high art: they are but 'torn halves' of each other.[17] In the 1930s, these came together in the writing of Zora Neale Hurston. During her nine-month stay on Haiti over the winter of 1936, the novelist and anthropologist met, photographed and recorded the first encounter with an actual, real-life zombie.

5

Felicia Felix-Mentor:
The 'Real' Zombie

Zora Neale Hurston was one of the writers associated with New York's Harlem Renaissance in the 1920s and '30s, that fantastic flowering of black cultural forms in music, theatre, dance, art and writing that intersected with but was entirely distinct from Modernist 'negrophilia'. The political motivations of black activism at the time made Haiti, with its proud tradition of independence currently under the heel of the American occupation, a key point of reference. There was a distinct Black Atlantic element to the politics of various Negritude movements, with Marcus Garvey moving between New York, London and Jamaica, for instance. The poet Langston Hughes, at a point of crisis in his work, travelled to Haiti and reported for the *New Masses* journal in 1931, writing that 'All of the work that keeps Haiti alive, pays for the American occupation, and enriches foreign traders – that vast and basic work – is done there by Negroes without shoes.'[1] Hughes grasped the economic logic of HASCO far faster than Seabrook. Communist activist and actor Paul Robeson starred in Eugene O'Neill's play *Emperor Jones,* inspired by Haitian history, on stage and in the film version in 1933. Three years later, a twenty-year-old Orson Welles directed an all-black version of *Macbeth*, set in Haiti, at the Lafayette Theater in Harlem, and a play called *Haiti* was staged at the Lafayette in 1938 before going on national tour to black theatres.[2]

Zora Neale Hurston moved in the same circles and shared the same patrons as writers like Langston Hughes. She had grown up the daughter of a Baptist preacher in Eatonville in Florida, one of

Zora Neale Hurston palying a Haitian Vodou *maman* drum, 1937.

the first all-black incorporated towns in America, an unusually free environment in the South. But Hurston was different from other Harlem Renaissance writers in two important respects. First, she was a political conservative, regarding the American occupation of Haiti as an unequivocal good. Second, she had professionally trained in anthropology at Columbia University under Franz Boas and had done fieldwork collecting folklore on 'Hoodoo' in Louisiana in the late 1920s before gaining a two-year Guggenheim grant to study Voodoo in Haiti in 1936. This made for a completely different level of engagement.

Boas, Hurston's teacher, was a crucial figure in shifting anthropology from armchair theory to practice in the field, and from the Victorian evolutionary model, which regarded tribal societies as survivals of earlier man, to a much more liberal and relativist model of cultural comparativism. His injunction in his famous lectures *The Mind of Primitive Man* was that 'the student must endeavour to divest himself entirely of his opinions and emotions based on the peculiar social environment into which he is born. He must adapt his own mind, so far as feasible, to that of the people whom he is studying.'[3] This was a crucial shift away from abstract hierarchies of races to valuing the complexity and contingency of the field. Participant observation came with attendant risks, though: there was still a view that fieldwork was not a 'gentlemanly activity', not least because immersion in another culture revived the old fear of losing perspective and 'going native'.[4]

Was this what happened to Zora Neale Hurston? She had far greater authority to speak of Haitian beliefs than any mere tourist, sensational journalist or pulp fiction writer, yet her findings were thoroughly ridiculed.

Hurston was a valuable researcher to Boas because as a black woman she could enter into certain fields in a way others could not. Her extensive transcriptions of rituals, spells and ceremonies published in the *Journal of American Folklore* in 1931 under the title 'Hoodoo in America', came from her extensive training with several Hoodoo priests in New Orleans and elsewhere. The tone of her report begins with an authoritative discussion of the religious

syncretism that typifies Louisiana Hoodoo, which she describes as a meeting of the Haitian diaspora with Roman Catholicism, plus the unique local twist of Spiritualism. Much of the report is neutral transcription of magical spells, hexes and curses. The narrative voice slips on occasion, however, into a first-person participant who isn't able to exercise a full level of control. Under the tutelage of Samuel Thompson, a 'Catholic Hoodoo doctor' who claimed to be the grand-nephew of Marie Laveau (the 'Last of the Voodoos' celebrated by Lafcadio Hearn), she endured several ceremonial initiations. 'I was full of anxiety', a personal voice breaks through, disturbing the illusion of objectivity. 'After a while I forgot my fears, forgot myself, and things began to happen. Things for which I can find no words, since I had experienced nothing before that would furnish a simile.'[5] The Voodoo gods come down and Hurston states: 'I had five psychic experiences during those days and nights' before the academic voice of reason immediately clamps down: 'I shall not detail them here.'[6] She was also sent by another Hoodoo doctor to a crossroads to call up the Devil. 'It was very dark and eerie', she confesses, and the objective observer becomes a trembling subject again: 'I was genu-inely frightened.' The passage concludes ambiguously: 'It was a very long hour. I hope never to meet its brother.'[7]

Under the instruction of Ruth Mason, another Catholic Hoodoo healer, Hurston took part in a Hoodoo dance that lasted for many hours and was meant to invoke 'death-to-the-enemy', as in these rituals 'death was being continuously besought'. In one short sen-tence – 'I danced, I don't know how' – Hurston again suggests that through her participation she has lost her anthropological distance, her subjectivity erased. The phrase implies that she has, in fact, become ridden by one of the gods, as was the sole aim of ecstatic dancing.[8] Three years later, the New York avant-garde dancer Katherine Dunham, also professionally trained in anthropology, travelled to Haiti and explored the same kind of ecstasy; she in turn would inspire the avant-garde filmmaker Maya Deren to undertake research in Haiti.[9]

Under the heading 'Relation to the Dead', Hurston reported how, through the Southern states and into islands like the Bahamas,

'the dead have a great power which is used chiefly to harm.' The graveyard became the site for 'killing ceremonies', with spells involving grave dust, and she adds:

> It is generally held in the Bahamas that strong obeah men can cause a death-like sleep to fall upon whom they will. The person is buried for dead and then the obeah sends his helpers to dig him up and he, or she, is put to work . . . If he is given salt he regains his mental powers and revolts.[10]

In the Bahamas, these (un)dead workers are said to be sent away to pick coffee on plantations. Collected in 1928, and published in 1931, it is striking that Hurston does not use the word *zombi* here, as if it had not been heard in that particular field of inquiry, or else that she simply considered the word too local or unimportant. By the time she published *Tell My Horse* in 1938, however, about her researches in Haiti, there is a whole chapter called 'Zombies' and a lot of rather sensational material.

Tell My Horse is considered a great embarrassment of a book, even by Hurston's admirers. It was a confusing mix of modes, the *Saturday Review* complained: 'the remembrances are vivid, the travelogue tedious, the sensationalism reminiscent of Seabrook, and the anthropology a mélange of misinterpretation and exceedingly good folklore.'[11] She was mocked in the press that 'after eleven months in the dark jungles back of Port-au-Prince, chanting voodoo chants, drinking the blood of the sacrificial goat and worshipping with descendants of the African slaves whose people were bred in the Congo, Miss Hurston returns a believer in voodooism.'[12] Perhaps this reflected the tug of different audiences and patrons. It was published as a trade book by Lippincott's, so the anthropology had to entertain, while Hurston remained indebted to her 'negrophile' backers Charlotte Osgood Mason and the writer Carl Van Vechten (who had written *Nigger Heaven*) to write a thrilling account of energizing 'savagery'. The title translates a Haitian saying that suggests that when possessed, 'the loa begins to dictate through the lips of his mount.'[13] More than one critic has suggested that this is

Original cover of Nora Zeale Hurston's *Tell My Horse* (1938).

what happens in the strange mix of tones and genres; the book is possessed by many gods.[14]

Hurston had travelled to Haiti intending a lengthy and immersive research trip. While she established contacts among Vodou practitioners, she spent the first seven weeks in Haiti writing her best-known novel, *Their Eyes were Watching God*. Then, as in Louisiana, she began her training in a local *honfort*, learning to navigate the complex rituals and cosmogony of the Vodou gods. In June 1937, only nine months after arriving, Hurston hastily left the island with a serious gastric illness, something she ascribed to poisoning by those unhappy with an American outsider dabbling in sacred secrets.

Tell My Horse follows this darkening trajectory, with sections on Jamaica and Haiti that mix the authority of systematic anthropological reportage with the lazy opinion of the travelogue by an American in support of colonial occupation. 'The Haitian people are gentle and loveable except for their enormous unconscious cruelty' is a typical ridiculous sentence.[15] Part III, 'Voodoo in Haiti', works harder than most travelogues to explore and explain the panoply of Vodou gods, although it is an inevitably local and partial snapshot of a constantly moving hierarchy of deities. Then, as the element of closer participation becomes more prominent, Hurston records that at a renowned *honfort* in a place called Arcahaie she saw the body of dead man suddenly sit up in the middle of the funeral, 'and it was so unexpected that I could not discover how it was done'.[16] The local explanation is that one of the *loa*, the gods, has taken possession of the body. Later in the same ceremony, 'the thing of horror happened': Hurston seems to share entirely the feeling of the gathered congregation that an 'unspeakable evil' entered when a man was possessed by a demonic spirit, his face lost beneath 'a horrible mask'.[17] The panoply of Petro gods, a particular branch of Voodoo, Hurston continues, 'demand sacrifices' and 'in some instances' worshippers 'have been known to take dead bodies from the tombs'.[18] This brings the reader to unlucky chapter Thirteen, 'Zombies'.

'What is the truth and nothing else but the truth about zombies?' Hurston begins, as if on oath but not quite willing to get the wording exactly right. She addresses the different levels of belief in Haitian society (peasant conviction versus elite denial), before disarmingly stating her own position:

> I had the good fortune to learn of several celebrated cases in the past and then in addition, I had the rare opportunity to see and touch an authentic case. I listened to the broken noises in its throat, and then, I did what no one else has ever done, I photographed it. If I had not experienced all of this in the strong sunlight of a hospital yard, I might have come away from Haiti interested but doubtful. But I saw this case of Felicia Felix-Mentor which was vouched for by the highest authority. So

I know that there are Zombies in Haiti. People have been called back from the dead.[19]

Hurston lures the reader in with the promise of a direct encounter with what is evocatively called 'the broken remnant, relic, or refuse of Felicia Felix-Mentor', but then veers into a discussion that mixes folklore about the zombie with allegedly 'proven' historical cases, such as the case of 'C. R.' in Cap Haitien in 1898, or the apparently famous case of 'Marie M.' in 1909. These read like the cases collected by the Society for Psychical Research, with the same drawback. A well-attested anecdote remains just that: an anecdote. It proves only that such stories have the fascination to circulate widely, not that they must have a basis in truth. But in November 1936, the Director General of Haiti's Service d'Hygiene invited Hurston to visit an actual zombie now residing on a mental hospital ward.

What Hurston describes is immensely moving and distressing, a woman in a hospital yard who 'hovered against the fence in a sort of defensive position . . . and showed every sign of fear and expectation of abuse and violence . . . The doctor uncovered her head for a moment but she promptly clapped her arms and hands over it to shut out the things she dreaded.'[20] Hurston's act of photographing this 'remnant' of a person is perhaps the closest one can get to believing the idea that the camera can, after all, steal the soul, or in this case, whatever is left of the soul:

> I took her first in the position that she assumed herself whenever left alone. That is cringing against the wall with the cloth hiding her face and head. Then in other positions. Finally the doctor forcibly uncovered her face. And the sight was dreadful. That blank face with the dead eyes as if they had been burned with acid. It was pronounced enough to come out in the picture. There was nothing that you could say to her or get from her except by looking at her, and the sight of this wreckage was too much to endure for long.[21]

The real zombie:
Felicia Felix-Mentor
in Zora Neale
Hurston's *Tell My
Horse* (1938).

Told to Hurston by her doctors, Felicia's story – if this is who this woman was – was that she had come from a small village, married young and died in 1907. In 1936, a naked and distressed woman was found stumbling along the road towards the farm where she claimed her father had lived. Her brother appeared to recognize his long-dead sister, and Felicia's former husband, under duress, was compelled to make the same identification. The village believed – as was standard – that Felicia's master must have finally died, thus freeing her from bondage to wonder back as an utter ruin of a person to the only life she had known, just as zombies who eat salt usually return to their graves. As was also standard, the village refused to accept her back into the community and she was cast out, eventually ending up in a mental hospital.

For Hurston, the zombie Felicia Felix-Mentor is a brute fact, demonstrating the power of Voodoo. Felicia's condition is created, she is convinced, by the use of poisons concocted to a secret recipe handed down in a clear lineage of descent from African witch-doctors. In

the following chapter she gets on the trail of the 'Sect Rouge', a secret society that causes great fear and evasive tactics among her native informants. Fully invested in conspiratorial logic, Hurston suggests that behind even this sect is another very secretive Petro-worshipping group, the 'Cochon Gris', which, she is told, is 'banded together to eat human flesh'.[22] The further the modern anthropologist explores, the closer she seems to get to the myths of cannibals long circulated in Western texts about Haiti.

This presumably explains her odd attack at the end of the book on the common source of information on these occult matters in Haiti, 'Dr' Reser. Reser was a white American who was in charge of the insane asylum at Port Beudet (never mind that he had never been a doctor, only a pharmacist's assistant in the U.S. Navy). Reser was a celebrity because he also happened to practise as a Voodoo priest. 'Everyone who goes to Haiti to find out something makes a bee line for Dr Reser', Hurston says, but separates herself from these 'lazy mind-pickers': 'I consider myself amply equipped to go out in the field and get it myself.'[23] In the end, she was asserting the anthropological authority of the trained fieldworker. Nevertheless, Hurston was shortly to leave Haiti, believing that the secret societies had targeted and poisoned her.

Hurston provides the model for the sensational anthropological account that would be repeated 50 years later by Wade Davis, who explored the same theory of exotic poisons and secret societies in a similar uneasy mode of writing situated somewhere between anthropology, botany and sensation fiction. Wade could also produce his own real-life zombie, in this case Clairvius Narcisse. Even at the time she was writing, however, Hurston was ridiculed by her fellow anthropologists. Her timing was unlucky. One of the leading intellectuals in Haiti, the anthropologist Jean Price-Mars, had in his book *So Spoke the Uncle* (1928) taken the revolutionary position that the religion and folklore of Haiti should be embraced as a point of national identification rather than as something to be suppressed in shame, or explained away as the psychoneurosis of a whole nation. Even as Price-Mars explored Vodou seriously, he dismissed stories of cannibalism and zombies as 'heinous rubbish'. Price-Mars sighed:

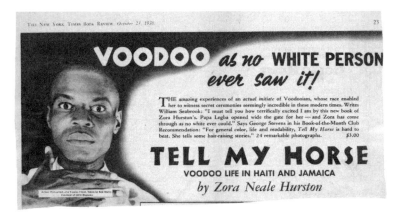

An advertisement for Hurston's *Tell My Horse* taken out
in the *New York Times Book Review*, October 1938.

'Not a year, not even a month passes that we do not hear recounted
authoritative details of the most bizarre stories about people who
have been found dead for a certain period and had been found living
again in some place or another.'[24]

Just the year before *Tell My Horse* appeared, Melville Herskovits,
another Columbia University anthropologist trained by Franz Boas,
had published *Life in a Haitian Valley*, an immersive account of
three months of fieldwork designed to discredit the 'condescension
and caricature' heaped on Haiti since Spenser St John's cannibal
fantasies. Herskovits, who knew Hurston and at first encouraged her
in her anthropological work, explores Haitian religion and magic in
detail, suggesting a literate and scholarly interaction with European
occultism, rather than voodoo being just a case of 'African survival'.
The tone is sober and detached, unlike Hurston's melodramatic
account. Herskovits erases himself with professional legitimacy rather
than being ridden by the local gods. Sudden or unnatural deaths do
produce accounts of the *zombi*, Herskovits says, but he deplores the
way that this 'has been presented in recent years with unjustifiable
sensationalism to the reading public' and situates it in a lengthy
folkloric tradition.[25] Another serious folklorist, Harold Courlander,
published *Haiti Singing* in 1939, again a careful treatment of the ritual
and religion of Vodou.

Louis P. Mars, professor of psychiatry and eventually Haitian government minister, directly addressed Hurston's findings in *Man*, America's leading anthropological journal. He discussed Felicia Felix-Mentor as 'evidently a case of schizophrenia' and expressed frustration that at the end of the war, in 1945, 'tourists believe that they will be able to see zombis roaming through villages.' Hurston is dismissed as just another American tourist: 'Miss Hurston herself, unfortunately, did not go beyond the mass hysteria to verify her information.'[26]

Hurston was more in tune with the pulps and B-movies than the direction of pre-war anthropology, but *Tell My Horse* strongly evokes the complex situation ten years after Seabrook's *The Magic Island*, in which the Caribbean *zombi* is never quite shaken off in its translation to European and American Gothic conventions of popular culture. It retains an uncanny power precisely because it is at once a laughable and ridiculous Hollywood generic icon by 1940 yet also a 'real', if disputed, anthropological object. The emergence of the zombie in American popular culture is not just a simple case of colonial appropriation and the stripping out of original contexts. This very particular and variegated Caribbean history is a consistent undertow to its New World meanings and resonances.

All the same, something shifts profoundly in the representation of the zombie in the post-1945 era. The zombies stop coming in ones or twos, elusive or vanishingly rare fugitive creatures, squinting in blind terror down the lens of a camera. Instead, they start massing at the gates, coming in hordes to announce the end of the world.

6
After 1945:
Zombie Massification

The most striking change in the representation of the zombie after 1945 is that it is no longer always a lone figure or a gang of pitiful slaves under a single master. Instead, the zombies come in an anonymous, overwhelming mass. The key scene of the zombie film since George Romero's *Night of the Living Dead* (1968) is of the horde pressing in on the Last Redoubt, feeble defences giving way under the sheer dead weight of reanimated bodies pushing in from the outside. They have no strategy, no intelligence, merely the advantage of number. This nightmare of engulfment by the mass is constantly repeated, reflected in titles like *The Horde* (dir. Yannick Dahan and Benjamin Rocher, 2009), and perhaps reaching its apotheosis in the swarms of infected zombies that devour downtown Philadelphia in the spectacular opening minutes of *World War Z* (dir. Marc Foster, 2013).

How did the zombie move from a rare and elusive oddity to become one of the exemplary allegorical figures of the modern mass? In the 1930s, the pulps and American cinema had already begun transporting the *zombi* from the colonial margin to the imperial centre. *Revolt of the Zombies*, the feeble 1936 follow-up to *White Zombie* by the Halperins, innovated by extending the notion of slavery and control to whole armies – the most eye-catching moment is when the camera pans across the faces of an implacable zombie army. But the real transformation began to take place, I want to propose, in or immediately after 1945. The lone Caribbean *zombi* never goes away – indeed, it is very important to retain all the historical resonances

that I have excavated so far, as these will continue to underpin later developments. But the zombie finds a whole new set of contexts and media ecologies in which to thrive after 1945.

As if the catastrophic military and civilian losses to a global war over six years were not enough, the last months of the conflict produced two profoundly ruptural moments. In April 1945, British and American forces advancing over the German border came across the Bergen-Belsen concentration camp, discovering 60,000 starving prisoners on the verge of death and surrounded by 13,000 unburied corpses. Although the vicious system of imprisonment of enemies of the Nazi state was well known, and intelligence had reported systematic murder in some camps, this was the first highly traumatic encounter in the West with the extent of the catastrophe. As Susan Sontag eloquently testified on seeing a book of images from Belsen that year, 'one's first encounter with the photographic inventory of ultimate horror is a kind of revelation, the prototypically modern revelation: a negative epiphany.' She was left, she said, 'irrevocably wounded'.[1] The advancing Soviet troops had found something even worse in the liberation of the Auschwitz-Birkenau camp on 27 January 1945: a vast factory machine dedicated to the liquidation of entire peoples, particularly the Jewish population of Europe. The extent of this genocide (the term coined for a 'crime without a name' by Raphael Lemkin in 1946) gradually became known over the course of 1945.

Then, in August, the war in the Pacific was abruptly ended by the American use of a devastating new bomb, which wiped out the Japanese towns of Hiroshima and Nagasaki. The Japanese high command surrendered the following day in the face of this over-whelming destructive force. The nuclear device that detonated over Hiroshima, product of the top-secret Manhattan Project that also invented the 'military-industrial complex', inaugurated a new age of terror. The atom bomb realized the prospect for the first time in history of a weapon with genuinely global reach. There was nowhere on the planet left to escape its deadly technological embrace. Within days of the news of the use of this super-weapon, American culture was flooded with the recognition that it could just as easily be turned

on American cities. Fantasies of destruction – of New York or Chicago levelled within 30 minutes of a declaration of war – flooded the American imagination.² This was before anyone knew much about the second deadly element of a nuclear detonation. The American government denied the fatal consequences of atomic radiation for years, but by the 1950s the culture was drenched in dread at the prospect of an insidious wave of poisonous radioactive clouds that would advance inexorably across the world, either killing or horribly mutating everything in its wake. Nevil Shute's bestselling novel *On the Beach* (1957) was set in faraway Australia, its protagonists doomed to await the fatal wave of radiation as it sank south. It spoke to everyone forced to share in this new planetary consciousness.

This double trauma created new types or states of being. In a famous editorial published on 14 August 1945 entitled 'Modern Man is Obsolete', Norman Cousins announced 'the violent death of one stage in man's history and the beginning of another'.³ Many felt that they were suspended in an odd liminal state between life and death. One of the most influential psychologists and public intellectuals dealing with these new 'massive traumas' was New Yorker Robert Jay Lifton. Lifton examined the psychological condition of the Hiroshima *hibakusha*, poorly translated as 'survivors', the more literal meaning being 'explosion-affected persons'. In subsequent books, Lifton detailed his work with Korean War veterans, large-scale disaster victims, Holocaust survivors and perpetrators, and his advocacy in the 1960s and '70s on behalf of the psychologically damaged soldiers returning from the Vietnam War was crucial in developing the notion of post-traumatic stress disorder, a diagnostic term first officially recognized in 1980.⁴

In his key book on Hiroshima, *Death in Life*, Lifton argued that the atom bomb had produced 'a sudden and absolute shift from normal existence to an overwhelming encounter with death'. He suggested that in the wake of the detonation, those who clung on miraculously in the ruins experienced 'a widespread sense that life and death were out of phase with one another, no longer properly distinguishable'.⁵ He aimed to categorize the psychological condition of the *hibakusha*, which he argued was marked initially by a defensive

'psychic numbing' and then later by a 'survivor guilt'. Numbing deadened the mind following immersion in mass death, but the *hibakusha* also began to feel that they they were '"carriers of death", who take on a quality of supernatural evil', suffering what Lifton called 'contagion anxiety', as if their survival was a vector of transmission for more mass death to enter the world.[6] Survivors felt either harassed by or came to identify with the 'homeless dead', the vengeful ghosts of those who die dishonoured in the Japanese folkloric tradition. 'Survivors', Lifton later said, extending this condition beyond Hiroshima, 'feel compelled virtually to merge with the dead.'[7]

We have been carefully trained to avoid appropriating the suffering of others vicariously, but in this early work Lifton had no compunction in seeing the *hibakusha* as emblematic of a new, universal condition of a post-nuclear world. The atomic survivor was 'representative of a new death immersion' and 'we all share it', he said.[8] It was Lifton's message throughout his career: we lived now under the imprint of mass death, saturated in its symbolism.

In the B-movie science fiction and horror boom of the 1950s, which flowered as an effect of the breaking of the Hollywood studio monopolies, atomic bomb blasts or the insidious radiation threat became a catch-all explanation for the arrival of the Bug-eyed Monster, from the new mutant to the disturbed prehistoric beast, from the gigantic (*Godzilla* or *Them!*) to the miniature (*The Incredible Shrinking Man*, steadily diminishing owing to exposure to radiation). Zombies were typically subsumed into this superficial exploitation of nuclear anxiety. *Creature with the Atom Brain* (dir. Edward L. Cahn, 1955) featured radio-controlled atom-powered zombies, commanded by a fugitive mad Nazi doctor (obviously). There is some impressive looming at the camera by the unfettered zombies at the end of the film, although they are easily suppressed by the local army. The B-movie maestro Cahn returned to more traditional zombie representation in *Zombies of Mora Tau* (1957). At the end of the decade, *Teenage Zombies* (dir. Jerry Warren, 1959) involves an experimental gas that enslaves the protagonists of also being trialled by ex-Nazis on a remote island, using fears of germ warfare

and radiation. In these B-movies, the threat is of a potential mass extension of new nuclear-age technologies that 'zombify' in the simple sense of human agency being dissolved by a *bokor* (replaced by a generic mad scientist), although these plans are thwarted. They tend to be one-note exploitations of contemporary anxiety, but we shouldn't dismiss all 1950s cinema zombies outright, since some examples from the period accrued subtle and ambiguous layers of meaning.

If the living dead *hibakusha* staggered out of the ruins of Hiroshima perpetually haunted by the imprint of death, then it was the figure of the 'Musulman' that assailed the memory of those who survived the concentration camps. This prison slang term associated with Auschwitz, variously spelled, was an 'exotic' and 'foreign' word that was awkward on the prisoner's tongues and which derived from the German word *Muselmann* (Muslim). It named the final stages of the condition of 'utmost inanition', beyond starvation, beyond life, beyond reason, indifferent to pain and suffering, utterly abject and scorned, but not yet dead.[9] Since 'Muslim' derives from the Arabic meaning 'submission to God', it was presumably evoked by prisoners as a slang term for resignation to fate (other camps had different, equally contemptuous terms for exactly the same terminal condition). In Primo Levi's account of his year in Auschwitz, he defines the Musulman as 'the weak, the inept, those doomed to selection' for inevitable death in the gas chambers. Levi continued: 'Their number is endless', forming 'the backbone of the camp, an anonymous mass, continually renewed and always identical, of non-men who march and labour in silence, the divine spark dead within them, already too empty to really suffer. One hesitates to call them living: one hesitates to call their death death, in the face of which they have no fear, as they are too tired to understand.'[10] The impossible interval occupied by the Musulman, the 'non-human who obstinately appears as human', is the focus of Giorgio Agamben's philosophical commentary on Levi's work in *Remnants of Auschwitz*. These 'mummy-men' or 'living dead' are aporia – irresolvable contradictions – who demand memorial and witness but precisely cannot remember or speak for themselves.[11]

Wolfgang Sofsky's description of the *Muselmänner*, those 'persons destroyed, devastated, shattered wrecks strung between life and death', is much more visceral:

> In a final stage of emaciation, their skeletons were enveloped by flaccid, parchment-like sheaths of skin, edema had formed on their feet and thighs, their posterior muscles had collapsed. Their skulls seemed elongated; their noses dripped constantly, mucus running down their chins. Their eyeballs had sunk deep into their sockets, their gaze was glazed. Their limbs moved slowly, hesitantly, almost mechanically. They exuded a penetrating, acrid odor; sweat, urine, liquid feces trickled down their legs.[12]

Testimony from other survivors describes their slow 'shuffle in clogs', that they 'used to sway in a peculiar fashion, sitting or half-sitting. The movement was monotonous, horrifying.' They were described as 'giant skeletons', 'strangely alike', feral, with shining eyes, obsessed with food, driven beyond all taboos by hunger, even to eat corpses.[13] Before their final physical death they suffered social death, expelled from the community as pariahs, abused for their apparent laziness and lack of dignity. They offended because they presaged everyone's future fate: this was the inevitable conclusion of camp logic.

In Sofsky's view, 'The Muselmann is the central figure in the tableau of mass dying – a death by hunger, murder of the soul, abandonment; dead whilst still living.'[14] And it is the *massification* of death that produces the major challenge: 'Individual death leaves the existence of the collective unaffected. By contrast, dying in massive numbers involves a fundamental disorientation ... [that] shatters the concept of the peaceful continued existence of society.'[15]

The ethical questions that crowd around how to represent this unprecedented Holocaust always make this fraught cultural terrain. Critics frequently challenge any routinization of Holocaust representations, insisting either on a kind of 'traumatic realism', broken forms that register the shattering of mimetic language or narrative,

or an aesthetic of interruption, fracture, difficulty, and a refusal of anything approaching narrative pleasure or generic repetition.[16] This is perhaps why only the abjected mass-cultural form of the horror comics in the early 1950s dared to equate concentration-camp victims with zombies. An extraordinary six-page comic-strip called 'The Living Dead', published in *Dark Mysteries* in 1954, told the story of Ivor Blau, lost in the Black Forest at dusk. He finds shelter in a fairy-tale house presided over by a beautiful young girl, who cares for a group of young men and women who sleep the sleep of the dead upstairs. In a jaw-dropping plot development, it is revealed that this group of sleepers are the products of concentration-camp medical experiments by Ivor's father, Klaus, 'the Nazi scientist who disappeared' at the end of the war. 'Soon we'll have these scum back to life with my formula!' he cackles in flashback over his selected camp prisoners. 'Now, they are half-dead zombies who cannot die.'[17] Using the merciless rough justice of the comic world, the son pays with his life for his father's sins. He is pursued and killed by the wakened zombies: 'Boney arms enveloped the terror stricken ex-Nazi youth . . .', and they laugh with vengeful glee over his dead body in the final panel of the story.[18]

It is rare to find such explicit treatments, but Jim Trombetta's fascinating account of the brief flare and accompanying moral panic about horror comics between 1949 and 1954 in his anthology *The Horror! The Horror!* compellingly suggests that the camps were one of the contexts for the consistent use of skeletons, rotting corpses and zombies returning singly and then increasingly in hordes. The comics depicted whole cities of the living dead, masses of zombies creeping across the panels. The horror that an enlightened Western power had rationally planned the manufacture of the Musulman cannot be far beneath these abject depictions.

My sense is that while there remains a taboo on explicitly eliding the dead of the concentration-camp system with the zombie mass, the trace remains with the continued cultural obsession with Nazi zombies. This became popular with Robert Anton Wilson's cracked conflation of conspiracy theories in *The Illuminatus! Trilogy* (1975) – about the time trashy 'Nazi sexploitation' films were pushing at

the boundaries of acceptable taste. One late sequence in the *Trilogy* involves an attempt to reanimate battalions of undead Nazis that slumber beneath Lake Totenkopf in Bavaria. Shortly afterwards, the American horror film *Shock Waves* (1977) involved a Nazi 'Death Corps' of seemingly unkillable, undead ss men who surface from a Second World War shipwreck to menace John Carradine and Brooke Adams, and the idea was recycled again in Jean Rollin's *Zombie Lake* (1981), where the 'lake of the damned' near a French village once occupied by German forces hides a nasty secret of wartime atrocity. These are among the most reviled zombie films ever made, with good reason, but the idea has returned again and again, in Steve Barker's film *Outpost* (2008), for instance, or in the delirious splatter of Tommy Wirkola's *Dead Snow* (2009), in which a crack German Einsatzgruppe (the 'mobile killing squads' that pioneered mass liquidations in the East) have become frozen zombies under the Norwegian ice, but are disturbed by teens in their ski cabin. There has also been a Nazi zombie version of the video game franchise *Call of Duty: World at War* (2009): killing already dead Nazis in a shoot-'em-up seems to appease some parents' anxieties about the violence of video games.

The zombie Nazi simply conflates two unqualified mass evils. It stays away from the 'living dead' of their starved and tortured victims, but evokes them by inversion, switching victims for perpetrators. Viewers are morally freed twice over to enjoy the spectacle of (re-)killing. Nazis, after all, come in masses too. Totalitarianism, in Hannah Arendt's view, was a phenomenon of the masses rather than a specific class fraction, and German fascism answered a longing for 'self-abandonment into the mass'.[19] Zombification becomes a post-war metaphor for this willed abandonment of the will under the Mesmeric gaze of a Führer who commands the *Volk* to ever more exorbitant acts of violence. There is also a German connection that keeps us tied to the Haitian context. Long before the Second World War, in pulp fiction like Roscoe's *Z is for Zombie*, it is the Germans who lurk in the hills of Haiti, using the screen of native superstition to conceal their nefarious plans. Part of the impetus for the American occupation in 1915 was to quash increasing

Nazi zombies, *Dead Snow* (*Død snø*, 2009).

German financial control of Haitian banks and markets. This history does not vanish: it means, rather, that the zombie accrues ever more complex layers of meaning.

The initial colonial context for the emergence of the zombie far from disappeared after 1945. Indeed, one of the crucial consequences of the shift in world power that became evident after the Yalta Conference in February 1945, when Roosevelt, Stalin and Churchill met to discuss the future of Europe, was the American demand for the dismantling of the protected markets of the British Empire. Britain, economically broken by the war and saddled with steep debt repayments to the American banks, began to release itself from the costs of colonial occupation and administration and to divest itself of its empire. The year 1945 inaugurated an era of decolonization, although it was a disavowed, elongated and often violent process for many European empires. This was an absolutely immediate post-war problem: on 8 May 1945, the day the Nazi regime surrendered in Europe, French gendarmerie fired on a crowd of Algerians celebrating the end of the war and holding up anti-colonial banners in Sétif, killing an estimated 6,000 people over the next few days.

As we have already seen in the Introduction, nationalist and post-colonial theorists have repeatedly figured the dead hand of empire and its woeful legacies as a form of zombification. Under

fascist Vichy rule in the French colony of Martinique and then later during the Algerian War, Frantz Fanon evoked the zombie in his writings on colonial subjection in *The Wretched of the Earth* (1961). He had learned this from his teacher in Martinique, the radical intellectual and poet Aimé Césaire. In his *Discourse on Colonialism* (1950), Césaire influentially argued that the murderous logic of Nazism had been actively trialled in Europe's colonies for decades, and that the atrocities perpetrated in the European camps just reimported these tactics from the edges of empire. The English had invented and named the 'concentration camp' during the Boer War (1899–1902) and the Germans had deliberately and systematically murdered the Herero and Nama in southwest Africa (1904–7). For this barbarism to recur in Europe was a logical consequence of the dehumanization of the perpetrators. Césaire called this 'the boomerang effect' (although in his commentary on Césaire, Michael Rothberg prefers the more literal translation of *un choc en retour*, 'the shock that comes back').[20] This was also the thesis of Hannah Arendt's *Origins of Totalitarianism* (1951), where she proposed that imperialism's 'machine of death', which possesses territories, materials and peoples through destruction, was the test-bed for the liquidations in Germany and the Soviet Union. Arendt also understood the war and the camps as 'the much-feared boomerang effect upon the mother countries'.[21]

For Césaire, colonization was a process that degraded the colonizers too, turning them into objects or dead things. 'It is not the head of civilization that begins to rot first', he said: 'It is the heart.' To further the analogy, Césaire envisaged the European bourgeoisie, who had driven imperialism and then embraced fascism, as the walking dead. In staccato, poetic sentences, Césaire saw them as 'A sign that feels itself mortal. A sign that feels itself to be a corpse. And when the corpse starts to babble' – Césaire does not finish the horrible thought.[22] Much later, when the zombie had become an established cultural trope, the Tunisian post-colonial theorist Albert Memmi mournfully regarded the psychological condition of the displaced, immigrant, decolonized sons of the nationalist liberation movements under the title 'The Zombie'. 'The

son of the immigrant is a kind of zombie, lacking any profound attachment to the land in which he was born', Memmi said.[23]

After 1945, mass decolonization did not terminate the colonial contexts in which the enslaved zombie shuffled into popular culture. If anything, it transmitted them back to the centre in intensified form. In the year 2000, Michael Hardt and Antonio Negri argued in *Empire* that we had reached a truly global extension of capitalism, which exerted a 'biopolitical power' through which life itself could be manipulated. Globalization extends the state of metaphorical zombification to us all, commanded by abstract, international flows over which we have no control. In 60 years, we moved from World War II to *World War Z*.

The implacable Cold War blocs that emerged at the end of the Second World War provided another important context in which the mass zombie entered American popular culture. This was an era of large-scale geopolitical reordering of the world by the Soviet Communist and American capitalist blocs. Once the Soviets tested their own atomic bomb in 1949, the strategy of Mutually Assured Destruction locked the world in an icy embrace, trembling on the brink of global disaster. The first major proxy war between these ideological foes had been shaping up on the Korean peninsula since 1945, with American troops openly committed to fighting to protect the South against the Communist North from 1950. This engagement escalated when Mao Zedong sent vast numbers of the Chinese People's Liberation Army to support the Communist push south to capture the capital, Seoul. After initial losses, the American forces pushed back, dug in and became deadlocked until an uneasy peace was signed in 1953.

The Korean War supplies two essential elements for popular imagery of the post-1945 mass zombie. The first relates directly to the tactics of the Communist forces in the early months of the war: the use of the 'human wave'. Mao Zedong long advocated this tactic of sending forward thousands of barely armed infantry to overwhelm better equipped professional armies through sheer force of numbers. When half a million Chinese troops entered North Korea through Manchuria and attacked in October 1950, they forced the shocked

American army into major retreat. The American command had underestimated numbers and was aghast at this new 'mobile warfare', which thrived on chaos and accepted its own mass body count. It was even speculated that the piles of corpses mown down as they advanced were meant to demoralize the Americans, who would be disgusted by their own slaughter. Unable to compute numbers, a joke circulated among the American press corps that 'three swarms equals one horde, two hordes equal a human wave, two waves equal a human tide, after which come the bottomless oceans of Chinese manpower.'[24] The initial success of this tactic – although it was soon abandoned when the losses became too high – cost the American war hero General Douglas MacArthur his command.

Military books that came out of the Korean War had titles like *Red China's Fighting Hordes* by Robert Rigg, and even a memoir written 60 years later by a British brigadier on the United Nations forces in Korea used the title *Chinese Hordes and Human Waves*, as if this were the most striking detail of the war. The 'disregard for human life' as the hordes advanced stayed with the brigadier.[25]

The Asian hordes, *Revolt of the Zombies* (1936).

It is possible that the human wave proved so successful because it reinforced a central racist stereotype of the 'Yellow Peril' that had been established in American public discourse since at least the Chinese Exclusion Act of 1882, a law passed in panic to restrict Chinese immigration. The prospect of an annihilating wave of anonymous masses from Asia was a staple of invasion fantasies from the 1890s, as in M. P. Shiel's *The Yellow Danger* (1898) or Jack London's 'The Unparalleled Invasion' (1910). The nefarious plots of Fu Manchu in Sax Rohmer's novels sold in their millions; Flash Gordon fought 'Ming the Merciless', a dastardly Oriental mastermind. In the paranoid context of the Cold War, where infiltration and invasion fears were stoked high by 'Red Scare' rhetoric, the Reds and Yellows were conflated: 'Communism is an Asiatic theory of government. It grows out of heathenism and barbarism ... By the "yellow peril" we mean the organizing of Orientals into a force that seeks to destroy all white men from the face of the earth', warned the Christian Republican Dan Gilbert in 1951. The 'mass slaughters' to be expected from these ruthless infidels rising from the East were fully predicted in the Book of Revelation, Gilbert continued.[26] This is a sign of the fusion of political paranoia with Christian apocalyptic thinking, crucial to the later development of 'zombie apocalypse' narratives.

The trauma of those early months of the Korean War and of the defeats under this relentless mass attack retains an echo in later American zombie fictions. Sometimes, you don't have to fish for it: the title of Cy Gunther's novella *Zombie Outbreak, Korea, 1950* (2014) says it all. This unedifying tale shows Communist cruelty extending to deliberately killing and reanimating South Korean civilians to send into American positions in the early stages of the war.

The second element that emerged from the Korean War to influence the development of the post-war zombie was a far less physical image. What was the ideological force of Communism that so compelled the Chinese hordes into this terrible, mindless sacrifice? The answer lay in a term that was coined in 1950: brainwashing. The Chinese Communist tactic of 're-education' or 'thought reform' to adjust citizens correctly to the new collective was called *hsi nao*. The

journalist and CIA agent Edward Hunter suggested something wonderfully sinister in translating this as brainwashing. In the 1950s, the term became rapidly elided with the idea of the will-less, enslaved zombie, ensuring that zombification became a powerful metaphor for deeply paranoid times. It was a strange echo of the idea of the *zombi astral*, whose soul is captured by the *bokor*, leaving the empty shell of the body to labour in utter servitude.

The true terror of the Korean War for Americans was ultimately focused not on the battle front but on a tiny handful of American POWs who had been captured and sent to camps in Manchuria, where they were taken through re-education programmes by Chinese and Russian interrogators. The alarm was raised when a handful of soldiers and airmen issued public confessions that they had engaged in germ warfare – illegal under international law. Confessions like this were familiar from Soviet show trials and easily dismissed as propaganda. More alarming was the group of 21 POWs who refused to return to America after negotiated prisoner exchanges: they had reformed their thought and embraced Communism. There was consternation that Americans might willingly choose a 'Slave World' over the 'Free World'. Edward Hunter explained what had happened in a set of articles started in 1950 and culminating in his book *Brain-washing in Red China* (1953). 'The intent is to change a mind radically so that its owner becomes a living puppet – a human robot – without the atrocity being visible from the outside. The aim is to create a mechanism in flesh and blood.'[27] In the *American Journal of Psychiatry* in 1951, the psychiatrist Joost Meerloo called the technique 'menticide' (on the model of geno-cide) for this 'condition of enslavement'.[28] After the war, once the POWs had returned, they were treated with deep suspicion, feared and suspected of having been secretly 'turned' by their cunning captors. A number were court martialled and disgraced. They were emblems of a post-war softness, of a decadent liberal democracy that was unable to provide sufficient ideological strength of con-viction to counter the lure of Communism. They were probed, psychoanalysed and pilloried in studies like Eugene Kinkead's *Why They Collaborated* (1959).

Chinese Communists brainwash U.S. troops in
The Manchurian Candidate (1962).

This material was fictionalized in the celebrated novel by Richard Condon *The Manchurian Candidate* (1959), in which apparent Korean War hero Raymond Shaw is imprisoned, indoctrinated by a fiendish master brainwasher in Manchuria called Yen Lo, and returned to America as a 'sleeper' agent, to be activated like a machine by post-hypnotic suggestion to assassinate a presidential candidate. Shaw proves a perfect subject for this experiment due to his unresolved Freudian hang-ups (Condon's target is as much castrating mothers – the suffocating American culture of 'momism' – as evil Communists). The technique does not quite work on his fellow captive Marco: 'What do you think I am – a zombie?' he asks, disgusted.[29] Marco slowly pieces together the truth through the haze of hypnotic amnesia and mental blocks. 'You are a host body and they are feeding on you', he warns Shaw. He is intent on deprogramming his commander, 'sort of removing the controls, ripping out the wiring', he says, searching for the right metaphor.[30] Images of robot command and automation tend to predominate over those of the zombie in Condon's novel, it has to be said, although critics often discuss Shaw using the terms 'zombie' and 'robot' interchangeably. *The Manchurian Candidate* offered such a potent myth of what was becoming known as the 'paranoid style of American politics' that Frank Sinatra, who starred in the film and owned the rights, hastily

withdrew the film version after the assassination of John F. Kennedy a year after its release. It was a decision that of course only intensified its conspiratorial reputation.[31] The film is sometimes also held to reveal the American national security state's own profound interest in developing the psychological techniques to create their own 'prefabricated assassins'.

Brainwashing does not initially suggest a mass, but rather a single individual put under severe and sustained psychological pressure, like Shaw in *The Manchurian Candidate* or Harry Palmer in Len Deighton's *The Ipcress File* (1962). Hallucinatory disorientation and brainwashing techniques were the culminating scenes of Sidney J. Furie's film version of the novel in 1965. Aside from these individual cases, there are, however, repeated fantastical images of collective brainwashing in popular American fiction and film where the metaphorical stitching is looser. The most compelling example from the era is Don Siegel's film *Invasion of the Body Snatchers* (1956), perhaps because its plot invites so many potential allegorical readings. It is not a zombie film, but it is a film entirely about zombification in the post-war paranoid style.

Invasion was shot in a matter of days on a low budget, faithfully adapted from Jack Finney's 1954 serial for *Collier's* magazine. The film takes us efficiently from a small-town idyll, where the local doctor Miles Bennell knows everyone in town and traditional social order binds the community together, to the nightmare of an insidious takeover of Santa Mira by alien beings. Miles can't quite cope with local cases of hysterical delusion, the conviction in a number of patients that their loved ones have been replaced by identical but somehow emptied-out robotic doubles. 'There's no emotion. None. Just the pretence of it', a patient explains (this was recognized as a psychiatric disorder related to hysteria in 1923, but is now understood more neurologically as Capgras syndrome). The local psychiatrist declares these cases to be 'a strange neurosis, evidently contagious. An epidemic of mass hysteria.' Bennell soon enters this delusion himself, briefly persuaded that he has only imagined seeing a corpse-like double in the dark of a basement, growing into the form of his girlfriend, Becky. The material evidence grows, however, as

does the paranoia, until Miles and Becky recognize that they are the only humans left in town: the police and all local authorities are part of the conspiracy. The secret is that alien seed-pods, an interstellar parasite, have landed in Santa Mira and have quietly absorbed and reproduced their human hosts down to a cellular level. The psychiatrist Kaufman, speaker for the pod people, celebrates the new collective, always speaking in the third person, presenting a communistic vision of a rational shared life: 'Accept us!' he exhorts Miles and Becky. All the wasted energy of human emotions will be erased; gone will be the tiresome struggles associated with American individualism. In Finney's written version, these body doubles are acknowledged to be merely temporary hosts for a rapacious parasite: 'We can't live, Miles. The last of us will be dead . . . in five years at most.'[32] The film was to end in an open way, with the demented Bennell reaching the highway alone, screaming at the cars: 'You're fools! Can't you see you're in danger? They're here already! You're

The pod people take over, *Invasion of the Body Snatchers* (1956).

'I didn't know the real meaning of fear until . . .

next!' The complacent small-town doctor has had his social reality entirely disassembled. It was reframed to include a last scene where larger federal agencies appear finally to be swinging into action to counter the threat.

Invasion of the Body Snatchers feeds directly on Red Scare anxiety. Although Senator Joseph McCarthy's exorbitant claims of Communist infiltration of the Washington establishment had crashed with his disgrace in 1954, the director of the CIA, J. Edgar Hoover, had yet to publish *Masters of Deceit*, in which he would declare Communism to be a threat to 'the safety of every individual, and the continuance of every house and fireside' in America.[33] Hoover detailed the insidious tactics of infiltration and warned citizens to be vigilant for the tiniest signs. 'They want to make a "Communist man", a mechanical puppet, whom they can train to do as the Party desires', he warned all right-thinking American citizens.[34] In the

... I kissed Becky', *Invasion of the Body Snatchers* (1956).

film, it is significant that the pod people seek first to *persuade* Bennell to embrace them, scenes that are exercises in 'thought reform' and only distantly undergirded with the threat of forcible conversion. That this transformation takes place during sleep, when ego defences are suspended, also hints at fears of hypnotic invasion and control. By the end of the film, it only takes a moment of sleep for Becky to be converted. She becomes a cold and mechanical creature. With blissful pop-Freudian relish, Miles's voiceover thunders, 'I didn't know fear until . . . I kissed Becky.' Physical and mental states of zombification lurk in this whole nexus of associations.

But *Invasion* endures more than most B-movie alien invasion fantasies of the 1950s because of its marked ambiguities. Siegel was conservative (as was Finney), but such films 'reflected not one but several warring ideologies'.[35] As most commentators note, the ambiguity of *Invasion of the Body Snatchers* is finely balanced, for

the coercive conformity of Santa Mira might not be a Communist threat so much as the constricting forces of American post-war consensus. These new normative pressures, according to several liberal commentators, had produced profound changes in the American character. David Riesman famously argued in *The Lonely Crowd* (1950) that many were increasingly 'other-directed', concerned to fit in with their neighbours and friends, suppressing their inner selves for 'close behavioural conformity' in nearly every public and private aspect of life.[36] Automation and the new consumption economy mass-produced machine-tooled people living in identikit suburbs and working for identikit corporations. This was the bland 'Organization Man' (the title of another bestseller of the time), with a personality obsessively trained, tested and policed for any worrisome deviations from the norm. By the late 1950s, fears about brainwashing and hypnotic control were targeted at the new culture of American advertising and hyper-capitalism. 'No one anywhere can be sure nowadays that he is not being worked upon by the depth persuaders', Vance Packard claimed, detailing how the new supermarket environments induced soporific trance states in young women shoppers while advertisers reshaped the nation's unconscious desires.[37] Juvenile delinquency was fuelled by mass culture and consumption, teenagers shuffling around dance halls like zombies, Packard said in his later book *The Status Seekers* (1959); shades of *Teenage Zombies* again.[38] These are the seeds for the satire of Ira Levin's robotic *Stepford Wives* (1972) or the indoor shopping mall populated by listless zombie consumers in George Romero's *Dawn of the Dead*. Fiendish tactics for so long ascribed to America's enemies rapidly experienced their own curious boomerang effect to resurface at the heart of the American Dream. This is how the mechanism of paranoia works: fears projected outward return as demonic persecutions.

The open allegorical grid of a film like *Invasion of the Body Snatchers* allows for the accumulation of many different possibilities. It is often claimed that these forms of science fiction and horror were able to escape an era of media censorship and control – once Hollywood became the target for anti-Communist witch-hunts – because

any social criticism was displaced through genre trappings. More likely, they were simply ignored. Susan Sontag, usually more attuned than other cultural critics, regarded the B-movie science fiction boom of the 1950s as entirely devoid of ideas, expressions only of 'primitive gratification' in spectacles of destruction.[39] This was culture that did not contribute to the public sphere, but actively degraded it.

The last element we need to explore in this period is the reception of the *forms* of mass culture themselves. For many leading intellectuals in the 1940s and '50s, the splurge of American mass culture of 'crime, science fiction and sex novelettes' (as Richard Hoggart put it) was an annihilating tide of worthless rubbish.[40] In the influential collection *Mass Culture: The Popular Arts in America* (1957), one of the editors, Bernard Rosenberg, warned that these mass products of a 'machine civilization' created a 'dehumanized' and 'deadened' population, resulting in a 'stupefaction'. At its worst, Rosenberg continued, 'mass culture threatens not merely to cretinize our taste, but to brutalize our senses while paving the way to totalitarianism.'[41] This stance might have been expected from commentators on the cultural right (Ortega y Gasset had long warned of the 'coming of the masses' that would overwhelm the excellence of the high culture of the elite). But this critique also came from the left, a radical like Dwight MacDonald condemning 'the deadening and warping effect of long exposure to movies, pulp magazines and radio'.[42] The German Marxist Theodor Adorno, exiled in America, also routinely condemned the idiocy of 'the culture industry'. In a crucial way, then, the thematic *content* of the zombie mass, that resonant image of mindless shuffling hordes, was also one of the strongest reflections on the abjected *form* of mass culture. The zombie was one of the most abjected products of the American mass culture industry because it became a commentary on *massification itself*. Perhaps this is why the zombie found its most persistent presence in this era in the most widely read yet most reviled cultural form: the horror comic.

The comics industry was huge: with the expansion of the market at the end of the Second World War, it was estimated that there were 60 million copies bought in America each month (with each copy

likely exchanged and read by another three or four people). In 1948, there was a notable shift in tone and a boom in violent and gory horror comics began to emerge. Bland titles like *Teen Comics* or *Joker Comics* turned into *Journey into Unknown Worlds* and *Adventures into Terror*. In bold four-tone colours, with shrill and arresting cover images of death and dismemberment, comics companies tried to outdo each other to stand out on news-stands. The height of the boom was between 1950 and 1954, with nearly 150 titles, including memorable runs of *Black Cat Mystery*, *Weird Mysteries*, *Black Magic* and, most notoriously, *Tales from the Crypt*. As the titles suggests, these comics picked up on the lurid end of pulp fiction, kids' stuff but with added twists of sexual torture, perversity and unhinged criminality. Crime themes were incredibly popular, with outrageous bad faith titles like *Crime Does Not Pay* selling millions. As in *Weird Tales*, there was an obsession with the vengeful dead, victims rising from the grave, skeleton gangs exacting punishments on their killers, the decaying dead crawling out of the ground to drag their killers down to hell. It was an exorbitant world with Jacobean levels of bloodthirsty revenge, the gore so extreme that it regularly tipped over into hilarity. A title like 'Horror of Mixed Torsos', featuring an unscrupulous gravedigger finally attacked by the composite mutilated corpses of the cemetery dead, suggests the deliberate courting of bad taste and disgust.[43] But there were oddly Surrealist elements too. The comic *The Strange World of Your Dreams*, for instance, offered readers the chance not only to have their nightmares illustrated by legendary artists like Jack Kirby, but to have them psychoanalysed by 'dream doctors' in the comic too.

'The fifties world was haunted, all right, but not by ghosts. A ghost is a spirit without a body, but what possessed the fifties was the reverse: a body without a soul – a zombie.'[44] The comics teemed with zombies and the restless undead. Titles like *Voodoo* and *Black Magic* kept the tie back to the 1930s anxiety about colonial monsters from the margin, crossing over with a whole subset of 'jungle comics' which revelled in pulp primitivism, cannibalism and witchcraft among savage tribes. Evil priests continued to mesmerize victims in the old-school Haitian manner. The story 'I AM A ZOMBIE!' in

Adventures into the Unknown, for instance, portrays the abject tale of 'Morto' the zombie, cruelly commanded by the *mamaloi* Mother Harana to do her evil bidding. In flashback, Morto remembers his life as ruthless oil executive Roger Hanks, illegally throwing poor homesteaders off their land in the Louisiana bayou, even resorting to murder to secure his drilling rights. The killing of the voodoo witch Mother Harana results in his eternal servitude to her: 'You are one of the *undead*, Roger Hanks . . . *forever!* You have no will now . . . only mine! Obey me . . . for I am your master!' The 'impossible' narration of the dead Morto allows for a simple reader identification with the punished man and another lesson rammed home in the moral universe of the comics: that 'No one cheats death. No one escapes retribution.'[45]

Many comics featured these basic 'boomerang' stories, of a death exacted for a death by the rotting corpses of returning victims. Significantly, though, the comics zombie also evidenced the kind of massing up that I have been examining in this chapter. In March 1954, *Voodoo* comic included the story 'CORPSES . . . COAST TO COAST', framed as the dream of a nervous undertaker, initially unconcerned about a national strike leaving thousands of unburied corpses across America. This, however, is only the first plank in the secret plan of the demagogue 'The Big Z'. In a kind of oneiric reversal of the Holocaust, the corpses are collected in their thousands and taken to processing centres where they arrive as dead but leave as a marching army of the undead. What is established is the UWZ – the United World Zombies – who in a rapid succession of panels take over the White House and the Senate, then the Kremlin, France and the world. The resisters are herded into 'Rehabilitation Camps' and turned into zombies, 'just like human adding machines! They work 24 hours a day, and never need any rest!' The plot is foiled by atomic attack: luckily it turns out that 'zombie tissue doesn't stand up well under blast and radiation!' This nightmare somehow collapses the mass movements of Nazism and Communism while also mocking the American rhetoric of exporting the values of the free world, one of the last panels cynically celebrating 'making the world safe for zombiocracy'.[46] It is an impressively nihilistic vision. The story

'MARCHING ZOMBIES', from *Black Cat* in 1952, is set in 'the *desolate wastes* of an obscure Asian desert', where two adventurers find a city entirely populated by the living dead. This is a more conventional lost world story, where the threat is contained by the inaccessible city where the relation of life and death is reversed, but the last panel offers another vision of massified zombies, a vast column of the undead trailing through the night, 'a *weird* procession of marching zombies, doomed *never* to rest but to wander like *lost souls* through the long pathways of *eternity*.'[47]

Daniel Yezbick has argued that in the wake of the Second World War and amid the onset of the Cold War, the horror comics were 'designed to debase, disturb, or destroy all manner of conventional, orthodox, or conformist perspectives with gallows humour and gratuitous helpings of violence, psychosis and fetishism'. Deeply contentious, they 'simply went further than most media dared in their sour deconstruction of the American dream'.[48] This is why they became the subject of a moral panic that resulted in their denunciation by liberal criminal psychologist Fredric Wertham in his bestselling jeremiad *Seduction of the Innocent* (1954). A catastrophic defence of the 'good taste' of horror by the owner of EC Comics Bill Gaines before the Senate Subcommittee on Juvenile Delinquency in April 1954 led to a new industry Comics Code in November 1954 that effectively destroyed this whole first wave of horror comics culture in a matter of months.

Commentators started to complain about the moral opprobrium of the post-war comics almost as soon as they appeared. In 1949, Norbert Muhlen noted the 'mass preference' for this new form, and asked what effect 'may this endless tidal wave of terror have on our national life?' He pointed to apparent copycat crimes performed by young children, and worried that the celebration of crime and sexual perversity would corrupt a generation, contributing to the rise of 'godless, totalitarian man' and helping 'the trend toward the robotization of the individual'.[49] The form and content of this mass culture united to zombify the nation's youth. This was typical liberal commentary, most of which followed the lead of the implacable opponent of the comics, Fredric Wertham.

Wertham was a liberal psychologist who analysed the origins of delinquency in poverty, ran a free psychiatric service in Harlem and was a major expert influence in the court cases that ended racial segregation in schools. In comics, however, Wertham found only moral and psychological corruption: 'This is a new kind of harm, a new kind of bacillus that the present-day child is exposed to.'[50] Children simply imitated the violence they read from tales that reinforced the allure of crime, violence and sexual sadism. Comics were gateways: 'All child drug addicts', he insisted, had first been 'inveterate comic-book readers'. Meanwhile, all superheroes were antidemocratic and fascist: looking at the 'S' on Superman's outfit, he commented 'we should, I suppose, be thankful it is not an ss', and he fulminated against this nefarious Nietzsche in the nursery.[51] Comics revelled in racist, white supremacism. It was somewhat rich of the authorities to accuse the comics of racism, since it has been documented that in the last years of the Second World War, the Office of War Information encouraged comics companies to amplify racial stereotypes of the Japs and the Huns, while fictionalizing the extent of racial integration on the home front.[52] Wertham was only one element of a notable shift in suspicion of children and teenagers in the 1950s, a mutant generation of bad seeds and rebels without a cause, intent on defying all authority. Intellectuals found Wertham's comics stance vaguely ridiculous. Robert Warshow wrote a thoughtful reflection on his son's own addiction to EC Comics, arguing for the place of humour, distance and subversion in the child's imagination. Warshow did not think it was desirable for culture to be 'entirely hygienic': on the other hand, he rather hoped Wertham succeeded in banning these disturbing horror comics.[53]

Wertham's book appeared in early 1954 and in April he presented his case to the Senate Subcommittee on Juvenile Delinquency. He was followed by the owner of EC Comics, Bill Gaines, whose disastrous testimony effectively ended the boom in a few short minutes. Shown the cover of one of his comics with an axe and the severed head of a woman held up in glee, he was asked by the committee chair whether this constituted 'good taste'. 'Yes, sir, I do', Gaines replied. 'A cover in bad taste, for example, might

be defined as holding the head a little higher so that the neck could be seen dripping blood from it.'[54] In November, the Comics Magazine Association of America issued a Comics Code. Under 'General Standards' it stated: 'No comics magazine shall use the word horror or terror in its title', and also declared that 'Scenes dealing with, or instruments associated with, walking dead, torture, vampires and vampirism, ghouls, cannibalism and werewolfism are prohibited.'[55] The era of the zombie in horror comics came to a sudden end. Gaines had to pour his vitriol into the satire of *Mad* magazine instead.

The suppression of the horror comics reinforced the abject status of its emblematic mass monster, the zombie. It remains the case, I think, that the zombie exemplifies the mindlessness of mass culture, since it is an orphan creature without the legitimating literary forebears of Baron Frankenstein or Count Dracula. One recent history of the Gothic ends by judging the zombie film to actively 'aspire to dismissive critical notice, gesture towards their own disposability', unable to free itself from this redoubled 'creative slavery of mass culture'.[56]

Later, horror comics returned with adjustments to the Code, with *Tales from the Tomb* (from 1962), or the innovative *Eerie* and *Creepy* comics (from 1964), and particularly from the early 1970s, when another major horror boom developed. There were reprints from the lost 1950s era, but also revivals and elaborations of characters, as in Marvel's *Tales of the Zombie* (1973–5), which focused on the melancholic figure of Simon Garth, sacrificed in a voodoo ceremony but revived in an agonized liminal state. Garth 'The Zombie' shuffles intermittently through other series, but nothing featuring zombies quite matched the Gothic elaboration of vampire or superhero mythologies, at least until the independent release of *Deadworld* in 1987, one of the first post-apocalyptic zombie comic narratives (which is still ongoing). It took a third horror comics boom in the early 2000s, long after the demise of the Comics Code, for the zombie to find centre stage: the phenomenal success of Robert Kirkman's *The Walking Dead* (started in 2003) was conceived from the start as open-ended and episodic, 'the zombie movie that

never ends', focusing less on horror and gore and instead on human characters in 'extreme situations' after a disaster ends modern American life in a matter of weeks.[57] 'We will change! We will evolve. We'll make new rules – we'll still be humane', the protagonist Rick Grimes agonizes early in the series, although his terrible losses continue to accumulate. Kirkman's sober rendition of the apocalypse trope, focusing on the survivors and pushing the massification of zombies into the background, proved highly influential. The mass presence of the zombie horde becomes the new norm, the permanent emergency. Kirkman then had his fun in the *Marvel Zombies* series (2005–6), in which leading superheroes are infected by a zombie virus, crave human flesh and start to rot horribly ('Oh, Jeez!' says Zombie Spiderman, 'I broke my leg – like – in half'). Commissioned artists also set about 'zombifying' iconic Marvel covers from the past, in delighted acts of desecration. The sight of the Marvel canon of superheroes indulging in cannibal orgies across lovingly detailed splash pages suggested the extent of the zombie infection of the comics universe in the first years of the new century. Many of these later zombie comics retained the resonances of the first post-war boom. In the comic *'68*, the jungles of Vietnam at the height of the war hide not just the Viet Cong but an outbreak of zombies. The Asiatic horde, the massified undead intent on murderous attack, returns in the form we have now thoroughly excavated.

The first horror comics boom was brief but had an enduring effect on the kids that first encountered it and a huge influence on the trajectory of horror that followed. Two of these '50s kids would pay their respects to the world of EC Comics in the anthology film *Creepshow* (1982): the scriptwriter Stephen King and the director George Romero. *Creepshow*, framed by a kid's voodoo doll revenge on a brutish father who has thrown away his 'worthless' comics, contained two classic sequences of the restless dead returning from their graves to exact revenge. King wrote extensively about the influence of EC Comics on his own fiction, calling them 'the epitome of horror, the emotion of fear that underlies terror', and the simple moral universe of the comics colours everything King has

written, for better or worse.[58] The influence on George Romero – those panels of massed zombies that climb out of the wreckage of 1945 – would utterly transform the idea of the zombie, and send it on the path towards world culture domination.

7
The Zombie Apocalypse: Romero's Reboot and Italian Horrors

We have finally arrived at the zombie that everyone thinks they know: the horde unleashed by George A. Romero's *Night of the Living Dead* (1968), but only really consolidated ten years later with its sequel, *Dawn of the Dead.* Romero spawned an army of imitators, particularly in the European horror industry. It is in this sequence of films, from horror cinema's glorious decade of perverse wonders, that the zombie came together as a relentless, devouring, cannibalistic creature driven by insatiable hunger to turn living flesh into dead meat.

Night Falls

Strictly speaking, Romero's *Night of the Living Dead* is not a zombie film. The lone cadaverous creature hanging around the cemetery in the first scene is another exotic: a *ghoul* (the Arabic term for soul-hungry spirits that haunt graveyards). In the film, no one knows quite what to call these dead that walk again. Early on, the radio refers to 'unidentified assassins', but by the end the sheriff just shrugs, 'They're dead – they're all messed up.' Romero's key source was the film *The Last Man on Earth* (dir. Sidney Salkow and Ubaldo Ragona, 1964), an adaptation of Richard Matheson's brilliant novel *I Am Legend*, about a blood disorder that turns the whole population into vampires that nightly assail the last human left alive in shambling, ineffective crowds. Sure, Romero's brain was crammed with the undead from a thousand EC Comics he had read as a child, and

Night of the Living Dead (1968).

he had watched the progressive multiplication of zombies revenging themselves on mad scientists in the 1950s B-movie cycle. But it was only when Romero was persuaded to return to the same scenario ten years later that this became a sequence of zombie films. *Dawn of the Dead* also assiduously avoids the 'z' word, but was released as *Zombies* in Britain and *Zombi* in Italy and elsewhere. It was a global hit and raised the legion of imitators that just keeps on coming. It was only retrospectively, then, that *Night* became a zombie film – indeed, one of the single most transformative texts in the entire history of the zombie figure.

Like most influential films, the impact of *Night* was entirely unforeseen. It was produced by a group of industry outsiders in Pittsburgh, funded by a group of ten friends in the advertising business who kicked in start-up funds (the film was eventually made for $114,000). Pittsburgh was a long way even beyond the low-budget independent outfits like American International Pictures, home to Roger Corman's atomic monsters or florid Poe adaptations. This group was entirely off the map. Romero only gradually emerged as the director and others ended up taking the key acting roles in a

project that they gave the dismissive working title of *Monster Flick*. It was an accident, they always say, that the main role of Ben was played by black postgraduate student Duane Jones – he was simply the most accomplished actor among a bunch of mostly amateurs. It was significant, though, that this team were professionals who owned their own film equipment: it was shot cheaply on black-and-white film at night and on weekends, but Romero had the time to edit and synch the sound to polished levels. Its highly accomplished, frenzied montage contributed to its impressive visceral effect.

Nevertheless, the crew kept the references very local to South Pennsylvania because they figured that in the worst case they could at least sell to local drive-ins and recoup some costs there. The finished film was shown to the distributors Continental Releasing in brutal times, the day after Robert Kennedy had been assassinated live on TV. Continental were marginal players, with a reputation for arty and controversial films, and they took the film on. They retitled it *Night of the Living Dead*, but in doing so forgot to add a copyright declaration at the beginning of the movie, meaning that Romero and his crew would for years see very little money from making such

The first attack, *Night of the Living Dead*.

a seminal film (this was why many of the same team gathered to remake the film in 1990). It is oddly appropriate that this film was effectively public property from the start, given that it seemed to have a direct channel into the collective unconscious.

On its first release, *Variety* considered that 'This film casts serious aspersions on the integrity of its makers . . . and the moral health of filmgoers who cheerfully opt for unrelieved sadism.'[1] Notoriously, booked unseen, it was shown on Fridays and then repeated in the Saturday matinee slot for kids, where it was watched by the appalled critic Roger Ebert, surrounded by traumatized children with nothing to 'protect themselves from the dread and the fear they felt'.[2] With this kind of reputation, it began to achieve note across bewilderingly diverse audiences. It was shown in inner-city neighbourhood theatres in double bills that were often targeted at black audiences by being paired with *Slaves*, Herbert Biberman's 1969 historical drama about an 1850s slave revolt. It featured in city grindhouses but also became one of the first cult 'Midnight Movies' shown at the countercultural Waverly cinema in Greenwich Village to students and radicals. In 1970, it was dragged out of the exploitation circuit and showcased in the first film slot in the august precincts of the Museum of Modern Art in New York. The cultural temper of the times was to 'cross the border – close the gap' between high and low art. *Night* was the exploitation movie that was claimed by the political avant-garde. This was radical outsider art: cutting edge 'art-horror', sticking it to The Man.[3]

Night retains many of the crucial historical resonances of the Haitian *zombi* and American culture's post-war massification of the zombie. Yet it deserves its reputation as an epochal film. Romero crystallized, with mythic simplicity, the plot formula that was the logical conclusion to all this massing of the undead: the narrative of what we now call the *zombie apocalypse*. The film follows a relentless path from the open spaces of the hillside cemetery and Johnny's mocking mastery of all he surveys down to the cramped confines and utter dethronement of all human value in the basement of a boarded-up farmhouse. Johnny's disdain for the empty ritual of paying respect to the dead father marks a generational shift, no less

Building the Last Redoubt, *Night of the Living Dead*.

than his mockery of decades of domesticated horror by imitating Boris Karloff in the most famous line of the film: 'They're coming to get you, Barbara.' Barbara's catatonic reaction to her brother's sudden, vicious death and her headlong flight through bland fields and trees hints at raw emotional states uncontained by routine movie melodrama. What you want from a horror film is a dangerous sense that rules will be broken. *Night*'s toxic celluloid clattered through the gate like there were no rules at all.

The film makes the farmhouse, the Last Redoubt of the handful of survivors, a place of bitter quarrel, murderous infighting and stupid escape plans that steadily deplete the last remaining human resources. Race tensions flare: the white paterfamilias Harry Cooper itches to shoot Ben, the uppity black boy. In a truly incendiary moment, it is Ben who shoots Harry – and with evident pleasure. This was in the year when riots broke out after the assassination of Martin Luther King, and the Black Panther Eldridge Cleaver composed the essay 'Requiem for Nonviolence'. 'That there is a holocaust coming I have no doubt at all', Cleaver said. 'The violent phase of the black

liberation struggle is here, and it will spread. From that shot, from that blood, America will be painted red.'⁴ Following the escalation of the Vietnam War in early 1968, and a major extension of the draft, students too were turning to violent revolutionary tactics – in France, in Mexico and around the world. American student radicals would turn to violence modelled on an understanding of its revolutionary necessity to overthrow imperial power, as outlined in the writings of Frantz Fanon, the Black Panthers and others. They staged 'Days of Rage' and three of the Weather Underground terrorist group blew themselves up in a Greenwich Village bomb-making factory in 1970, not far from the Waverly. Stalinism offered little hope either: Soviet tanks crushed the Prague Spring in the late summer. The radical filmmaker Chris Marker always suggested that 1967 was the really revolutionary year: 1968 was the curdling of those hopes.⁵

In *Night*, courage, love and sacrifice – all the noble human virtues – are stamped on and destroyed. Tom and Judy, the teenage couple who would have foiled the dastardly plan in cahoots with benign cops ten years earlier in *Teenage Zombies*, are killed by a stupid mistake by Ben, the ostensible 'hero' of the film. Love does

Engulfment, *Night of the Living Dead*.

not conquer all; it gets you fried in a jalopy. In the next scene, *Night* takes the vengeful dead from EC Comics and re-injects them with all the cannibalistic terror that underwrote colonial fantasy. There is no coy turning away from what the ghouls devour: a group sups on ropes of intestines pulled from the fried corpses, while another contemplatively eats a finger-licking good severed hand. Ben Hervey's excellent examination of *Night* is right to suggest that this ghastly aftermath scene has been 'the single biggest influence on a new strain of horror film: the "splatter" or gore film, the "meat movie".'⁶ The Last Redoubt is the model of the fragile ego, menaced from without, but every zombie film after *Night* will incorporate a scene of a literal breaking open of the 'skin-ego', the ruination of bodies opened by frenzied crowds of ghouls. After *Night*, all zombies seem solely motivated to devour the living without purpose, to turn the world into an undifferentiated mass of deadened sameness.

Family will not save you either. The basement is where, finally, the family unit will spectacularly turn on and devour itself. The Coopers have been nursing their stricken daughter Karen down there. The fatally wounded Harry Cooper stumps down the steps into the arms of his reanimated daughter. She is discovered moments later munching on the severed arm of her father, and advances on her mother to stab her an unblinking fourteen times. At a young age, Romero had worked on the set of *North by Northwest* (1959), one of Hitchcock's many weird reflections on stifling mother love. *Night's* explicit slasher scene sets out to show everything hidden in the cuts of *Psycho's* frantic murder montage just eight years before.

In the end, Ben's cack-handed carpentry constitutes no defence against what Elliott Stein called 'a symphony of psychotic hands' that push through the windows and doors (something Romero borrowed from Polanski's vision of schizophrenia in *Repulsion*, from 1965).⁷ This is the spectacle of the final engulfment of the living by the dead, another major influence on the development of the genre, a scene opened out from *The Last Man on Earth*. Barbara is shocked out of her own zombified traumatic state to fight briefly before she spies her brother Johnny among the crowd, come back to get her. Hadn't she denied him candy in the first scene? Now his hunger has

The cannibal feast, *Night of the Living Dead*.

become incestuous, insatiable. Her surrender to him and to the horde tips the balance from horror to a kind of willing masochistic ecstasy of release. It makes *Night* the purest form of kinetic cinema, at least according to Steven Shaviro: 'All cinema tends away from the coagulation of meaning and toward the shattering dispossession of the spectator.'[8] Romero's zombie cinema exemplifies this insight, the thrillingly perverse thirst for annihilation. It was *meant* to sound pompous and jarring when one of the leading film critics of the day, Robin Wood, dared to suggest that the progressive but disordered horror films like *Night* and *The Texas Chain Saw Massacre* (1974) had the 'force of authentic art' in their rigorous nihilism.[9] This was a grand, transgressive statement to make at the time: these nasties mostly subsisted in a world far beyond the taste of the cinéaste.

Night also has a rigorously bleak coda, with a bitter EC Comics twist, that sets off yet more political firecrackers in an era of revolutionary violence. The screen frames a comically banal television interview by actual Pennsylvania TV star Bill 'Chilly Billy' Cardille with a redneck sheriff leading a posse. The report is designed to

The family devours itself, *Night of the Living Dead.*

parody the bland propagandistic news reports on 'Search and Destroy' missions in Vietnam (even down to the 'kill' statistics at the end), but it also drips with segregation iconography, and Romero used local groups of hunters who brought their own guns for these scenes. This irregular company or lynch mob is on a mission to clear the territory of the undead, offered in the calm tones of a mopping-up exercise after the crisis has passed. They move across the fields in a ragged line seen from a helicopter, deliberately meant to echo the ambling beings they pursue. The increasingly declarative message of Romero's film sequence will be: the zombies are us.

At the farmhouse, they calmly target and shoot the last living survivor, Ben, as he clambers out of the basement. Survival has been an epic struggle; it is cast away worthlessly. They drag his body out of the rubble with meat hooks to burn it on the fire. This is done over the closing titles in still images, photographs explicitly used to echo the photos of murdered blacks that were often taken by lynch mobs and circulated as mementos. The survivor of a 1930 lynching remembered seeing his two friends, torn and bleeding, hanging

from the trees: 'they vied with one another to have their pictures taken alongside the tree.' He was up next, for a crowd driven crazy by bloodlust: 'I was already dead', he thought.[10] Imagine how this scene played alongside *Slaves* in black neighbourhoods, or among an anti-war movement on the verge of advocating violent resistance to the militarized state. The National Guard started gunning down students at Kent State University in May 1970.

The meaning of this closing scene therefore kept changing, in lock step with the bitter end of the 1960s. By the time it was a Midnight Movie in Greenwich Village, these images now evoked the mass slaughter perpetrated by American troops in Vietnam. The scandal of the My Lai village massacre, when up to 504 unarmed civilians were killed by U.S. infantry, was exposed after a year of denials when Ronald Haeberle's reel of colour photographs surfaced in November 1969. Images of the massacred dead were constantly circulated by the anti-war movement for the next few years. At the time *Night* was released, the Pittsburgher Tom Savini, who would become the legendary special effects maestro for *Dawn of the Dead* and beyond, was in Vietnam as a combat photographer, recording damaged battlefield bodies. There was no 'subtext' here for him, or for many of Romero's crew: the war spills out on screen in the lurid guts. For every viewer since, though, the last scenes of *Night* rendered explicit the explosive *allegorical* potential of the zombie trope for commentary on the contemporary world.

While Romero's outsider status gave kudos to the countercultural force of *Night*, he has struggled throughout his career to find a stable way of making films within the studios and on their margins. A couple of non-horror films failed in the early 1970s, while other filmmakers explored the allegorical potential of the undead ghoul. Bob Clark's *Deathdream* (aka *Dead of Night*, 1974) featured an undead Vietnam veteran returning to prey on his family, in a mode somewhere between vampirism and zombiedom. The criminally overlooked *Messiah of Evil* (1973) by Willard Huyck and Gloria Katz continued that strange fusion of art-house existential angst and low-budget horror. This film has unnerving scenes of shopping malls abandoned and empty but for the crowds of fiends cramming

raw meat into their mouths at the deli counter. It explains little or nothing in scenes disordered by dream logic, and is all the better for it. The Europeans, as we shall see shortly, took *Night of the Living Dead* to be a serious political film, and cooked up an entire sub-genre of considerably more dubious political intent. Romero's *The Crazies* (1973) should be considered integral to his zombie sequence, not just because the anti-statist, anti-military satire becomes broader and much cruder in this film, much more hectoring, but because the ghouls are driven to murderous frenzy by the accidental leakage of a germ warfare virus, inexpertly covered up by the secret state. Romero sketches out the script for a million bio-medical horror imitations.

The Crazies directs the same poisonous energy at paternal authority (fathers are everywhere psychotic and rapine), with the iron chain of military hierarchy receiving the most contempt. The antidote for the outbreak is found, but lost in the bureaucratic parameters of the secret state, bent on containing the flow of information. The President is briefed to prepare a hygienic nuclear strike: slowly but surely, normalcy and lunacy switch places. *The Crazies* also develops Romero's signature buzz of confused and competing voices that overlap on the soundtrack, from TV, from radio, from the phalanx of talking heads and advisers – a welter of noise that is his figure for the last days of the public sphere in America. It features again in the radio talk show discussions that bombard the audience through his very fine revisionist vampire film, *Martin* (1977). The chaotic vision of the public sphere intensifies throughout the zombie series, but finds its first and strongest articulation in *Dawn of the Dead* (1978).

Dawn was a hybrid American-European production, mainly because Romero absolutely resisted compromise with potential backers, refusing to consider delivering a tame 'Restricted' rated film, pinning his oppositional principles to an 'Unrated' shocker. The film was therefore part-funded by Italian horror producers, who agreed to part-finance the film on the understanding that it would be chopped up and fed to the Eurotrash exploitation markets. It was recut for the Italian market by the Italian horror maestro Dario Argento, who greatly admired Romero's *Martin*. As a result of this

financing, the Italian *Zombi 2* appeared only a matter of months after Romero's renamed *Zombi* was released. *Dawn* was made for a low-rent $650,000 but made an estimated $55 million across the world. The film is an odd mix: a one-off that was far more important than *Night* in establishing the whole genre of the zombie apocalypse in modern cinema, and a movie that wears its politically progressive satirical aims openly on its sleeve, but also boils with crudely regressive tendencies that ultimately disable much chance of social critique.

Dawn begins in the utter chaos of a TV studio, competing talking heads shouting contradictory theories about the murderous outbreaks in the city. The confident containment at the end of *Night* has not worked: the strange contagion has spread. The TV director (played by Romero himself) is unable to control the disputes in the studio. Meanwhile, troops seek to concentrate potentially infected populations – Hispanic and black slum-dwellers – trying to flush them out of tenements as the dead reanimate. It is another explosive racial representation of civic disorder. There is no meaningful rational discourse on display anywhere, only suicidal strategies and murderous disagreements. Out of this chaos, four people escape in a helicopter, including a pregnant woman, Fran, and a black soldier, Peter. Fran makes up for the passive or catatonic women of *Night*, and the series henceforth contains strong female survivors.

The next last redoubt: the shopping mall, *Dawn of the Dead* (1978).

Zombies go shopping, *Dawn of the Dead.*

This group eventually makes it to the Monroeville shopping mall east of Pittsburgh. The mall was one of the first self-enclosed suburban shopping centres completed in America: it becomes this film's last redoubt for the survivors. As always, their survival strategies prove pretty stupid; avarice and boredom invite the inevitable invasion from nihilistic bikers who only bring the zombies back in behind them, wrecking the defences. The film was scripted to end with the zombie horde closing in on Peter and Fran; Peter was to turn the gun on himself, Fran to decapitate herself on the helicopter blades. This nihilistic end was rewritten with a tiny loophole: Fran and Peter taking off to seek yet another last redoubt, left unseen and perhaps unimaginable amid these last scenes of engulfment.

Dawn is the central film for cultural critics to declare that the zombie is a 'capitalist monster', the exemplary figure of late capital's invasion of every last public space, a contagion that speeds through the body politic and 'turns' every last consciousness into zombified slavery. Robin Wood long ago offered this reading in his Freudian Marxist advocacy of the radicalism of 1970s horror, but Romero has remained the poster boy for progressive readings up to the present day, the last bearer of a flame amid the darkness of vacuous American horror.[11] The zombie, after the 2008 global financial crash, has been declared 'the official monster of the recession', the image of the

Overrun again, *Dawn of the Dead.*

suckered global poor.[12] All of these readings are ultimately rooted in the heavy-handed satire of *Dawn*'s shopping mall sequences, when the muzak, fountains and escalators are turned back on and the dumb zombies totter around the shops in a shambolic instinct-ual repetition of ingrained habit. This sequence is played for laughs under harsh strip lights, no longer for terror in the chiaroscuro of a dank basement. 'This was an important place in their lives', Peter muses, looking down on the zombie hordes from the mall's roof. 'They're not after us. They're after *the place.*'

This reading of *Dawn* is hardly the unearthing of a brilliant ideological subtext: it is openly avowed on the surface of the text. For a progressive critic, the film is often just a narcissistic mirror. But aside from nudging out of the picture the complex colonial history of the zombie, it is also important to recognize how the film's critique of consumption is thoroughly part of its historical moment – and necessarily limited by it. The post-'68 analysis of the containment of youth revolt was that the era rapidly looked less like a revolution and more 'profoundly adaptive to the system's productive base', a disruptive seizure in the West's shift from a pro-duction to a consumption economy.[13] This was the 'Society of the Spectacle', Guy Debord's pessimistic pronouncement on a new level of extension of capital in everyday life, a book that first appeared in

1968. Perhaps this is what the bikers, the third term between humans and zombies, are meant to represent in *Dawn* – the emergence of adaptive possessive individualism with a nihilistic edge rather than any collective opposition. They are not easy riders, but post-Altamont Hell's Angels, here to bring the world to an end.

The Pittsburgh area, which Romero's zombie films always heavily reference, felt this economic transition particularly keenly. Pittsburgh had been the centre of America's steel industry, with Andrew Carnegie's mill towns built around the regional centre in the late nineteenth century. Job losses and closures began dramatically in the early 1960s and were finally completed in the vicious union-breaking struggles of the '80s, leaving de-industrialized ghost towns and vast populations of the structurally unemployed. Romero made the melancholic post-industrial wreck of the town of Braddock a key part of *Martin*'s demystification of the vampire, and one of his key collaborators, Tony Buba, has made a number of documentaries on the industrial decline of the Pittsburgh area. With neat circularity, the local union activist Carol Bernick said in 1991: 'Braddock is like the land that time forgot. It looks like somebody just bombed it and didn't clean it up . . . People look like zombies.'[14] The rise of shopping malls in de-industrialized areas is the starkest emblem of a shift from Fordist production to low-wage, de-skilled service industries floating on the whims of international capital.

This is a powerful undertow in *Dawn*, but there remains something problematically smug about the subject position the film invites the viewer to adopt: by definition, *you* are not a zombie, *you* are not fooled by this ideological mystification or a part of this mindless mass, *you* can resist this interpellation into the casino of consumption capitalism. Romero's view of the shopping mall masses echoes Vance Packard's *The Hidden Persuaders* (1957), where the immersive, soporific world of the shopping centre lures the off-guard and unsuspecting into consumption. Cultural theorists still talked about malls as zones of mass *distraction* into the 1990s, dreamworlds of capitalism, from which to awake required the jolt of radical critique.[15] For all the assertion that Romero's message is 'the zombies are us', this mode of survival horror often flatters the

Opening nightmare, *Day of the Dead* (1985).

exceptionalism of its audience, reinforcing a sense that it is possible, with the appropriate exercise of cynical reason, to see behind and demystify 'false consciousness' and stay humanly alive.[16] Yet this is a very 1970s stance on ideology critique.

There is considerably less optimism on display in Romero's third film, *Day of the Dead* (1985), a darker and even more despairing vision in which the zombie apocalypse is presumed to have spread virtually everywhere. Romero made the film with Laurel Entertainment, a production company set up with the express aim of capitalizing on the economic success of *Dawn* by producing another sequel. By 1984, however, Romero had done poorly with *Knightriders* (1981) and *Creepshow*, and his backers declined to fund his epic vision for *Day*, particularly as he once again refused to deliver a Restricted certificate film, holding out for an Unrated. The decision cut the budget in half and the film was scaled back to a gruesome ensemble piece, dominated by Tom Savini's gory special effects and largely filmed underground in a disused cement mine and a decommissioned missile silo site in East Pittsburgh. In the culturally conservative 1980s, and in the wake of 'Video Nasty' panics, the circulation of *Day* was limited and eclipsed that year by

the comic rendition of the zombie trope by another EC Comics nut, Dan O'Bannon, in *Return of the Living Dead* (1985).[17]

Day markedly shifts the sympathy towards the undead, who are pacified and corralled in a secret research centre like concentration-camp prisoners, where they are experimented upon by a mad scientist protected by a much diminished military guard. Dr Logan's vicious vivisections and his arguments with the murderous brutes that protect him leave no doubt as to who are the lower species in these last days of the contagion. The central figure of *Day* is the zombie Bub, who appears to show 'the bare beginnings of social behaviour', being trained painfully slowly by Logan to recover simple actions: shaving, saluting, picking up a Stephen King novel. His military commander thinks only in genocidal terms, though, and Logan's conception of the human is such an impoverished form of behavioural training that it takes only a little more zombie 'development' to overthrow their masters. We last see Bub remembering how to use a gun and leaving the military commander Rhodes fatally wounded, doomed to be pulled apart and eaten.

The film repeats the same basic trajectory: the last redoubt, accelerating dissent and disorder, the final breach, engulfment, a cannibalistic feeding frenzy and another final loophole escape. Romero's marginals are this time a woman, a Jamaican pilot and an Irish engineer, who escape the implosion of the military-industrial

Teaching the zombie Bub, *Day of the Dead*.

complex in a helicopter. In the last shot of the film we see them on an island beach, perhaps the very Caribbean island the pilot had long pressed for as an escape plan. It is another stub of utopian possibility, although ironically on the islands where the notion of the zombie first emerged.

A trilogy has a certain formal elegance, and Romero left this sequence alone for nearly twenty years – many of those outside the business entirely – before he compromised with financiers on *Land of the Dead* (2005) and produced an 'R'-rated film with a bankable star (Dennis Hopper). Romero returned on the wave of the zombie apocalypse genre he had started: he was backed because of the box-office success of Zack Snyder's 2004 *Dawn of the Dead* remake. In *Land*, zombie education has now progressed to a rudimentary political intelligence: 'they're learning how to work together'. 'Big Daddy', a zombified black garage mechanic, grasps the nature of their servitude and leads the masses on a march to target their exploitative human masters, now holed up in a luxury mall where all of America's class inequalities have been preserved intact. The iconography of the film happened to resonate uncannily with the Katrina disaster in New Orleans that took place in the year of the film's release. A column of dispossessed poor and black zombies wade through swamp waters towards the human zone of privilege, seen rising above the flood plain. There are distant echoes of the Black Jacobins in this image. This context invested the film with a punchy contemporaneity, as a commentary on the Republican ad-ministration's indifference to the fate of poor black populations: Romero has said that Hopper's character was based on Donald Rumsfeld, then Secretary of Defense in George Bush Jr's team. It is also a significant echo of the roots of the zombie in slavery, figur-ing the dispossessed as 'proletarian pariahs' who 'make visible a phantom history'.[18] As ever, the last redoubt is overrun, the privi-leged engulfed. The only possibility of human survival is seen across the border in Canada.

Romero has since made two very low-budget late additions to the series, digital technology making it possible to return to the smaller-scale, more guerrilla productions of his youth. *Diary of the*

The horde overruns the Last Redoubt again, *Day of the Dead*.

Dead (2007) swings back to a focus on media addiction to atrocity, abandoning any interest in the zombies themselves. It is a film that seems caught up in an odd self-loathing about violence and the compulsion to repeat, centred as it is on a filmmaker unable to stop filming the disaster as his hokey horror film turns into documentary. 'All that's left is to record', he says, even unto his own death. Although there is some human organization (notably among urban blacks long prepared for survival), the film ends on the last survivors shutting themselves in a panic room: there is no possibility of getting out here, only a shutting in. 'Are we worth saving?' the female narrator asks over the last seconds of footage that again echo the worst images of lynch mobs in the series since the end of *Night*; 'You tell me.' Robin Wood thinks we are meant to answer this last question with a resounding Yes; I am not so sure.[19] *Survival of the Dead* (2009) finally situates a drama on that long-imagined island retreat, but only to re-tread *Day's* exploration of the doomed possibility of teaching zombies to make an accommodation with human survivors. This time, the film ends on an image of two feuding islanders, each now dead, staggering back into undead life to recommence their gun battle, firing empty barrels at each other, presumably for the rest of time, or until their bodies rot away. It is a bitter last image: zombies learn, but only enough to reduce human stupidity to its purest form.

Romero's transformation of the zombie narrative from a marginal horror into a dominant cultural trope has been so influential, I think because it ultimately fuses with the post-war revival of Protestant millenarian thought in America. Although the American state was of course founded by millenarians hoping to establish the New Jerusalem as the last redoubt against a sinful, fallen Europe, the contemporary revival of eschatological thinking has been striking since the success of Hal Lindsey's *The Late Great Planet Earth* (1970). Eschatology has been a presence in national discourse since the late 1960s, Paul Boyer claims, exactly coincident with the production of *Night of the Living Dead*.[20] Romero is not religious (the film *Martin* is Romero at his most staunchly anti-Catholic), but this has not stopped his notion of the zombie apocalypse cross-fertilizing with notions from the Book of Revelation to make a prophetic record of the end times. For many believers, contemporary history is an unfolding apocalypse, the final 'unveiling' of truth, the Last Judgement, and the Rapture is only just around the corner. Certainly, Romero's zombie films have been appropriated by Christian thinkers: in *Gospel of the Living Dead* (2006), Kim Paffenroth asserts his belief that the films 'vividly show the state of damnation of human life without the divine gift of reason'.[21] From a menaced farmhouse in rural Pennsylvania, Romero hatched a plot that fed into these visions of global apocalypse.

The most interesting critique to emerge from Romero's film cycle is his meditation on the nature of the public sphere. In 1962 the German sociologist Jürgen Habermas published his influential study *The Structural Transformation of the Public Sphere*, in which he argued that his idealized model of an enlightened public arena of rational and inclusive debate, established with the modern bourgeois state in the eighteenth century, had been put progressively under pressure by the interference of states and a fracturing of the public into disputatious and irreconcilable voices, prompted by the proliferation of media and communications. In many ways, Romero's films track this collapse of the public sphere in America: by racial division in *Night*, consumerism in *Dawn*, the militarized state in *The Crazies* and *Day*, and by a self-cannibalizing, disputatious media

culture in *Dawn* and particularly in *Diary*. Habermas, a cultural conservative, blames crass popular culture as one cause of a debased public discourse. But Romero displays just how eloquent Gothic devices can be for exploring precisely these concerns, even being able to develop a critical *counter*-public discourse. The perpetual disputes in the last redoubt mark the end of a cohesive public sphere, while engulfment by the zombie mass becomes a dramatization of its mute and deathly embrace, yet each loophole escape signals the fugitive chances of a counter public sphere, a different way of living. Romero's series, over 40 years, has become a monumental study of the structural zombification of the American public sphere.[22]

But it is important to emphasize that the series was never simply or straightforwardly 'American'. *Night of the Living Dead* took key inspiration from the Italian Ubaldo Ragona's *The Last Man on Earth*. In turn, the scenes of cannibal feeding in *Night* inspired a whole sequence of European horror films, from Amando de Ossorio's *Tombs of the Blind Dead* (1971) and its several sequels, to Jorge Grau's Spanish-Italian co-production *The Living Dead at Manchester Morgue* (1974), all of which elaborated on the zombie as the relentless and insatiable ghoul, dedicated solely to eating the flesh of the living. Grau's film, which improbably unleashed a horde of living-dead Italian character actors in the streets of Manchester and the Lake District (although the actual locations were Sheffield and the Peak District), used vivid Technicolor to pause lovingly on the entrails and dismembered limbs of their victims. There is a persuasive argument that both Ossorio and Grau saw the allegorical potential of Romero's revision of the zombie and used it as a commentary on the 'living dead' Fascist dictator of Spain, General Franco, then living out his final deathly years in power.[23] Certainly, Grau staged a generational conflict between the hippy male hero George and the repressive police sergeant who guns him down with evident relish, proclaiming 'I wish the dead *could* come back to life, you bastard, because then I could kill you again.' Having sounded off about the permissive society and all these long-haired dead dudes, Sergeant McCormick is duly revisited by George's reanimated corpse and polished off. The revolutionary spirit will come back and bite you.

In turn, these films directly influenced the look and explicit gore of Romero's *Dawn of the Dead*, which was released first in Italy as *Zombi* in 1979. As an immensely successful *Italian* film, *Dawn* became the start of a cycle of films in Italy that are among the most notorious films ever made.

Zombie Apocalypses and Cannibal Holocausts: The Italian Recipe

Horror film production in Italy is one example of what is called *filone* filmmaking. A major cinematic success produced a 'stream' of remakes, imitations, off-shoots and unofficial sequels.[24] These were made cheaply and often pre-sold for distribution, making modest profits before films even went into production (hence the studios being rather uninterested in the quality of the finished films, which were hacked up and re-edited for different tastes and the censorship schemes of different national markets). Horror boomed with the *giallo*, the precursor of the serial killer/slasher film, after Mario Bava's bravura shocker, *Blood and Black Lace* (1964), and cresting with Dario Argento's delirious and perverse wonders that started with *The Bird with the Crystal Plumage* (1969) and its many follow-ups. Argento reached the heights of Grand Guignol and stylized super-natural horror with *Deep Red* (*Profondo Rosso*, 1975) and *Suspiria* (1977). Often gloriously uninterested in narrative or logic, these films cross unblinking gore with art-house Surrealism, moving from one spectacularly staged death to another.

These achievements were always surrounded by a vast swirl of opportunistic, gratuitous and unoriginal knock-offs. Nevertheless, in England and America, where film censorship was tighter, the whole genre was given the patina of transgressive promise, fans desperate to see clandestine 'uncut' versions. These became briefly available in the early 1980s with the arrival of video distribution, which was initially left outside the purview of the British Board of Film Censorship, but the 'video nasty' panic of 1984, which focused overwhelmingly on these Italian horror films, ended this access, legally at least, under the Video Recordings Act of 1984. As always,

censorship only rarefied the value of the worthless product they withheld. Perhaps recognizing this paradoxical effect, the films were quietly returned to distribution, almost entirely uncensored, with DVD releases in the 1990s. 'Previously Banned!', the covers now plaintively say, surfing on nostalgia.

The large profits associated with *Zombi/Dawn of the Dead* destined its Italian co-producers and their rivals to foster a cluster of immediate zombie sequels and imitations. Lucio Fulci's *Zombi 2* (1979, released in England as *Zombie Flesh Eaters*) proved massively successful too, and resulted in Fulci's return for the diminishing returns (in every sense) of *Zombi 3* (1987). This disaster was probably topped by Claudio Fragasso's *Zombi 4: After Death* (1989). But Romero's revisioning of the zombie as a cannibal meant that the zombie film fused with another Italian *filone*, of horror films set in distant jungles where all tribes are deemed savage and bent on devouring their white explorers. There were many films that followed in the wake of Umberto Lenzi's *Deep River Savages* (1972), culminating in the controversy surrounding Ruggero Deodato's notorious *Cannibal Holocaust* (1980), which was banned for three years in Italy while it was investigated whether the director had actually murdered his actors. This Italian conjuncture reconstituted the historic link in colonial fantasy between the cannibal and the zombie, just as Romero was redirecting the zombie trope elsewhere, so we need to see these genres in tandem.

In *Zombi 2*, or *Zombie Flesh Eaters*, the journalist Peter West accompanies a woman to the Antilles, where she is searching for her missing father. His boat has arrived empty and abandoned in the river off Staten Island in New York, pitching up like the mysterious *Demeter* in *Dracula*, and with its own bloated undead creature on board who slips into the waters, having bitten a coastguard. Peter and Anne eventually arrive on the uncharted island of Matul, the home of white-suited Dr Menard (shades of H. G. Wells's *The Island of Dr Moreau*), where either a strange plague is killing off the last of the whites and the villagers, or else Voodoo magic is reviving the recently deceased who are compelled, in their relentless shuffling way, to take large chunks of flesh out of the nearest living human

being. These zombies are no longer trained for labour in the fields, and the film has no interest in portraying the *bokor* witch-doctors that might have commanded them – no interest, indeed, in any local culture at all. The zombies shuffle purposelessly through the ruined and abandoned village, abstracted figures of failed post-colonial development. To stay their advance, gruesome damage to the head is very necessary and carefully depicted: bullets to the body do nothing. The plague escalates. The zombies feast lovingly on gushing jugulars and opened torsos, depicted by special effects ace Giannetto De Rossi. The survivors stagger through a jungle only to find themselves in the midst of an old cemetery of the irritated corpses of Spanish conquistadors dragging themselves from the earth after 400 years. The survivors retreat to the last redoubt but are soon depleted and overrun. Peter and Anne finally escape on a boat, only to hear on the radio that the dead are returning to life in New York. The film ends with a famous image of a vast horde of the dead processing across the Brooklyn Bridge towards Manhattan, with the World Trade Center and the end of advanced civilization looming in the background.

The plot is unusually coherent for the director and the genre. Fulci went on to complete an informal 'zombie' trilogy with *City of the Living Dead* (1980) and *The Beyond* (1981). *The Beyond* in particular is a memorably deranged accumulation of brutal set-piece deaths, built around a vaguely Lovecraftian idea of one of the Gates of Hell being opened under a hotel in Louisiana, old school 'hoodoo'

Zombies return in Lucio Fulci's *Zombie Flesh Eaters* (aka *Zombi 2*, 1979).

Zombies take Manhattan, *Zombie Flesh Eaters*.

style. One set-piece involves an unnerving sequence in a hospital morgue, as autopsied bodies begin to revive. Shrugging off any criticism, Fulci said: 'my idea was to make an absolute film . . . there's no logic to it, just a succession of images.'[25] Presumably this is why *The Beyond* involves a good five minutes devoted to tarantulas biting the face off a man in a library. And another scene in which a vat of acid dissolves the head of a woman, her daughter stepping back from the froth of blood spreading across the tiled floor. These scenes clearly try to up the ante on Romero's injunction not to look away. It is no wonder Fulci (following Argento) is so obsessed with portraying damage to the eye. The most notorious moment in *Zombie Flesh Eaters* – the one that got the film listed as a banned 'video nasty' – is the death of Mrs Menard, skewered through the eye on a splint of wood, shown in unflinching detail in a crazed homage to the razor and eyeball in Salvador Dalí and Luis Buñuel's Surrealist film *Un chien andalou* (1929). You will see so much, the scene seems to say, that what you see will blind you.

Deodato's *Cannibal Holocaust* is even more graphic than this, although formally quite accomplished and artfully designed. The film is a nasty trick in trying to persuade the viewer they are watching 'actual' atrocity footage, a sleight of hand many Italian lawyers and judges fell for (it turns out that legal training does not cover simple techniques of montage). The film grows out of the so-called 'Mondo' genre, named after the Italian pseudo-documentary *Mondo*

Bad news in the morgue: *The Beyond* (1981).

Cane (1962), which purports to be exotic travelogue footage of shocking cultural customs and lots of gratuitous nudity from around the world. Many films followed in the same mode, echoing the American tradition we've already explored in relation to Voodoo films in the 1920s and '30s. In *Cannibal Holocaust,* an anthropology professor is persuaded by a New York TV company to retrace the steps of a film crew of four whites who vanished after going into the heart of the Amazon in search of the elusive cannibal tribe the Yanomamo. Professor Monroe eventually finds the eviscerated and ritually displayed remains of the crew, decorated with film canisters. What is in the canisters, which we see as raw and unedited footage continually interrupted by revolted viewers in a New York viewing room, is a shocking tale of violence and degradation as the film crew desecrate, rape and pillage their way through the jungle. They are out to provoke a response that they can offer as primitive savagery, only to end up filming their own evisceration, death and devouring. As with zombie films, the footage captures heads bludgeoned, torsos opened, bodies brutalized, raped and castrated in a rhythm of increasing intensity.

Cannibal Holocaust is clearly meant as a heavy-handed satire on sensational 'Mondo' filmmaking, the rapacity of TV companies seeking

'authentic' horror, and the desire of certain viewers for 'real' snuff movies. *Cannibal Holocaust*'s bad faith problem is that it wants to offer all these sensational delights while finger-wagging at the same time. Others went on to try to outdo the gross-out levels of carnage: Umberto Lenzi's *Cannibal Ferox* (1981) is a film with an equally gruesome reputation. Very rapidly, these two genres fused together in titles like *Zombi Holocaust* or *Zombie Creeping Flesh* (both 1980) to produce a frenzy of exotic zombie cannibal excesses for several years in the 1980s, all given transgressive allure by heavy censorship or outright bans. Precisely because these remain deliberately abject and tasteless films, it has been left to fans to catalogue and document the extent of the genre.[26]

This *cinema vomitif* is of course designed to be disgusting. Disgust is an involuntary physical recoil from things that pollute or contaminate, that leak or ooze, breaching borders policed by powerful taboo. Disgust is 'precisely the emotion that is meant to guard the sanctity of the soul as well as the purity of the body'.[27] As the anthropologist Mary Douglas observed in *Purity and Danger*, some of the strongest taboos surround the recently dead, who must be transported between the rigorously divided worlds of the living and the dead through rituals that manage this fraught transition.

Back in 'cannibal' country, *Cannibal Holocaust* (1980).

Horror and disgust surge around bodies that fall out of ritual place, that are desecrated or defiled. Italian zombie cinema pushes relentlessly on these taboos, the dead biting and breaking open the skin of the living, delightedly pulling the insides out. That this must be compulsively represented is not just a matter of the economics of horror genre filmmaking; it also implies that the films do the cultural work of registering traumas around breached bodily boundaries by continually restaging them.

The problem with disgust is that it cannot sustain an aesthetics. Long ago, the philosopher Immanuel Kant argued that 'disgusting objects present themselves to the imagination with an inescapable immediacy that prevents the conversion of the disgusting into something discernably artistic and aesthetically valuable.'[28] What this means is that films exploring the abject find it difficult to be anything but abjected themselves – as happened with the 'video nasty' moral panic. Whatever the varied ambitions of these films, Italian horror made the zombie an emblem of wallowing in the disgusting and the tabooed. They became the nadir of mass cultural ooze, zombies that zombified their corrupted audiences: the zombie squared.

There are always defences for this phase of zombie culture. What Jeffrey Sconce has called the 'paracinema', which delights in an existence beyond the safe bounds of bourgeois taste, is still, after all, cinema, and always open to cultural reading.[29] Others have argued that Eurotrash genres like Italian horror – films so bad they become avant-garde critiques of cinema itself – can create a Brechtian 'vulgar modernism' or pulse with 'trash vitality' that get their kick exactly by refusing the boundaries of good taste and proportion in art.[30] For Patricia MacCormack, there is a radical liberation in the 'ecstatic excess beyond the need for narrative or comprehensible pleasure' in these films, which opens up a 'cinesexuality' far beyond standard accounts of trauma or loss, because the pleasure is located precisely in the undoing of bounded bodies.[31] Ian Olney is unambiguous in regarding films like *Cannibal Holocaust* and Margheriti's *Cannibal Apocalypse* (1980) as progressive political critiques. In Olney's view, the films restore the colonial contexts of the cannibal and the zombie, lost in the translation to America.

They use Caribbean, Amazonian or Pacific settings to launch searing attacks on American neo-imperialism after 1945. Where American zombie cinema has disavowed this origin, Olney argues that in Italian horror 'the black zombie becomes the perfect embodiment of all that is repressed in the colonialist scenario.'[32]

I would be more persuaded by this if *Cannibal Holocaust* didn't clearly rely uncritically on the deeply contested sociobiological anthropology of Napoleon Chagnon, who used his fieldwork with the Yanomami (the 'Fierce People') in the Amazon to argue for an inherent, genetically encoded tendency to violence in *Homo sapiens* in best-selling books and ethnographic films throughout the 1970s. The critique of the white imposition of savagery is utterly compromised by the exploitation of myths of lost tribes and cannibals. The film remains thoroughly invested in the Chagnon position on innate violence. On indigenous cultures, Deodato and Fulci are a long way from being 'progressive'.

Where the cannibal/zombie films remain of symptomatic interest is in their exorbitant nihilism, an embrace of violent transgression of all human value surely born of the catastrophic crisis of the Italian state in the 1970s, when the republic's democratic institutions were being violently assailed and resisted by terrorist actions from across the political spectrum, from the Red Army Brigade to anarchists and neo-Fascists, including the kidnap and murder of the political leader Aldo Moro in 1978. In the final scene of Fulci's *The Beyond*, the last two survivors of the attacks by various forms of the undead discover that they have pushed beyond the tissue-thin walls of everyday reality and found the hellish, blasted wasteland that lies beyond. It is a vision of the psychotic Real, the complete breakdown of all symbolization. This is an extraordinary metaphysical moment, an instant of *vastation*, that culminating glimpse of a wholly other order of things which results in a 'laying waste to a land or psyche', that reveals that the 'malignant system of the world . . . is tearing you apart.'[33] Eugene Thacker has described modern horror as an attempt to think 'the enigmatic thought of the unknown', beyond all necessarily limiting human categories of thought, where humanity is utterly dethroned on a planet teeming with other agencies.[34]

The Italian zombie backs us into a corner in the last redoubt, with little or no hope of escape, but these films are at their most frightening when the crowd pushes us through the flimsy walls and out the other side, to see not just social apocalypse but the very end of meaning itself.

Romero's zombie cinema established the template for the zombie apocalypse; his Italian imitators dragged it into the margins and wallowed in its annihilating gore. For a time, the zombie looked consigned to rot away unquietly in this state of abject extremity. Yet the zombie was retooled again in the 1990s and blasted out of the margins and into the cultural mainstream in an extraordinarily pervasive way, making it an iconic figure around the world *as* a figure of the condition of the world. Let's now turn to this global apotheosis of the zombie.

8

Going Global

In the last fifteen years, the zombie has reached saturation point. Zombies emerged from the lowest forms of mass culture in pulps, comics and exploitation films but, like the viral catastrophe it so often imagines, they have entered the global bloodstream to become an instantly recognized metaphor around the world. Indeed, the zombie apocalypse is precisely one of the privileged ways of imagining our interconnected global condition. This late in modernity, in what sociologists call the risk society, where 'the state of emergency threatens to become the normal state', the zombie has become a paradigmatic allegorical mode for imagining the multiple disasters that threaten human society and the planet.[1]

Crucial to this change in the last twenty years has been a shift in the locus of experience and identification of zombie culture. In the proliferating zombie video games that emerged in the 1990s from a cultural sector that is now economically larger than cinema, the player is immersed inside the zombie apocalypse, becoming a wired-up and networked participant in the catastrophe, although as a result the relation to the undead significantly shifts. That change is registered in the phenomenon of zombie parades or walks, which first began in 2001 in Sacramento but have since become a global ritual in cities across the world (48 cities took part on World Zombie Day in 2008). No one participates in a zombie walk as a survivor – that would be boring. Instead, much care is taken in assuming the identity of the previously abjected other, the undead. Why this shift of focus? Is this a reflection of the medical and biological revolutions

The World Record for the largest number of people dancing simultaneously
to Michael Jackson's 'Thriller', Mexico City, 2009.

Mapping catastrophe: infection spreads out from Tokyo, *Resident Evil: Afterlife* (2010).

that have steadily redefined death? Or is it a process of routinizing the zombie, of domesticating it, as suggested by the stream of TV dramas and even children's fictions that explore not the catastrophe itself but the return to a new kind of normal in the wake of a zombie catastrophe? Perhaps this still depends on where you are located in relation to the profound unevenness and inequities of the processes of globalization. In places of poverty, border insecurity and violence, the old anthropology of the *zombi* is still very much alive, dead and kicking.

Video Games: Survival Horror

In 1996, the Japanese computer game designer Shinji Mikami helped design a quest game for consoles set in a haunted mansion and loosely based on the Japanese horror film (and subsequent game) *Sweet Home* (1989). It was called *Biohazard*, and one key inspiration was Romero's zombie films. 'I saw [*Dawn of the Dead*] as a junior high school student', Mikami said. 'It made me dream about living in a realistic world in which zombies appeared.'[2] The dark doings of the military-industrial Umbrella Corporation and their development of the biological warfare T-Virus, which breaks out in their secret laboratories, was also influenced by the plot of Romero's *The Crazies*. At a late stage, Capcom decided to release the game outside

Alice as medical test subject, *Resident Evil* (2002).

Japan under the name *Resident Evil*. The strapline for the game was 'Welcome to the World of Survival Horror.'

Along with *Alone in the Dark,* which appeared a little earlier in 1992, *Resident Evil* invented a new genre of horror game which then fed back into the cinema and fostered a new wave of zombie apocalypse films, completing the feedback loop by reinforcing the success of a film like *28 Days Later* (2002) and ensuring the remake of *Dawn of the Dead* (2004) by Zack Snyder. *Resident Evil* made the idea of anxious strategizing to survive a global zombie 'outbreak' a narrative with global range. It also largely abandoned supernatural explanations or Voodoo magic for an entirely medicalized explanation of the zombie horror. Zombification becomes a matter of viral contagion – a product of the interconnectedness of the modern world itself, rather than the ancient, primordial return more typical of the Gothic imagination.

Since 1996, there have been over twenty *Resident Evil* games in the franchise, including a remake of the original with more processing power in 2002 and a re-remake in 2015. In 2004, *Resident Evil: Outbreak* moved the game online for the first time, so that players could encounter each other's avatars. This new communality, breaking the isolation of the lone console player, multiplied the risks with all manner of new threats, the technology again reinforcing the sense of the fragility and danger of interconnection. Players could

cooperate but the more common route, as predicted in Romero's films, was either to act humanly, like an asshole, or more interestingly, like a zombie. Shortly afterwards, the game *Stubbs the Zombie* (2005) reversed the usual play and made the player a zombie intent on eating human brains and exacting revenge on a whole town built over your grave. Computer games were evidently shifting the axis of identification within the zombie plot in major ways. Mikami returned to design *Resident Evil 4* (2005), which more obviously fused with action and shooter games, with greater player agency motored by greater fire power, making some question the survival of 'survival horror' as a meaningful category.[3] Romero's *Dawn of the Dead* directly inspired the game *Dead Rising* (2006), with zombies roaming through an elaborate shopping mall environment, and another major zombie outbreak narrative, *Left 4 Dead* (2007 and 2009), which zombifies populations after an outbreak of 'Green Flu'.

There are currently six delirious and thunderously stupid *Resident Evil* movies (starting in 2002), starring the supermodel Milla Jovovich as the increasingly post-human, technologically augmented, living-dead heroine, Alice. The plots are openly structured to work through game levels, even using computer models of the buildings to orient the viewer between levels of action. The bullets are limitless and the slaughter of infected zombies and other T-Virus mutant

Trapped by biopolitical machines, *Resident Evil* (2002).

creatures relentless. There is little interest shown for these CGI zombie hordes, except as fodder for the spectacle of mass slaughter.

Holding off zombies is now a multi-billion-dollar, multi-platform industry. The zombie offers transmedial synergies for global entertainment corporations. Again, plots of global zombie infection by faceless corporations uncannily echo the staged 'release' of games across global trading zones by media megaliths like Capcom. *Resident Evil* is now a cluster of texts that can open the question of what it really means for the figure of the zombie to end up going global.

When the zombie moves from cinema to computer screen, this is not a straightforward shift from the masochistic passivity of merely watching horror on film to a new kind of agency, where the gamer is in control. Survival horror was initially about locating the avatar of the player in an extremely anxious situation with scarcely any weapons or defences, in a space seen from a fixed, high angle that emphasized vulnerability, with doorways and voids invoking dread and zombies groaning and shuffling towards you unless you learned to avoid them. 'Be smart!' the instructions said. 'Fighting foes is not the only way to survive this horror.' As a completely useless player, I can vividly recall being repeatedly bitten to death in the very first corridors off the lobby of the mansion as I panicked and failed to master the controls at the first sight of the shambling undead.

In a deliberate subversion of action driven, first-person shoot-'em-ups, the first *Resident Evil* taught you about scarcity, evasion and restraint. Strong on spooky atmospheres, there were long stretches of investigation of spaces and rooms before you hit upon the right clues to advance to the next room (or, in my case, before you got bitten to death and had to start again). Tanya Krzywinska has argued persuasively that the survival horror genre of gaming exploited the technological limitations of memory power to operate on an axis between limited agency and predetermined trajectories, these moments of loss of control, or 'cut-scenes', where the plot is advanced in mini-film animations, only underscoring feelings of inevitability, dread and anxiety.[4]

Some have suggested that this different kind of agency comes from a distinctively Japanese ethos of the first designers. Japanese

horror does derive some of its power from the complex Shinto system of the debts and obligations between the living and the dead. Those vengeful ghosts in post-war Japanese film, from *Ugetsu* (dir. Kenji Mizoguchi, 1953) to *Ring* (dir. Hideo Nakata, 1998), are the wronged and dishonoured dead that seek recompense. But the zombie does not fit into this supernatural ethos and there is no native 'zombie' tradition in Japan; it was imported only after Romero's revision of the figure.[5] Perhaps in Japan the game initially echoed the 1995 sarin nerve gas attack on the Tokyo subway, subtended by a deep-seated fear of the radiation effects of the 1945 atomic bombs, but the terror of germ warfare attacks is shared across the globe. *Resident Evil* and the games like it are cultural hybrids, carefully calibrated to appeal to different traditions.

The oddest effect of the translation to gameplay is the readjustment of the zombie rules. In early *Resident Evil* games zombies required several pistol shots to be put down, and shots to the body were fine (largely because there was no way to aim precisely at the head). There is no specificity to the zombie in this gameplay: they are merely obstructive pixels – problems to be solved – that could just as well have been rendered as demons, or aliens, or Nazis. The fact that they are already dead means zombies can solve the occasional moral panic about the 'zombifying' effect of video games on the world's youth. *Carmageddon* (1997) was a game that involved running over pedestrians for points, and was initially refused a certificate by the British Board of Film Censorship. The censors relented when the pedestrians were changed to zombies. At a stroke, a reprehensible act became a responsible, even hygienic gesture. This trick, however, did not stop an American judge from excepting games such as *Resident Evil* from First Amendment protection since the games had no 'free speech' or conceptual content worthy of defence. Contempt for survival horror put it outside the domain of deliberative democracy – a continuation of the tendency to damn zombies to the outer darkness, beyond the bounds of mainstream cultural taste.[6]

If zombies are almost entirely detached from their history in these games, the biggest change is to the rules of infection of the usually human protagonists. In the post-Romero zombie film, a

single bite is fatal, leaving human life extremely vulnerable to accidental (un)death, to cruel and arbitrary fates. In the 'procedural adaptation' of zombies from cinema to game, this rule is necessarily transformed.[7] A player can sustain a bite or two and neutralize their effects with health packs picked up along the way. Only repeated bites, their effect sometimes measured on an on-screen health monitor, result in death. Even so, this death lasts only as long as the game takes to restart from the last save point. This makes the avatar of the player effectively a zombie, subject to repeated deaths and revivals, even as they learn to navigate and 'survive' each level. An irreversible economy of absolute death is replaced by a fluctuating rhythm of hundreds of little deaths. This change, I suspect, has had much to do with opening the way towards new kinds of identification with the zombie. Little by little, the binary opposition of self and other has bled out.

In the computer game, the framing narrative tends to be advanced in cut scenes, preset blocks of cinematic exposition with reduced interactive possibilities. The experience of survival horror gaming is separated from this diegesis and is largely about navigating maze-like environments, evading or confronting zombie-pixels and problem-solving. The frame narratives are rudimentary, built from elements that provide immediate genre recognition: a shadowy corporation, a rogue soldier/cop/spy, a secret military-industrial facility, an experiment gone wrong, an outbreak, a survival mission that twists and turns. The film versions of *Resident Evil* frequently suspend narrative to engage in spectacular shoot-outs, but narrative drive and elaboration remain important to them. Indeed, narratives of zombie apocalypse like *Resident Evil* can help us explore how the zombie figure has been medicalized in the recent apocalyptic imagination.

Medicalization I: The New Dead

The release of George Romero's *Night of the Living Dead* in 1968 and the revision of the zombie proved influential for another reason we have not yet examined. It coincided with the emergence of a

significant medical transformation of the boundary between life and death. In 1968, the medical definition of death was changed by a small group of doctors that came together in a group called the Ad Hoc Committee of the Harvard Medical School. This working group was prompted by medical advances that effectively invented new beings inside a brand new technological assemblage, which was called the Intensive Care Unit.

At the core of this newfangled ICU – which brought together a lot of disparate specialisms for the first time – was a new generation of artificial respirators. 'Iron lungs' had been developed amid outbreaks of the poliomyelitis virus in the 1920s as machines to keep paralysed lungs breathing. These were replaced by more efficient devices in the 1950s. Survival rates improved, but in doing so created a novel problem. The success of the mechanical respirator meant that the cardio-pulmonary system could be sustained separately from brain function. There were now patients with a complete absence of cortical activity – who were 'brain dead' – but who continued to live on within the biotechnical apparatus of the ICU. These paradoxical 'living cadavers', as they were first called, were interstitial beings of a new liminal world. They mark a cybernetic disarticulation of the human body into separate systems that can be managed and sustained independently of each other as long as they are plugged into a machine. Other names for these new beings included BHCs (beating heart cadavers), 'potential cadavers' and 'neomorts'.

In 1968, the Ad Hoc Committee wanted to address the 'obsolete criteria for the definition of death' in this new situation.[8] This was because legal discourse still defined death as the cessation of the heartbeat, a fixed and incontrovertible moment in the eyes of the law. It left many doctors risking prosecution for wrongful death if they elected to switch life-support machines off, a decision that in 1968 had very few formalized criteria and was largely determined by individuals in local situations. This was becoming urgent, too, because advances in human transplant surgery were making the living cadaver an object of intense interest as a potential source of organs. Christiaan Barnard had performed the first heart transplant the year before, and early attempts at kidney transplants between identical twins

had been made only a few years earlier. In the late 1960s, however, a doctor in Virginia who performed the first heart transplant in the state was prosecuted for the wrongful killing of a patient by the removal of their heart.[9]

As a solution to this crisis, the Ad Hoc Committee set out to relocate death from the heart to the brain and established the criteria for determining what they called 'irreversible coma'. This was marked by a complete absence of responsiveness in both autonomic systems and the higher neocortex. Yet while the recommendations of the report were hugely influential on medical practice in the next decade, there remained problems of definition. If the patient met the criteria for unresponsiveness, brain death could be declared, the respirators turned off and biological death allowed to follow. Or not, as it sometimes turned out. The creation of this interval between brain death and biological death shifted death from a decisive moment to an ongoing process. In the dilation of this space between deaths, not only were a thousand bioethical issues to bloom but a new panoply of liminal creatures were to be born, including the zombie. No wonder you have to shoot these post-'68 zombies in the head to be sure they stay down.

The definition of 'irreversible coma' has proved problematic and subject to a succession of refinements and subtle gradations, further dilating this zone between deaths. One of the criteria for establishing brain death in the Ad Hoc Committee proposals was a flat EEG record. However, it transpires that the brain-dead brain can appear to be disturbingly lively on an EEG monitor, even if these signs are often ICU 'artifacts' – misleading records generated in the complex feedback loops of the bodies and machines.

In 1972, Bryan Jennett and Fred Plum coined the term 'persistent vegetative state' for states of catastrophic collapse of brain function that nevertheless preserve evidence of higher neocortical activity. 'Persistent vegetative state' shifted to 'permanent vegetative state' after twelve months, although neither diagnosis has the same legal standing as 'whole brain death', and thus is constantly caught in legal wrangles when the rights to live and die in relation to the medical care of these states are raised. Plum had also coined

the term 'locked-in syndrome' in 1966 for another liminal state in which higher cortical activity is unequivocally preserved amid the catastrophic collapse of the voluntary muscular and nervous systems. These states were considerably livelier than whole brain death, a category confirmed by a presidential commission in 1981 called *Defining Death*, which became the basis for a uniform legal definition of brain death across the United States.

These manoeuvres all took place alongside spectacular and disturbing anomalies, such as the case of Karen Ann Quinlan, the woman who slipped enigmatically into an apparently brain-dead state in 1975. In 1976, her father was successful in being granted the legal right to turn off her respirator to let biological death follow. Instead, Quinlan's breathing stabilized without mechanical assistance and she lived on, without leaving the coma, for another ten years, in a twilight state, becoming a crisis of category for bioethics.

There was another flurry of diagnostic and definitional work in the mid-1990s. In 1994, a neurology task force attempted to shade the scales between persistent and permanent vegetative states, a crucial boundary for declaring brain death. Between 1995 and 1997 an entirely new category, the 'minimally conscious state', emerged. MCS was defined by the Aspen Neurobehavioural Work-Group as a 'severely altered consciousness in which the person demonstrates minimal but definitely behavioural evidence of self or environmental awareness'.[10] This encompassed not just severe physical trauma, but many forms of late-stage dementia. Margaret Lock has termed these new medical definitions a process of 'Making up the Good-as-Dead', and polemically contends it could be read as the cultural work of demarcating ever more categories of social rather than biological death. 'In late modernity', Lock pronounces, 'the numbers of people recognized as candidates for social death have increased exponentially.'[11]

The boom in zombie narratives since 1968 has coincided with this ongoing medical transformation of the definition of death, and the undead are undoubtedly exotic figurations for these new liminal states between life and death. The trauma of being inserted into the technical ensemble of the ICU unit is one of the foundational tropes

of the modern zombie film. It is significant how many times a plot is launched from the recovery room of an abandoned ICU unit. This is how *28 Days Later* starts, Jim de-intubating himself after weeks in a coma and walking through the abandoned hospital and out into the London streets. Exactly the same scene recurs in the first post-catastrophe sequence of the TV series *The Walking Dead* (2010–), Rick Grimes waking up and repeating the same bewildered process of discovery. Meanwhile Alice, in the *Resident Evil* series, repeatedly suffers waking into post-catastrophic worlds at the start of each film. She finds that her vulnerable human body has been directly plugged into a torturous medical-corporate system which manipulates the virus that courses through her veins, which either adjusts her biology or carefully induces in her structural amnesia. Alice's entrapment is imaged through her constantly being framed by banks of medical monitoring surveillance screens of the Umbrella Corporation's ICU, or tied down on gurneys in experimental medical facilities.

Coma works narratively in the zombie apocalypse film to locate the protagonist in a position where they must learn the new dispensation at exactly the same speed as the viewer. But at a more fundamental level, do the protagonists thrive in a world of the walking dead because they themselves, as coma survivors, are already one of the many living dead, another of the liminal creatures populating this era of the New Dead?

In the *Resident Evil* films, the least interesting thing is the zombies themselves, at least compared to the bizarre post-human journey taken by the female protagonist, who is progressively less a human being with bodily integrity than a biotechnological device, genetically spliced, enhanced, intermittently controlled by satellite, with irises that now bear the corporate logo of the Umbrella Corporation, and launched as a bioweapon sometimes called 'Project Alice' into a post-contagion world. Underground secret medical facility succeeds underground secret medical facility until the third film unveils the infinite reserve of cloned Alices awaiting deployment. These are all promptly killed off in the opening minutes of the fourth film, Alice suddenly de-augmented and rehumanized again, the reboot to readjust her to human sympathies and identification.

The *Resident Evil* franchise is a conflicted series, at once plaintive about the depredations of the human body and basically revelling in these post-human enhancements. Alice, after all, is little more than the spectator's enhanced first-person-shooter point-of-view, and must experience multiple deaths and revivals before learning how to get through to the next level, the next sequel.

On an individualized level, the zombie may be an emanation of the shifting boundary between life and death, but the zombie *masses*, the ravening horde, also help figure another aspect of the contemporary medical imagination: the epidemic narrative.

Medicalization II: The Outbreak Narrative

In 1989, a World Health Organization conference coined the term 'emerging infections' to name potentially catastrophic new global health threats. After the discovery of the Marburg haemorrhagic fever in the 1960s, the identification of the Ebola virus in the 1970s, HIV in the 1980s and the global panic around the SARS coronavirus in 2003, public health has been anticipating and planning for a lethal pandemic for decades. Fatal mutations in the influenza virus, a threat temporarily held off by antibiotics, can only last so long before a lethal pandemic recurs. It is perhaps the classic disaster scenario for reflexive modernity – that is, a risk that is created and amplified by modernity itself, by the interconnectedness of global transport and communication networks. 'A permanent modern scenario: apocalypse looms ... and it doesn't occur. And it still looms', Susan Sontag said in her reflections on AIDS *and its Metaphors*. 'We seem to be in the throes of one of the modern kinds of apocalypse.' Not *Apocalypse Now* but *Apocalypse from Now On.*[12]

In the eighteenth century, Enlightenment thinkers defined themselves against supernatural or theological explanations of disaster and plague, for millennia ascribed to the malign influence of unlucky stars (*dis astro* means 'unlucky star'). They sought first natural-scientific explanations for illnesses, and then social ones for their spread. 'Contagion' long referred as much to rumours and dreads as to the disease itself, and it was believed that fear and ideas could kill

as much as the mysterious agents carrying the illness. Plague and revolution were thus tightly tied together. When Heinrich Heine described the 'choleric riots' in Paris in 1831, it was unclear precisely what contamination the crowds fought against so frenziedly. What is certain is that the mob resembled the zombie horde:

> One thought the end of the world was coming . . . Woe to those who looked suspicious . . . The people rushed upon them as a wild beast . . . Nothing is more horrible than the people's anger, when the people is thirsty with blood . . . Then the black waves of a sea of men surges through the streets . . . and they howl wordlessly, like demons or the damned.[13]

Through the nineteenth century, disease increasingly became a matter of public health and the disciplinary administration of populations – what the historian and philosopher Michel Foucault called 'the rise of biopolitics'. Yet despite turning disease increasingly into administrative emergencies, outbreaks continually evolved to defy complete rational order and containment. The mutation of Spanish influenza at the end of the First World War killed an estimated 20 million people, and also hid within it an epidemic of encephalitis lethargica (or 'sleepy sickness'), which reduced hundreds of thousands of those who survived the first fever to 'the chilling appearance of a corpse' – living, yet largely comatose.[14] Since sleepy sickness affected tens of thousands of Americans in the 1920s, I sometimes wonder if this isn't one of the secret vectors that transferred the idea of the shuffling, catatonic zombie into American culture, since it was a major epidemic that was never 'cured', and left thousands in a perpetual twilight state.

The zombie really fused with the notion of the virus, though, which was first popularly understood and explained as a distinct entity in the 1950s. They remain an uncanny fit. Wendell Stanley, a pioneer Nobel Prize-winning virologist, explained that viruses were 'entities neither living nor dead, that belong to the twilight zone between the living and the non-living'.[15] Viruses are inert until they enter a host cell and take over its mechanisms, often killing the host

Computer modelling global infection, *World War Z* (2013).

in the drive to reproduce only itself. This is the medicalized notion of the viral zombie outbreak in a nutshell.

The tie of viral epidemics to the history of the zombie was consolidated in the early years of the HIV crisis, when a high preponderance was noted in the immigrant Haitian population in New York and it was called 'an epidemic Haitian virus'.[16] Under the headline 'Night of the Living Dead', the *Journal of the American Medical Association* speculated, entirely fantastically, that HIV was spread by Voodoo rituals using human blood. This simply rehearsed the age-old tactic of marking the migrant and foreigner as fatal disease invader, the demonized carrier, but the modernity of 'emergent infections' in particular resides in how they always trace out colonial and post-colonial pathways.

Modelling epidemiological catastrophe is intrinsically bound up with fantasy. It seems improbable that the Office of Public Health Preparedness and Response of the American Center for Disease Control and Prevention released a 'Zombie Apocalypse Preparedness' pack, including posters for schools, to educate the population on basic measures that would help contain an epidemic outbreak. Yet zombie pulp fictions, films and video games have long been imagining this outbreak narrative. The paradigmatic scene for the zombie pandemic is a computer map of the globe charting the exponential spread of the disease. In *World War Z* (2013) a global map hangs above the command centre, slowly turning red with infection, a counter clicking through the billions killed with exponential spread.

The opening of *Resident Evil: Afterlife* (dir. Paul W. S. Anderson, 2010) zooms out from a single bite on a street crossing in Tokyo, pulling back to see the lights of the city, then the island, and then progressively the globe, go deathly dark. The failure to contain new viral strains within the security protocols of medical facilities is central to the premise of the *Resident Evil* franchise and the 'Rage' virus of *28 Days* and *28 Weeks Later*. The HQ of the CDC in Atlanta is the destination of the ragged band of survivors in the first series of *The Walking Dead*, an empty hope for a solution or cure, it transpires. In zombie-virus fictions like M. R. Carey's novel *The Girl with All the Gifts* (2014), medical researchers end up the allies of viral transmission, placed in the long Gothic tradition of mad scientists.

In turn, epidemiologists have long used the notion of the 'Andromeda strain' for newly emergent pathogens, taking the name from Michael Crichton's novel and film about an extraterrestrial virus that wipes out a small town and then an advanced medical facility. The medical outbreak narrative fantasizes primitive and savage origins, such as Haiti or Africa for AIDS or the jungles of West Africa for Ebola – just as zombie fictions always have. The sheer nastiness of haemorrhagic fevers like Ebola create what Priscilla Wald calls 'an epidemiological horror story' that looks a lot like *The Invasion of the Body Snatchers*.[17] The popular science books that came out after 'emerging infections' were identified as a major global threat had titles like Laurie Garrett's *The Coming Plague*, and in Richard Preston's *The Hot Zone* Ebola is explicitly described as turning the infected person into a 'zombie' or 'a living virus bomb'.[18] As we learned from the outbreak of Ebola in 2014, the virus lives on in the dead body, making the corpse one of the most dangerous sources of infection. Those screened at airports returning from West Africa to Britain and America were asked if they had attended funerals, as a way of alerting authorities to the insidious reach of the lively dead.

'Apocalypse' has come to mean complete catastrophe, but it has also always meant, in the biblical tradition, a revelation, an unveiling of a tremendous Final Truth. Millennialists waiting for the Rapture to signal the beginning of the End Times read emerging infections

as portents and signs, just as plagues have always been interpreted. Meanwhile, the 'Preppers', a movement dedicated to preparing for the apocalyptic end of society by developing a survivalist skillset, with self-sufficiency farming techniques and a big arsenal of weapons, can either watch zombie movies or read leaflets from the CDC.

What the zombie outbreak narrative really reveals – as do all epidemics – is the shape of our networks and risky attachments, our sense of an incredibly fragile global ecology. Frank Kermode long ago suggested that disaster narratives served 'our deep need for intelligible Ends' while we were stuck in the confusing midst of things: 'We project ourselves . . . past the End, so as to see the structure whole, a thing we can't do from our own spot of time in the middle.'[19] Medicalized, viral zombie hordes offer us a figure of a properly globalized interconnection.

Figuring Globalization

We read over and over again that the zombie apocalypse is an allegory of neo-liberal globalization, accelerating after the new geopolitical dispensation since 1989, after the end of the Cold War. Perhaps the zombie is less *allegoresis* – a writing otherwise – than a literalization of the capitalist logic of the expropriation of dead labour from living bodies. 'Biopower', the extension of the system's invasive control into bodies and the processes of life (and death) itself, marks a new stage of capitalist development. The zombie hordes are the living-dead proletariat, dying as guest workers on construction sites or in heavy industry or garment factories around the world in their hundreds of thousands. Romero's *Land of the Dead* is not horror but a peculiar new form of social realism. This new empire of capital comes with a 'necropolitics' that Achille Mbembe regards as a renewal of the social death of slavery in neocolonial form.[20]

After the banking crisis of 2008 the system has continued to operate, even after its apparent death throes, further perfecting the analogy. 'Neoliberalism now shambles on as a zombie', Mark Fisher comments, 'but it is sometimes harder to kill a zombie than a living person.'[21] *Zombie Capitalism*, a study of the banking crisis, was one of

the last books written by Marxist theorist and agitator Chris Harman, in which he tries to account for this perplexingly lively afterlife.

It has been suggested that science fiction, fantasy and horror are able to capture these aspects of the 'world storm' because they are 'planetary fictions', uniquely aware of the imbrication of story and world in a way that more domesticated realism cannot begin to grasp.[22] Critics have coined the term 'globalgothic' for cultural fictions around the world that share the same conditions but embody them very differently in local superstitions and supernatural conventions. 'In its ghostly form, capital moves outside of what we might have considered a real world. Its disembodied and spectral presence signals something other than an invisible hand conferring or withholding wealth. The new monster operates autonomously, in an inhuman way.'[23] The medicalization of the zombie outbreak narrative already maps the space of flows in this new kind of informational capitalism, because it points up the permanent condition of teetering on epidemiological catastrophe that modern risk society experiences. The big pharma companies, too, are among the largest and most rapacious multinational corporations, seeking profits from patenting the medicines that hold off the emerging infections that course through the channels of the global body.

World War Z, Max Brooks's novel from 2006, which became an overblown $190 million film in 2013, ought to be the logical outcome of this new kind of globalgothic imagination, because the story self-consciously sets out to encompass the globe within an all-encompassing narrative, stretching from Antarctica to the frozen north of Canada. The novel is meant to be a patchwork of eye-witness accounts from across the world, put together by a United Nations representative in the aftermath of the war, a testimony to a threat from the 'Z Germ' now contained after a long struggle away from a near-extinction event. It puts Patient Zero in the depths of China (where SARS was thought to have emerged), and charts its spread through legal and illegal networks of trafficking around the world, to Brazil and South Africa, before going global. There is a satirical edge to this science-fictional future plague, which offers some neat inversions (for instance, a desperate flotilla of boat people

The Arab zombie horde, *World War Z* (2013).

head out from Florida for Cuba, reversing decades of traffic). It also gestures at contempt for the enclaves of the ultra-rich, whose defences are – as always – inevitably overrun. Ultimately, though, the book has a very narrow Western perspective, reinforcing the American way, but only once its liberalism has been toughened up with some brutal 'hard truths' learned from Israeli and South African hardliners, which are passed off as simply inevitable if the human race is to survive. The Israeli interviewee in the novel explains: 'I happened to be born into a group of people who live in constant fear of extinction. It's part of our identity.'²⁴ This is why the state of Israel holds out longer than anyone else, behind the wall it has long actually been constructing. The white Afrikaaner, who offers another extreme solution based on past policies of apartheid, is also given considerable focus. Humanity survives only once it begins to adopt these tactics, led by the American President after his commanding speech at the United Nations. As is common to the American apocalyptic imagination, the disaster proves a hygienic reboot for a nation that has forgotten its Puritan foundations.

The film is considerably more objectionable, as Brad Pitt, the white hero who discards black, Asian and Hispanic sidekicks with alarming regularity, sets about saving the world through dumb luck (it is never entirely clear why the World Health Organization so cherishes his particular skillset). The abiding memory of the film is the image of the last safe haven on Earth, Jewish Jerusalem, overrun by the frenzied zombie Arab hordes that pour over the wall in their

Defending Israel, *World War Z* (2013).

CGI millions and tear through the city. I suppose some might read this as the liberating 'multitude', the new kind of resistance that is incubated by the logic of globalization itself, a swarm of post-human subjects.[25] To me, it reeks of racial demonization, in accord with an underpinning violent colonial history. In another set piece, the infection breaks out on an aircraft, inevitably starting way back in the economy seats and spreading fast towards First Class. It is a potent communication of the danger of proximity with the diseased poor. Later, Brad Pitt's character learns that the zombies will simply ignore the sick, by injecting himself with a nasty bug in a medical facility in Cardiff. It is another striking image of how the super-rich West might inoculate themselves against the ravening global poor, learning to coexist with them by simply becoming invisible to their toxic touch. The sequence in the medical facility includes a provocative image of a caged lone black woman zombie snapping at the glass. She is being used as an experimental test subject. The image of the woman is reminiscent of the photograph that Zora Neale Hurston took 80 years earlier of the 'real' zombie, Felicia Felix-Mentor, and suggests that the colonial fantasy that rendered that abjected woman a zombie still operates in Hollywood's slick global commodities. It seems highly significant that in October 2014, the image of this caged black woman was doctored and used to spread a hoax news story that Ebola victims were rising from the grave.

The English Ford brothers have filmed *The Dead* (2010), shot in Burkina Faso, and *The Dead 2* (2013) in India, in a conscious attempt

Return of the black zombie, *World War Z* (2013).

to globalize at least the film production of the zombie trope. The films prove rather uninterested in inflecting the narrative to local contexts, however, merely colouring a familiar outbreak narrative from a hundred other films with a bit of exotic local colour. There is a gesture towards local religious conceptions of reincarnation in *The Dead 2* but it does not help reconceive the figure of the zombie: ravening zombies inevitably pour out of Mumbai slums in another set of images abjecting the poor.

Actually, though, it is entirely possible to take a trip around contemporary world cinema to see how the zombie has been adapted into local traditions, illustrating how the multidirectional global trade in genre elements can fashion new kinds of emphasis according to particular national histories. Local horror narratives can offer rich allegorical potential to address specific contexts of national or regional trauma through reworked horror tropes.[26] In India, *Go Goa Gone* (dir. Krishna D.K. and Raj Nidimoru, 2013) was the first Hindi zombie film, where Bollywood genre expectations exerted far more influence than Romero rules. In Japan, also without a native zombie tradition, zombie films have begun to emerge after *Resident Evil*, often with local satirical intent. My favourite remains *Stacy: Attack of the Schoolgirl Zombies* (dir. Naoyuki Tomomatsu, 2001), where teenage girls suffer a brief delirium of Near Death Happiness before returning as monstrously demanding, all-devouring zombies, which are nicknamed 'Stacys'. It is a deranged account of Japan's 'Lolita complex' and schoolgirl fetish. For a truly bizarre reworking

of the zombie trope, however, little will match Takashi Miike's *The Happiness of the Katakuris* (2001), which mashes up body horror with an all-singing, all-dancing homage to *The Sound of Music*, but otherwise defies description. In Britain, filmmakers have often sought to merge with American zombie conventions, even in films like Kerry Anne Mullaney's *The Dead Outside* (2008), which was nevertheless heavily invested in using specific Scottish locations to heighten atmosphere. Yet there is also a strand of English bathetic humour in the native film industry, the joke of *Shaun of the Dead* (dir. Edgar Wright, 2004) coming from the translation of grandiloquent Romero drama to the scruffy streets and pubs of North London. If *World War Z* depicts empire at full global reach, *Shaun* is suffused with local and very English post-imperial melancholia. Quite how far the jokes in *Cockneys vs Zombies* (dir. Matthias Hoene, 2012) could travel is unclear, although there is a memorable slow-motion chase of a shuffling zombie after an elderly man with a Zimmer frame, wonderfully emblematic of a decrepit nation's translation of zombie film conventions.

In Europe, Spanish and French directors have revisited their low-budget zombie histories and reproduced the outbreak narrative in films like the *[REC]* films (four since 2007), the first based in a quarantined Madrid housing block, or *La Horde* (dir. Yannick Dahan and Benjamin Rocher, 2009), an anonymous attempt to reproduce the American zombie action model. These films did not do much to transform conventions, only to mimic them. It is a measure of cross-cultural circulation that the British *Shaun of the Dead*, already a parody, inspired the Spanish-Cuban *Juan of the Dead* (dir. Alejandro Brugués, 2011). However, the breakout success of *Les Revenants* (a French film in 2004, then a TV series starting in 2013), suggests that its subtly disturbing narrative of the dead returning to their families and lovers as brute physical presences, markers of stalled mourning or melancholic denial, can twist away from the splatter-gore aesthetic that has predominated since Romero. *Les Revenants* returns to that hesitation between the literal and the figural, the sliding around of meaning that Lafcadio Hearn first encountered in Martinique, *le pays de revenants*.

In Latin America, similarly, the zombie apocalypse has been readjusted and rescaled. The Argentinian films *Phase 7* by Nicolás Goldbart (2011) and *The Desert* by Christoph Behl (2013) are chamber pieces, exploiting the assumption that we now know what the zombie apocalypse looks like and do not need to stage it in the spectacular manner of *World War Z*, instead letting this happen off-screen to focus on the bored and frustrated survivors waiting out the catastrophe. Both use the familiar apocalyptic scenario to offer a critique from the South of the dominance of the North. *Phase 7* contains no zombies, only an outbreak crisis happening beyond the apartment block we never leave. It toys with a conspiracy theory that imagines the viral outbreak is an eventual product of George Bush Sr's New World Order speech in 1991 after the First Gulf War, seen playing on a TV set in a survivalist's den. The film slyly critiques American hegemony and the American-backed insistence on Latin America conforming to the neo-liberal policies of the International Monetary Fund and World Bank, demands that have repeatedly sent the Argentinian economy into crisis, as Sherryl Vint has suggested.[27] *The Desert* is much more oblique, set largely in one apartment with three survivors in a destructive ménage and a chained-up zombie they call 'Pythagoras'. There are sequences where they attempt to get the zombie to return their gaze, finding the Other's lack of recognition intolerable. In this quieter, philosophical rendition the threat to identity and bodily boundaries is marked in a different way: while Ana's body is covered in unexplained scars, Axel spends the film carefully tattooing flies on his skin, ending the film entirely covered in a second skin. It is an insect carapace serving as a second ego-skin that is meant to protect the human but ends up destroying it. The camera ventures beyond the boundaries of the apartment only once, but the apocalyptic consequences are perfectly conveyed by the damaged dynamics of the survivors and their one captive.

Another low-budget chamber piece, this time from Canada, also implicitly turns the zombie apocalypse trope against North American general conventions. In *Pontypool* (dir. Bruce MacDonald, 2008) the zombie virus is a linguistic illness, something that is communicated through the clichés and banalities of public speech. The film is based

on Tony Burgess's elliptical novel *Pontypool Changes Everything* (1995), which explains:

> Once infected, the victim produces the virus in the language he or she struggles with . . . The victim becomes frantic, rebelling against the onset of the disease by wilfully destroying, ahead of the virus, his or her own normative behaviour. It is a desperate attempt to escape . . . Strangers' mouths are the escape route through which the victim attempts to disappear, in a violent and bloody fashion.[28]

In the filmed version, the action is restricted to a public radio station, where the massacres unfold through news reports phoned in by reporters. The jaded talk-radio DJ must learn to reinvent language, avoid empty cliché and do active damage to the degraded currency of talk on the radio in order to arrest or cure any incipient signs of zombie aphasia. Is this a comment on the linguistic colonialism of America's encroachment into the Canadian public sphere, the export of shock-jockery? It is certainly an explicit element of this unfolding apocalypse, for the virus is only carried in the English language. The last scenes include communications and directions issued by French-speaking troops coming in to master the outbreak. This detail is clearly attuned to the local context of the French-speaking Québécois minority's demands for independence within Canada. Burgess's novel and MacDonald's film seem very sensitive to debates about conceptions of the public sphere and whether there remains a possibility of escape from the cultural hegemony of America. The critique is advanced by subverting one of its most dominant exports – the zombie apocalypse – from within.

By tracking these examples across the globe – although my discussion above is by no means exhaustive – it is possible to see how the figure of the zombie has become a planetary icon, a figure for the homogenizing tendencies of global mass culture, but also flexible enough to get embedded in local contexts, accumulating the grit of difference to resist the frictionless circulation of the same. This is not entirely a recent phenomenon: the history of the zombie

is one of continual transport, translation and transformation, since it emerged from within the nexus of the transatlantic slave trade and colonial occupation. The zombie is born in transit, in between cultures, and is thus always susceptible to rapid reworking.

If the zombie has reached a certain global extension in the twenty-first century, then this has also been a remarkably intensive phase of cultural saturation. Kids can play free zombie games on their tablet computer (*Plants vs Zombies*), or read about the awkwardness of puberty through the zombie metaphor (the young adult series of books by Charlie Higson, for example). Architects could enter designs for the Apocotecture Awards for the best zombie-proof houses, or at least until the annual competition was closed, as it was considered in poor taste. Meanwhile, art collectors went wild for Dawn Mellor's paintings of zombified celebrities, the undead portraits of Audrey Hepburn, Mia Farrow or Judy Garland. The South African photographer Pieter Hugo has also used hints of zombification in his unnerving portraits of ragpickers subsisting among toxic waste dumps.

The mainstream literary novel has now absorbed the zombie apocalypse. Colson Whitehead's *Zone One* (2011) unfolds in finely honed prose that nevertheless tells the familiar apocalyptic story of the temporary last redoubt on Manhattan being inevitably overrun by the zombie masses, however much the military teams seem to clear and master each zone. Zombification has even extended back and infected literary classics, as in the remarkable success of the mash-up novel *Pride and Prejudice and Zombies* (2009). 'It is a truth universally acknowledged that a zombie in possession of brains must be in want of more brains', it begins.[29] The joke, a simple ramming together of high and low, Austen's genteel moral discriminations with vicious survival logic, rather outstays its welcome, but now includes a full-scale mock-heritage film treatment too. And zombification has extended to a whole slew of other classics, like those of Charles Dickens (who even teamed up with The Doctor to overcome a Victorian zombie plague early in the rebooted *Doctor Who* TV series).[30]

The zombie has infiltrated avant-garde writing too. One of Stewart Home's experimental anti-novels, *Mandy, Charlie and Mary-Jane* (2013), features a fractured, post-modern lecturer in cultural

studies teaching fractured, post-modern zombie films like Lucio Fulci's *Zombie Flesh Eaters*, while working on his own Eurotrash horror script, *Zombie Sex Freaks*, and beginning to hallucinate the apocalypse around him – unless the unfolding disaster is simply the normal state of the university. 'The essence of a great genre movie is that it is as much like every other film from its category as possible', the narrator says. 'I'm determined that *Zombie Sex Freaks* will be the greatest undead movie to stalk the horror section.'[31]

If all this is too intense and the local cinema is only showing zombie films, you could go for a walk (if you can avoid any local zombie parades), or a run (but maybe not using Zombies, Run!, the running app designed by writer Naomi Alderman). Or else you could slump in front of the television, except that you might stumble across the zombie episodes in the *X Files*, *Buffy the Vampire Slayer* or *Angel*. Voodoo made a big come back in *American Horror Story: Coven*, which pitted African American Vodou against a more white, Pagan group. By 2010, zombies got their own dedicated TV shows, from the BBC's zombie serial *In the Flesh* (2013–) to AMC's massively successful serial *The Walking Dead*.

We might take *The Walking Dead* as a significant sign of the *normalization* of the zombie apocalypse, the mark of how routine this genre has become. The series was turned down by the main American broadcast channel NBC as being simply unshowable on mainstream, primetime television. In 2010, the subscription channel AMC picked up the first season. Since it is subscription-only, AMC is not bound by the same strict censorship thresholds as mainstream television is, and commissioned a show that every week outdoes Romero's once 'unrated' horror films for the gruesome dispatch of hundreds of zombies, usually through visceral head wounds. The effects are designed by Gregory Nicotero, who had worked on Romero's *Day of the Dead* 25 years earlier. The freedom to depict graphic violence has made the horror genre an integral part of the development of 'American Quality Television' since the 1990s, because it so clearly declares the difference from public channels.[32] Worldwide, *The Walking Dead* was picked up by the multinational media corporation Fox, and is shown in over 120 countries in 30

languages almost simultaneously with its first airings on American TV, making it one of the most successful – or at least pervasive – global television programmes ever made.

As previously discussed, Robert Kirkman's source comic was envisaged as an open-ended episodic tracing out of the post-apocalyptic life of the central character, Rick Grimes. 'I want *The Walking Dead* to be a chronicle of years of Rick's life. We will NEVER wonder what happens to Rick next, we will see it. *The Walking Dead* will be the zombie movie that never ends.'[33] This open-endedness makes it perfect for conversion into the serial form of television. What it also does is switch the focus from the punctual point of the outbreak and catastrophic social collapse to an unfolding condition, Susan Sontag's notion of *Apocalypse from Now On*. There is no origin story (so far) for the outbreak and Rick never defends the last redoubt, only the next redoubt, an endless, ongoing chain of temporary respites. Although the zombies consistently press at the fragile boundaries of whatever redoubt they occupy, the series often ignores them for long stretches to deal with the dynamics of family and group relationships under conditions of barely tolerable risk and danger.

The accumulated losses and weight of grief sometimes push central figures (including Rick) beyond the bounds of human society, and they act in disordered and stricken ways before they find their way back to a diminishing terrain of being human. The series often feels as though it is dealing with an abstracted condition of 'precarity', the ugly shorthand term Judith Butler has coined for the war-torn, supremely violent, uncertain and grief-stricken world which has emerged to ensnare many places in the world after 9/11 and the global 'War on Terror' that came in its wake. Woundedness and grief have become foregrounded as the social bonds that co-constitute a precarious global condition: 'I am as much constituted by those I do grieve for as by those whose deaths I disavow, whose nameless and faceless deaths form the melancholic background of my social world.'[34] Butler might as well be talking about the undead who mass beyond the gates and fences.

Rick, a small-town sheriff before the disaster, is a leader struggling with a set of traditional social and moral values, seeking to adapt them

to a condition of permanent crisis. The 'walkers' are decidedly *not* there to be identified with in this series – only to be dispatched. The vicious rival human groups they encounter – the fascistic 'Governor' and roving cannibals – do not provide many models either. The series tends to revert to deeply conservative values of Christian family and close kinship, of 'defending your own', even as it registers alarming threats against the survival of these categories. The apocalypse is unending because there is no ability to imagine alternatives. Ulrich Beck declared the notion of the conventional family one of his 'zombie categories', a modern conception that has outlived its usefulness.[35] If that is so, *The Walking Dead* merely pits one set of walking dead against another, in a Southern landscape invisibly shaped by the history of its slave plantations.

The global armies of CGI dead might be an obvious place to end this history, a remarkable journey of a rare, hybrid superstition from the Antilles arriving at complete cultural saturation across the globe in just under 100 years. But the smooth glide of this metaphor of the digital dead as the allegory of globalization feels too easy to dispatch in this way, as if a single interpretive bullet to the head would do the trick. Instead, I want to emphasize again the often highly mobile meaning and local differences in each instance of the zombie, even under the heading 'going global'. Since the zombie developed from the syncretism forced by the slave trade, it seems better to end by following this circulation of meaning back to Africa.

In the North Province of South Africa there was an upsurge in accusations of witchcraft after the collapse of the apartheid regime and free elections in 1994. The dramatic increase in punishment killings led to formal commissions of inquiry and a number of anthropological studies. In the Sotho language, the *setlotlwane* is a person killed by poison or other occult means and revived after death as a mute and docile worker sent to labour day and night. The witch works by first capturing their shadow, then slowly taking over different parts of the body until they have possessed the entire person. Their apparent death and funeral is a trick that bewitches the families and conceals the soul-theft. After 'death', the *setlotlwane* can be magically transported great distances by their masters, and

are the secret source for the accumulation of wealth by the privileged few. It is the users of witchcraft that are accused by communities devastated by structural unemployment, the HIV/AIDS epidemic and border disturbances.

This belief echoes elements of Haitian Vodou, but it also transmutes ideas from further north in Africa, ones that have been common in Cameroon (where the *ekong* are revived from apparent death and sent to work on the slopes of magical Mount Kupe) and also in Tanzania, where these beliefs were recorded by police as far back as the 1920s, and may be the folkloric trace of the slavers that traded in Cameroon a century before.[36] These beliefs run in parallel to pervasive ideas about blood-sucking creatures like vampires (called *mumaini* in Swahili) that were associated with the presence of colonial missions and hospitals in Rhodesia (now Zimbabwe) and the Congo in the 1920s and '30s.[37] Under apartheid, the authorities in South Africa had suppressed or rendered complicit the tribal systems for adjudicating accusations of witchcraft, meaning that by the end of the regime local youth organizations were administering immediate rough justice by necklacing hundreds of those who had suspicious good fortune or wealth.

The *setlotlwane* seems self-evidently the idea of the zombie imported and translated to South Africa, part of a 'diasporic flow of occult images' that are communicated through global networks but that get 'spliced into local mystical economies'.[38] The research of Jean and John Comaroff sees this recent emergence of the zombie in South Africa as a result of the profound social and economic disturbances that are the consequence of the new South Africa entering the flows of global capitalism, experiencing major structural unemployment, migration and rapid social transformation.[39] There are even part-time zombies in South Africa, those half-bewitched who wake up exhausted, not knowing that that they have been at work half the night for a secret master. Even the job of the zombie has been casualized with zero-hour contracts.

Zombie witchcraft is a way of thinking magically about the mysteries of the unequal accumulation of wealth (a process so mystical that Marx himself resorted to the language of African fetishes to

describe it). Isak Niehaus, however, an anthropologist who spent three years in the field in the same area, warns against making witchcraft an easy *index* of something else, a matter simply of allegorical interpretation. The *setlotlwane* is a real being in the local cosmology, with real social effects. They are not metaphors but 'actual exercises in constructing, rather than merely representing, social realities', he suggests.[40] It might do the cultural work of translating precarious feelings about life, health, family, community, labour, migration and borders, but that is not how such things are *experienced.*

Wherever the zombie travels, it embeds in local belief, mutating in those liminal worlds of rumour, superstition and storytelling. In doing so, it sheds the traces of its transmission, burrowing into local economies of fear and wonder. The zombie is not simply a metaphor, ultimately reducible to a single explanation. Each instance demands attention and a recognition that it would not work to condense such complex social realities if it was instantly interpretable. This is why the zombie has steadily chomped its way into a bewildering variety of practices and discourses, pushed over the fences that mark off disciplinary thought, and devoured so many brains in its relentless advance over the last century. The ambulatory dead are a moving target, an enigma that resists simple capture. If you haven't caught this bug yet, there's only one thing left to say: 'They're coming to get you, Barbara.'

References

Introduction

1 Jennifer Rutherford, *Zombies* (London, 2013), pp. 18, 23–4.
2 Victor W. Turner, *The Ritual Process* (Harmondsworth, 1974), p. 81.
3 Fred Botting, 'Zombie Death Drive: Between Gothic and Science Fiction', in *Gothic Science Fiction, 1880–2010*, ed. Sara Wasson and Emily Alder (Liverpool, 2011), p. 42.
4 David McNally, *Monsters of the Market: Zombies, Vampires and Global Capitalism* (Chicago, IL, 2012), pp. 1, 2.
5 Gerry Canavan, 'Fighting a War You've Already Lost: Zombies and *Zombis* in *Firefly/Serenity* and *Dollhouse*', *Science Fiction Film and Television*, IV/2 (2011), p. 202.
6 Slavoj Žižek, *Living in the End Times* (London, 2011), p. 334.
7 Simon Pegg, 'The Dead and the Quick', www.theguardian.com, 4 November 2008.
8 December 1953 story, reprinted in *Zombies: The Chilling Archives of the Horror Comics*, ed. C. Yoe and S. Banes (San Diego, CA, 2012), p. 11.
9 These etymological speculations (and others) are discussed in Hans-W. Ackermann and Jeanine Gauthier, 'The Ways and Nature of the Zombi', *Journal of American Folklore*, CIV (1991), pp. 466–91.
10 Joseph Roach, *Cities of the Dead: Circum-Atlantic Performance* (New York, 1996), p. xi.
11 The *poétique de la relation* is a phrase coined by Édouard Glissant in *Caribbean Discourse: Selected Essays*, trans. J. M. Dash (Charlottesville, VA, 1989).
12 Paul Gilroy, *The Black Atlantic: Modernity and Double Consciousness* (London, 1993), p. 29.

1 From *Zombi* to Zombie: Lafcadio Hearn and William Seabrook

1 Lafcadio Hearn, 'The Last of the Voudous', in *Inventing New Orleans: Writings of Lafcadio Hearn*, ed. S. Frederick Starr (New Orleans, LA, 2001), p. 77.
2 Quoted in Adam Rothman, 'Lafcadio Hearn in New Orleans and the Caribbean', *Atlantic Studies*, V/5 (2008), p. 265.
3 Quoted ibid., p. 272.
4 Lafcadio Hearn, *Martinique Sketches* [1938], in *American Writings* (New York, 2009), p. 324.
5 Ibid., p. 325.
6 Ibid., pp. 326–7.
7 Ibid., p. 327.
8 See MacEdward Leach, 'Jamaican Duppy Lore', *Journal of American Folklore*, LXXIV (1961), pp. 207–15.
9 Hearn, *Martinique Sketches*, p. 489.
10 E. B. Tylor, *Primitive Culture: Researches into the Development of Mythology, Philosophy, Religion, Art and Custom*, 2 vols (London, 1871), pp. 15, 19.
11 Tylor, 'Conclusion', *Primitive Culture*, vol. II, p. 453.
12 Hearn, *Martinique Sketches*, p. 493.
13 See Richard Hamblyn, *Tsunami: Nature and Culture* (London, 2014).
14 William Seabrook, *No Place to Hide: An Autobiography* (Philadelphia, PA, 1942), pp. 280–81.
15 Ibid., p. 341.
16 Petrine Archer-Straw, *Negrophilia: Avant-garde Paris and Black Culture in the 1920s* (London, 2000), p. 19.
17 Michel Leiris, 'Civilization' [1929], reprinted in *Brisées: Broken Branches*, trans. Lydia Davis (San Francisco, CA, 1989), p. 20.
18 Susan Zieger, 'The Case of William Seabrook: *Documents*, Haiti, and the Working Dead', *Modernism/Modernity*, XIX/4 (2013), p. 744.
19 Nancy Cunard, typed note 'Meeting Mr and Mrs Seabrook' (Autumn 1929), in Cunard archive held at the Harry Ransom Center, Austin, Texas.
20 William Seabrook, *Jungle Ways* (London, 1931), p. 122.
21 Ibid., p. 172.
22 William Seabrook, *Witchcraft: Its Power in the World Today* (London, 1941), pp. 67–8.
23 William Seabrook, *The Magic Island* [1929], reissued as *The Voodoo Island* (London, 1966), p. 18.

24 Ibid., p. 63.

25 Ibid., p. 91.

26 Ibid., p. 92.

27 Ibid., p. 93.

28 Ibid., p. 103.

29 Hans Possendorf, *Damballa Calls: A Love Story of Haiti*, trans. L. A. Hudson (London, 1936), p. 9.

30 For commentary, see David Inglis, 'The Zombie from Myth to Reality: Wade Davis, Academic Scandal and the Limits of the Real', *Scripted*, VII/2 (2010), pp. 351–69.

31 Seabrook, *The Voodoo Island*, pp. 100–101.

32 Ibid., p. 101.

33 Orlando Patterson, *Slavery and Social Death: A Comparative Study* (Cambridge, 1982), p. 51.

34 Kate Ramsey, *The Spirits and the Law: Vodou and Power in Haiti* (Chicago, IL, 2011), p. 174.

35 See Elsie Clews Parsons, *Folk-lore of the Antilles, French and English*, 3 vols (New York, 1933–43), and also J. S. Handler and K. M. Bilby, 'On the Early Use and Origin of the Term "Obeah" in Barbados and the Anglophone Caribbean', *Slavery and Abolition*, XXII/2 (2001), pp. 87–100.

36 Jean-Paul Sartre, Preface to Frantz Fanon, *The Wretched of the Earth*, trans. Constance Farrington (Harmondsworth, 1985), pp. 11–12.

37 Fanon, *The Wretched of the Earth*, pp. 43, 39.

38 Ibid., pp. 42, 73.

39 Ibid., p. 236.

40 Édouard Glissant, *Caribbean Discourse: Selected Essays*, trans. J. M. Dash (Charlottesville, VA, 1989), p. 40.

41 Ibid., p. 59.

42 Jean Rhys, *The Wide Sargasso Sea* [1966] (London, 2000), pp. 88–9.

43 Erna Brodber, *Myal* (London, 1988), p. 107.

2 Phantom Haiti

1 A full English translation by John Garrigus of the Code Noir is available online at https://directory.vancouver.wsu.edu.

2 De Saint-Méry, cited in Kate Ramsay, *The Spirits and the Law: Vodou and Power in Haiti* (Chicago, IL, 2011), p. 42.

3 See Alasdair Pettinger, 'From Vaudoux to Voodoo', *Forum for Modern Language Studies*, XL/4 (2004), pp. 415–25.

4 Spenser St John, *Hayti; or, The Black Republic* (London, 1884), p. 188.

5 Ibid., p. 202.

6 Ibid., p. 205.

7 Ibid., pp. 217, 221.

8 Stephen Bonsal, *The American Mediterranean* (London, 1913), p. 98.

9 *The Journal of Christopher Columbus*, cited in Peter Hulme, *Colonial Encounters: Europe and the Native Caribbean, 1492–1797* (London, 1986), pp. 16–17.

10 Ibid., p. 40.

11 Gananath Obeyesekere, '"British Cannibals": Contemplation of an Event in the Death and Resurrection of James Cook, Explorer', *Critical Inquiry*, XVIII (1992), p. 638.

12 See Pascal Blanchard et al., eds, *Human Zoos: Science and Spectacle in the Age of Colonial Empires* (Liverpool, 2008).

13 Katherine Biber, 'Cannibals and Colonialism', *Sydney Law Review*, XXVII (2005), pp. 624, 626.

14 Bonsal, *American Mediterranean*, p. 88.

15 Ibid., pp. 112–13.

16 See A. W. Brian Simpson, *Cannibalism and the Common Law: The Story of the Tragic Last Voyage of the 'Mignonette' and the Strange Legal Proceedings to Which it Gave Rise* (Chicago, IL, 1985).

17 Grant Allen, *The Beckoning Hand and Other Stories* (London, 1887), p. 25.

18 H. Hesketh-Prichard, *Where Black Rules White: A Journey Across and About Hayti* (London, 1911), p. xiv.

19 Ibid., p. 106.

20 Ibid., p. 107.

21 Ibid., p. 127.

22 Ibid., pp. 142, 129.

23 Ibid., p. 133.

24 Richard A. Loederer, *Voodoo Fire in Haiti*, trans. D. Vesey (New York, 1935), pp. 2, 17.

25 Ibid., pp. 252–3.

26 John Houston Craige, *Cannibal Cousins* (London, 1935), p. 201.

27 See Laënnec Hurbon, 'American Fantasy and Haitian Vodou', in *Sacred Arts of Haitian Vodou*, ed. D. J. Cosentino (Los Angeles, CA, 1995), pp. 181–97.

28 Bernard Deiderich and Al Burt, *Papa Doc: Haiti and its Dictator* (Harmondsworth, 1972), p. 348.

29 Graham Greene, 'Nightmare Republic', *New Republic*, CXLIX (16 November 1963), p. 18.

30 Francis Huxley, *The Invisibles: Voodoo Gods in Haiti* (London, 1966), p. 9.

31 Ibid., p. 81.
32 See Paul Farmer, AIDS and Accusation: Haiti and the Geography of Blame (Berkeley, CA, 1992), p. 2.
33 William Greenfield, 'Night of the Living Dead II: Slow Virus Encephalopathies and AIDS: Do Necromantic Zombiists Transmit HTLV-III/LAV during Voodooistic Rituals?', Journal of the American Medical Association, CCLVI/16 (1986), p. 2200.
34 Report cited in Farmer, AIDS and Accusation, p. 2.
35 Hurbon, 'American Fantasy', p. 195.
36 Erika Bourguignon, 'The Persistence of Folk Belief: Some Notes on Cannibalism and Zombis in Haiti', Journal of American Folklore, LXXII (1959), pp. 36–46.

3 The Pulp Zombie Emerges

1 Terror Tales, from September 1934, cited in Robert Kenneth Jones, The Shudder Pulps: A History of the Weird Menace Magazines of the 1930s (West Linn, OR, 1975), p. 19.
2 Samuel Taylor Coleridge review of The Monk [1797], reprinted in Gothic Documents: A Sourcebook, 1700–1820, ed. E. J. Clery and R. Miles (Manchester, 2000), p. 187.
3 Edgar Allan Poe, 'The Premature Burial' [1844], in The Selected Writings, ed. G. R. Thompson (New York, 2004), pp. 361–2.
4 Roland Barthes' analysis of this story discusses this moment as 'a true hapax of narrative grammar, a staging of speech impossible as speech: I am dead', in 'Textual Analysis of a Tale by Edgar Allan Poe', in The Semiotic Challenge, trans. R. Howard (Oxford, 1988), p. 285.
5 Henry Kuttner, 'The Graveyard Rats', in Zombies! Zombies! Zombies!, ed. O. Penzler (New York, 2011), p. 162.
6 H. P. Lovecraft, Supernatural Horror in Literature (New York, 1973), p. 15.
7 Influential books from the time included Madison Grant's The Passing of the Great Race (1916) and Lothrop Stoddard's The Rising Tide of Color against White World-supremacy (1920).
8 For Lovecraft, see my introduction to Classic Horror Tales (Oxford, 2013), pp. vii–xxviii. See also Christopher Frayling, The Yellow Peril: Dr Fu Manchu and the Rise of Chinaphobia (London, 2014).
9 Other useful collections include P. Haining, ed., Zombie: Stories of the Walking Dead (London, 1985) and John Richard Stephens, ed., The Book of the Living Dead (New York, 2010).
10 Seabury Quinn, 'The Corpse-master', in Zombies!, ed. Penzler, p. 412.

11 Ibid., pp. 412–13.

12 Thorp McClusky, 'While Zombies Walked', in *Zombies!*, ed. Penzler, p. 309.

13 G. W. Hutter, 'Salt is Not for Slaves', in *Book of the Living Dead*, ed. Stephens, p. 383.

14 Vivian Meik, 'White Zombie', in *Zombies!*, ed. Penzler, pp. 118, 119.

15 Theodore Roscoe's travel notes are excerpted in Audrey Parente, *Pulpmaster: The Theodore Roscoe Story* (Kindle Edition, 2012).

16 Theodore Roscoe, 'The Voodoo Express' [1931], reprinted in *The Wonderful Lips of Thibong Linh* (West Kingstown, 1981), pp. 127, 102.

17 Ibid., p. 83.

18 Ibid., pp. 71, 134.

19 Theodore Roscoe, *A Grave Must Be Deep: A Chilling Mystery of Haitian Black Magic* (London, 1947), p. 17.

20 Ibid., p. 74.

21 Theodore Roscoe, *Z is for Zombie* (Mercer Island, WA, 1989), p. 65.

22 Ibid., p. 79.

23 Lovecraft, letter to Henry Weiss (5 June 1931), in *Selected Letters*, vol. III (Sauk City, WI, 1971), p. 374.

24 Lovecraft, letter to E. Hoffmann Price (7 December 1932), in *Selected Letters*, vol. IV (Sauk City, WI, 1976), p. 116.

25 Henry S. Whitehead, 'Negro Dialect of the Virgin Islands', *American Speech*, VII/3 (1932), pp. 175–9.

26 Henry S. Whitehead, 'Jumbee', in *Voodoo Tales: The Ghost Stories of Henry S. Whitehead* (London, 2012), p. 336. All references are to this collected edition.

27 Ibid., pp. 336, 337.

28 Ibid., p. 341.

29 Whitehead, 'The Projection of Armand Dubois', p. 596.

30 Whitehead, 'Black Terror', p. 6.

31 Whitehead, 'The Black Beast', p. 490.

32 Whitehead, 'The Passing of a God', p. 446.

33 Ibid.

34 Ibid., p. 459.

35 Whitehead, 'The Lips', pp. 617–18.

4 The First Movie Cycle:
White Zombie to *Zombies on Broadway*

1 Quoted in George E. Turner and Michael H. Price, *Forgotten Horrors: The Definitive Edition* (Baltimore, MD, 1999), p. 26.
2 Details in this paragraph come from Thomas Docherty, *Pre-Code Hollywood: Sex, Immorality, and Insurrection in American Cinema, 1930–1934* (New York, 1999).
3 See Eric Schaefer, *Bold! Daring! Shocking! True! A History of Exploitation Films, 1919–59* (Durham, NC, 1999), especially the chapters on the 'exotic exploitation film'.
4 Chris Vials, 'The Origins of the Zombie in American Radio and Film: B-Horror, U.S. Empire, and the Politics of Disavowal', in *Generation Zombie: Essays on the Living Dead in Modern Culture*, ed. S. Boluk and W. Lenz (Jefferson, NC, 2011), p. 50.
5 See Gary Rhodes, *White Zombie: Anatomy of a Horror Film* (London, 2001) for discussion of the press pack and an exhaustive account of the production and release of the film.
6 John Vandercock, *Black Majesty: The Life of Christophe, King of Haiti* (New York, 1933), p. 4.
7 Alison Peirse, *After 'Dracula': The 1930s Horror Film* (London, 2013), p. 80.
8 Opinion of Judge Hoffman, cited in Rhodes, *White Zombie*, p. 173.
9 Hans Possendorf, *Damballa Calls: A Love Story of Haiti*, trans. L. Hudson (London, 1936), pp. 21–2.
10 See John Carter, *Sex and Rockets: The Occult World of Jack Parsons* (Port Townsend, WA, 2004).
11 Val Lewton quoted in Joel E. Siegel, *Val Lewton: The Reality of Terror* (London, 1972), p. 31.
12 Inez Wallace, 'I Met a Zombie', *American Weekly* (3 May 1942), reprinted as 'I Walked with a Zombie', in *Zombie: Stories of the Walking Dead*, ed. P. Haining (London, 1985) p. 96.
13 See 'Black Haiti: Where Old Africa and New World Meet', *Life* (13 December 1937), pp. 27–30.
14 Chris Fujiwara, *Jacques Tourneur: The Cinema of Nightfall* (Jefferson, NC, 2011), p. 87.
15 See Clayton Koppes and Gregory Black, *Hollywood Goes to War: How Politics, Profits and Propaganda Shaped World War II Movies* (London, 1988), pp. 127–8.
16 See Frederick Smith, *Caribbean Rum: A Social and Economic History* (Gainesville, FL, 2005).

17 Theodor Adorno's discussion of the 'torn halves' of the culture industry and art is in his 'Correspondence with Benjamin', in Adorno et al., *Aesthetics and Politics* (London, 1977).

5 Felicia Felix-Mentor: The 'Real' Zombie

1 Langston Hughes, 'People without Shoes' [1931], in *The Collected Work of Langston Hughes* (Columbia, MO, 2002), vol. IX, p. 47.
2 See the chapter on these links in J. Michael Dash, *Haiti and the United States: National Stereotypes and the Literary Imagination* (London, 1997).
3 Franz Boas, *The Mind of Primitive Man* (New York, 1916), p. 98.
4 Henrika Kucklick, 'After Ishmael: The Fieldwork Tradition and its Future', in *Anthropological Locations: Boundaries and Grounds of a Field Science*, ed. A. Gupta and J. Ferguson (Berkeley, CA, 1997), p. 53.
5 Zora Neale Hurston, 'Hoodoo in America', *Journal of American Folklore*, XLIV (1931), p. 358.
6 Ibid., p. 359.
7 Ibid., pp. 390–91.
8 Ibid., p. 370.
9 See Dorothea Fischer-Hornung, '"Keep Alive the Powers of Africa": Katherine Dunham, Zora Neale Hurston, Maya Deren, and the Circum-Caribbean Culture of Vodoun', *Atlantic Studies*, V/3 (2008), pp. 347–62.
10 Hurston, 'Hoodoo', pp. 398–9.
11 Review cited in Robert Hemenway, *Zora Neale Hurston: A Literary Biography* (London, 1986), p. 251.
12 Journalist Helen Worden, cited in Mary Renda, *Taking Haiti: Military Occupation and the Culture of U.S. Imperialism* (Chapel Hill, NC, 2001), p. 293.
13 Zora Neale Hurston, *Tell My Horse* (New York, 1938), p. 234.
14 Amy Fass Emery, 'The Zombie in/as the Text: Zora Neale Hurston's *Tell My Horse*', *African American Review*, XXXIX/3 (2005), pp. 327–36.
15 Hurston, *Tell My Horse*, p. 102.
16 Ibid., p. 163.
17 Ibid., p. 164.
18 Ibid., pp. 178–9.
19 Ibid., p. 191.
20 Ibid., pp. 205–6.
21 Ibid., p. 206.

22 Ibid., p. 220.
23 Ibid., p. 266.
24 Jean Price-Mars, *So Spoke the Uncle: Ethnographic Essays*, trans. M. Shannon (Washington, DC, 1983), pp. 147–8. *Ainsi parla l'oncle* was first published in Port-au-Prince in 1928.
25 Melville Herskovits, *Life in a Haitian Valley* (New York, 1937), pp. vii, 246.
26 Louis P. Mars, 'The Story of Zombi in Haiti', *Man*, XLV (March–April 1945), pp. 38, 40.

6 After 1945: Zombie Massification

1 Susan Sontag, *On Photography* (Harmondsworth, 1977), pp. 19–20.
2 See Paul Boyer, *By the Bomb's Early Light: American Thought and Culture at the Dawn of the Atomic Age* (New York, 1985).
3 Norman Cousins, 'Modern Man is Obsolete', *Saturday Review of Literature* (14 August 1945), p. 5.
4 See Roger Luckhurst, *The Trauma Question* (London, 2008).
5 Robert Jay Lifton, *Death in Life: The Survivors of Hiroshima* (London, 1968), p. 21.
6 Ibid., p. 517.
7 Robert Jay Lifton, 'The Survivors of the Hiroshima Disaster and the Survivors of Nazi Persecution', in *Massive Psychic Trauma*, ed. H. Krystal (New York, 1968), p. 179.
8 Lifton, *Death in Life*, p. 540.
9 See Zdzisław Jan Ryn and Stanisław Kłodziński, 'Between Life and Death: Experiences of the Concentration Camp Musulmen', in *Auschwitz Survivors: Clinical-Psychiatric Studies*, trans. E. Jarosz and P. Mizia, ed. Z. J. Ryn (Krakow, 2005), p. 111.
10 Primo Levi, *If This is a Man* [1947], trans. S. Woolf (London, 1979), p. 96.
11 Giorgio Agamben, *Remnants of Auschwitz: The Witness and the Archive*, trans. D. Heller-Roazen (New York, 1999), p. 82.
12 Wolfgang Sofsky, *The Order of Terror: The Concentration Camp*, trans. W. Templer (Princeton, NJ, 1993), p. 199.
13 See Ryn and Kłodziński, 'Between Life and Death', pp. 116–19.
14 Sofsky, *Order of Terror*, p. 200.
15 Ibid., p. 204.
16 See Michael Rothberg, *Traumatic Realism: The Demands of Holocaust Representation* (Minneapolis, MN, 2000), or Robert Eaglestone, *The Holocaust and the Postmodern* (Oxford, 2004).

17 'The Living Dead', *Dark Mysteries* (October 1954), reprinted in *The Horror! The Horror! Comic Books the Government Didn't Want You to Read!*, ed. Jim Trombetta (New York, 2010), p. 182.

18 Ibid., p. 183.

19 Hannah Arendt, *The Origins of Totalitarianism*, new edn (New York, 1973), p. 316.

20 Aimé Césaire, *Discourse on Colonialism*, trans. J. Pinkham (New York, 2000), p. 41. For Rothberg's commentary, see Michael Rothberg, *Multidirectional Memory: Remembering the Holocaust in the Age of Decolonization* (Stanford, CA, 2009).

21 Arendt, *Origins of Totalitarianism*, pp. 171, xvii.

22 Césaire, *Discourse*, p. 49.

23 Albert Memmi, *Decolonization and the Decolonized*, trans. R. Bononno (Minneapolis, MN, 2006), p. 129.

24 Cited in Hugh Deane, *The Korean War, 1945–53* (San Francisco, CA, 1999), p. 114.

25 B.A.H. Parritt, *Chinese Hordes and Human Waves: A Personal Perspective of the Korean War* (Barnsley, 2011), p. 106.

26 Dan Gilbert, 'Why the Yellow Peril Has Turned Red!' [1951], excerpted in *Yellow Peril! An Archive of Anti-Asian Fear*, ed. John Kuo Wei Tchen and Dylan Yeats (London, 2014), pp. 299, 301.

27 Edward Hunter, cited in David Seed, *Brainwashing: The Fictions of Mind Control: A Study of Novels and Films since World War II* (Kent, OH, 2004), p. 29.

28 Joost Meerloo, 'The Crime of Menticide', *American Journal of Psychiatry*, CVII (1951), pp. 594–8.

29 Richard Condon, *The Manchurian Candidate* (London, 1960), p. 105.

30 Ibid., pp. 204, 230.

31 See Susan Carruthers, '*The Manchurian Candidate* (1962) and the Cold War Brainwashing Scare', *Historical Journal of Film, Radio and Television*, XVIII/1 (1998), pp. 75–94. 'The Paranoid Style in American Politics' was an essay by Richard Hofstadter, first published in *Harper's Magazine* in 1964.

32 Jack Finney, *Invasion of the Body Snatchers* (London, 1999), p. 179.

33 J. Edgar Hoover, *Masters of Deceit: The Story of Communism in America and How to Fight It* (New York, 1958), p. vi.

34 Ibid., p. 9.

35 Peter Biskind, *Seeing is Believing: How Hollywood Taught Us to Stop Worrying and Love the Fifties* (New York, 1983), p. 4.

36 David Riesman, *The Lonely Crowd: A Study of the Changing American Character* (New Haven, CT, 1950), p. 22.

37 Vance Packard, *The Hidden Persuaders* [1957] (Harmondsworth, 1977), p. 9.

38 Vance Packard, chapter Ten of *The Status Seekers* (1959), excerpted at www.writing.upenn.edu.

39 Susan Sontag, 'The Imagination of Disaster', in Sontag, *Against Interpretation and Other Essays* (London, 1987), p. 214.

40 Richard Hoggart, *Uses of Literacy: Aspects of Working-class Life, with Special Reference to Publications and Entertainments* (London, 1957), p. 204.

41 Bernard Rosenberg, 'Mass Culture in America', in *Mass Culture: The Popular Arts in America*, ed. B. Rosenberg and D. Manning White (Glencoe, IL, 1957), pp. 3, 5, 8, 9.

42 Dwight MacDonald, 'A Theory of Popular Culture', *Politics*, I (February 1944), p. 22. This essay was rewritten and retitled for the Rosenberg and Manning White collection as 'A Theory of Mass Culture'.

43 'Horror of Mixed Torsos', *Dark Mysteries* (August 1953), reprinted in *Zombies: The Chilling Archives of Horror Comics*, ed. C. Yoe and S. Barnes (San Diego, CA, 2012), pp. 50–55.

44 Trombetta, ed., *The Horror! The Horror!*, p. 167.

45 Last panel of 'Step into My Empty Shroud', *The Beyond* (January 1954), in *Zombies*, ed. Yoe and Banes, p. 30.

46 All quotes from 'CORPSES . . . COAST TO COAST', *Voodoo* (March 1954), reprinted in *The Horror!*, ed. Trombetta, pp. 193–9.

47 All quotes from 'Marching Zombies', *Black Cat* (May 1952), reprinted in *Zombies*, ed. Yoe and Banes, pp. 122–8.

48 Daniel F. Yezbick, 'Horror', *Comics through Time: A History of Icons, Idols and Ideas*, ed. M. Keith Booker, 4 vols (Westport, CT, 2014), vol. I, pp. 1071–84.

49 Norbert Muhlen, 'Comic Books and Other Horrors', *Commentary* (January 1949), pp. 80–87, all citations from unpaginated online version at www.commentarymagazine.com.

50 Fredric Wertham, *Seduction of the Innocent* (London, 1955), p. 87.

51 Ibid., pp. 26, 34.

52 See Paul Hirsch, '"This is Our Enemy": The Writers' War Board and Representations of Race in Comic Books, 1942–45', *Pacific Historical Review*, LXXXIII/3 (2014), pp. 448–86.

53 Robert Warshow, 'Paul, the Horror Comics, and Dr Wertham', in *The Immediate Experience: Movies, Comics, Theatre and Other Aspects of Popular Culture* (Cambridge, MA, 2001), p. 73.

54 Testimony cited in Bart Beaty, *Fredric Wertham and the Critique of Mass Culture* (Jackson, FL, 2005), p. 159.

55 The 1954 Code is reprinted in full at
www.comicartville.com/comicscode.htm, accessed 27 January
2015.
56 Markman Ellis, *The History of Gothic Fiction* (Edinburgh, 2000),
pp. 205, 239.
57 Robert Kirkman, 'Introduction', *The Walking Dead*, vol. 1: *Days
Gone Bye* (Berkeley, CA, 2012), n.p.
58 Stephen King, *Danse Macabre* [1981] (London, 1988), p. 36.

7 The Zombie Apocalypse: Romero's Reboot and Italian Horrors

1 Cited in Elliott Stein, 'Night of the Living Dead', *Sight and
Sound*, XXXIX (Spring 1970), p. 105.
2 Roger Ebert review, *Chicago Sun* (5 January 1969), cited in
Kevin Heffernan, 'Inner-city Exhibition and the Genre Film:
Distributing *The Night of the Living Dead* (1968)', *Cinema Journal*,
XLI/3 (2002), p. 60.
3 See Leslie Fiedler's Zeitgeist essay 'Cross the Border – Close
the Gap', in his *Collected Essays* (New York, 1971), vol. II. The
convergence of low horror and high art is the subject of Joan
Hawkins, *Cutting Edge: Art-horror and the Horrific Avant-garde*
(Minneapolis, MN, 2000).
4 Eldridge Cleaver, 'The Death of Martin Luther King: Requiem
for Nonviolence', *Post-prison Writings and Speeches* (London,
1971), pp. x, 75.
5 See Chris Marker, 'Sixties', *Critical Quarterly*, L/3 (2008),
pp. 26–32, an essay that is a comment on his extraordinary
documentary about the revolutionary years 1967–8, *The Grin
Without a Cat*.
6 Ben Hervey, *Night of the Living Dead* (London, 2008), p. 88.
7 Stein, 'Night', p. 105.
8 Steven Shaviro, *The Cinematic Body* (Minneapolis, MN, 1993),
p. 54.
9 Robin Wood, *Hollywood from Vietnam to Reagan* (New York,
1986), p. 93.
10 James Cameron, *The Time of Terror: A Survivor's Story*, cited in
David Marriott, *On Black Men* (Edinburgh, 2000), p. 1.
11 See Tony Williams, *The Cinema of George A. Romero: Knight of the
Living Dead* (London, 2003).
12 David McNally, *Monsters of the Market: Zombies, Vampires and
Global Capitalism* (Chicago, IL, 2012), p. 1.

13 John Clarke, Stuart Hall, Tony Jefferson and Brian Roberts, 'The Rise of the Counter-cultures', in *Resistance through Rituals: Subcultures in Post-war Britain*, ed. Hall and Jefferson (London, 1976), p. 65.

14 Carol Bernick, quoted in John Hinshaw, *Steel and Steelworkers: Race and Class Struggle in Twentieth-century Pittsburgh* (New York, 2002). The role of Pittsburgh in *Martin* is discussed in Stacey Abbott, *Celluloid Vampires: Life after Death in the Modern World* (Austin, TX, 2007).

15 Margaret Morse, 'The Ontology of Everyday Distraction: The Freeway, the Mall, and Television', in *Logics of Television: Essays in Cultural Criticism*, ed. P. Mellencamp (Bloomington, IN, 1990), pp. 193–221.

16 This argument relies on the excellent account of the limits of this routine anti-capitalist reading of *Dawn of the Dead* by Evan Calder Williams in his *Combined and Uneven Apocalypse* (Winchester, 2011).

17 See Lee Karr, *The Making of George A. Romero's 'The Day of the Dead'* (London, 2014).

18 Jean and John Comaroff, 'Alien-nation: Zombies, Immigrants, and Millennial Capitalism', *South Atlantic Quarterly*, CI/4 (2002), p. 783.

19 Robin Wood, 'Fresh Meat', *Film Comment*, XLIV/1 (2008), pp. 28–31.

20 Paul Boyer, *When Time Shall Be No More: Prophecy Belief in Modern American Culture* (Cambridge, 1992).

21 Kim Paffenroth, *Gospel of the Living Dead: George Romero's Visions of Hell on Earth* (Waco, TX, 2006), p. 23.

22 I have argued this at more length in my essay 'The Public Sphere, Popular Culture and the True Meaning of the Zombie Apocalypse', in *The Cambridge Companion to Popular Culture*, ed. D. Glover and S. McCracken (Cambridge, 2012), pp. 68–85.

23 See Jim Harper, 'The New Regime: Spanish Horror in the 1970s and the End of the Dictatorship', in *The End: An 'Electric Sheep' Anthology*, ed. V. Sélavy (London, 2011), pp. 63–70.

24 See Donato Totaro's explanation in 'A Genealogy of Italian Popular Cinema: The Filone', *Offscreen*, XV/11, www.offscreen.com (2011).

25 Lucio Fulci, quoted in Jay Slater, *Eaten Alive! Italian Cannibal and Horror Movies* (London, 2002), p. 176.

26 For a full but sceptical survey, see Kim Newman's 'Cannibal Zombie Gut-crunchers – Italian Style!', in his *Nightmare Movies: Horror on Screen since the 1960s*, 2nd edn (London, 2011), pp. 253–69.

27 Carolyn Korsmeyer, *Savoring Disgust: The Foul and the Fair in Aesthetics* (Oxford, 2011), p. 34.
28 Immanuel Kant, *Critique of Judgment*, cited ibid., p. 46.
29 Jeffrey Sconce, '"Trashing" the Academy: Taste, Excess, and an Emerging Politics of Cinematic Style', *Screen*, XXXVI/4 (1995), pp. 371–93.
30 See J. Hoberman, *Vulgar Modernism: Writing on Movies and Other Media* (Philadelphia, PA, 1991). The phrase 'trash vitality' comes from Newman, *Nightmare Movies*, p. 49.
31 Patricia MacCormack, 'Masochistic Cinesexuality: The Many Deaths of Giovanni Lombardo Radice', in *Alternative Europe: Eurotrash and Exploitation Cinema since 1945*, ed. E. Mathijs and X. Mendik (London, 2004), p. 107.
32 Ian Olney, *Euro Horror: Classic European Horror Cinema in Contemporary American Culture* (Bloomington, IN, 2013), p. 211.
33 John Clute, 'Vastation', *The Darkening Garden: A Short Lexicon of Horror* (Cauheegan, WI, 2006), pp. 147, 149.
34 Eugene Thacker, *Horror of Philosophy*, vol. I: *In the Dust of this Planet* (Winchester, 2011), pp. 8–9.

8 Going Global

1 Ulrich Beck, *The Risk Society: Towards a New Modernity*, trans. M. Ritter (London, 1992), p. 79.
2 Shinji Mikami, cited in Matthew Weise, 'The Rules of Horror: Procedural Adaptation in *Clock Tower*, *Resident Evil*, and *Dead Rising*', in *Horror Video Games: Essays on the Fusion of Fear and Play*, ed. B. Perron (Jefferson, NC, 2009), p. 252.
3 See, for instance, Leigh Alexander, 'Does Survival Horror Really Still Exist?', www.kotaku.com, September 2008.
4 Tanya Krzywinska, 'Hands-on Horror', in *Screenplay: Cinema/Videogames/Interfaces*, ed. G. King and T. Krzywinska (London, 2002), pp. 206–23.
5 See Colette Balmain, *Introduction to Japanese Horror Film* (Edinburgh, 2008).
6 For discussion of this case, see Wagner James Au, 'Playing Games with Free Speech', www.salon.com, 6 May 2002.
7 See Matthew J. Weise, 'How the Zombie Changed Videogames', in *Zombies Are Us: Essays on the Humanity of the Walking Dead*, ed. C. Moreman and C. Rushton (Jefferson, NC, 2011), pp. 151–68.
8 Report of the Ad Hoc Committee of the Harvard Medical School to Examine the Definition of Brain Death, 'A Definition

of Irreversible Coma', *Journal of the American Medical Association*, ccv/6 (5 August 1968), p. 337.

9 Many of the details in this paragraph derive from Dick Teresi, *The Undead: How Medicine is Blurring the Boundary between Life and Death* (New York, 2012).

10 Cited in Margaret Lock, 'On Making Up the Good-as-Dead in a Utilitarian World', in *Remaking Life and Death: Toward an Anthropology of the Biosciences*, ed. S. Franklin and M. Lock (Santa Fe, NM, 2001), p. 186.

11 Ibid., p. 189.

12 Susan Sontag, AIDS *and its Metaphors* (London, 1989), p. 87.

13 Heinrich Heine, *Conditions in France*, quoted in Marie-Hélène Huet, *The Culture of Disaster* (Chicago, IL, 2012), pp. 72–3.

14 Molly Caldwell Crosby, *Asleep: The Forgotten Epidemic that Remains one of Medicine's Great Mysteries* (New York, 2010), p. 25.

15 Wendell Stanley quoted in Priscilla Wald, *Contagious: Cultures, Carriers, and the Outbreak Narrative* (Durham, NC, 2008), p. 163.

16 Paul Farmer, AIDS *and Accusation: Haiti and the Geography of Blame* (Berkeley, CA, 1992), p. 2.

17 Wald, *Contagious*, p. 27.

18 Richard Preston, *The Hot Zone* (New York, 1994), p. 18.

19 Frank Kermode, *The Sense of an Ending: Studies in the Theory of Fiction* (Oxford, 1968), p. 8.

20 Achille Mbembe, 'Necropolitics', *Public Culture*, xv/1 (2003), pp. 11–40.

21 Mark Fisher, 'How to Kill a Zombie: Strategizing the End of Neoliberalism', www.opendemocracy.net, 18 July 2013.

22 John Clute, 'Fantastika in the World Storm', in *Pardon this Intrusion: Fantastika in the World Storm* (Harold Wood, Essex, 2011), p. 24.

23 Fred Botting and Justin D. Edwards, 'Theorizing Globalgothic', in *Globalgothic*, ed. Glennis Byron (Manchester, 2013), p. 15.

24 Max Brooks, *World War Z: An Oral History of the Zombie War* (London, 2006), p. 32.

25 See Sarah Juliet Lauro and Karen Embry, 'A Zombie Manifesto: The Nonhuman Condition in the Era of Advanced Capitalism', *boundary 2*, xxxv/1 (2008), pp. 85–108. The idea of the 'multitude' derives from Antonio Negri and Michael Hardt, *Multitude: War and Democracy in the Age of Empire* (London, 2009).

26 See Adam Lowenstein, *Shocking Representation: Historical Trauma, National Cinema, and the Modern Horror Film* (New York, 2005).

27 Sherryl Vint, 'Abject Posthumanism: Neoliberalism, Biopolitics, and Zombies', in *Monster Culture in the 21st Century: A Reader*, ed. M. Levina and D. Bui (London, 2013), pp. 143–4.

28 Tony Burgess, *Pontypool Changes Everything* [1995] (Toronto, 2009), p. 158.

29 Seth Grahame-Smith, *Pride and Prejudice and Zombies* (London, 2009), p. 1.

30 *Doctor Who*, 'The Unquiet Dead' (BBC One, 9 April 2005).

31 Stewart Home, *Mandy, Charlie and Mary-Jane* (Los Angeles, CA, 2013), p. 11.

32 See Lorna Jowett and Stacey Abbott, *TV Horror: Investigating the Dark Side of the Small Screen* (London, 2013).

33 Robert Kirkman, preface to *The Walking Dead*, vol. I: *Days Gone Bye* (Berkeley, CA, 2012), n.p.

34 Judith Butler, *Precarious Life: The Power of Mourning and Violence* (London, 2006), p. 46.

35 Ulrich Beck, 'Zombie Categories: An Interview', in Ulrich Beck and Elisabeth Beck-Gernsheim, *Individualization: Institutionalized Individualism and its Social and Political Consequences* (London, 2002), pp. 202–13.

36 See Elizabeth Isichei, 'The Entrepreneur and the Zombie', in her *Voices of the Poor in Africa* (Rochester, NY, 2002).

37 See Luise White, *Speaking with Vampires: Rumor and History in Colonial Africa* (Berkeley, CA, 2000).

38 Jean Comaroff and John Comaroff, 'Occult Economies and the Violence of Abstraction: Notes from the South African Postcolony', *American Ethnologist*, XXVI/2 (1999), p. 289.

39 See Jean Comaroff and John Comaroff, 'Alien-nation: Zombies, Immigrants, and Millennial Capitalism', *South Atlantic Quarterly*, CI/4 (2002), pp. 779–805.

40 Isak Niehaus, *Witchcraft and a Life in the New South Africa* (Cambridge, 2013), p. 5.

Select Bibliography

Ackermann, Hans-W., and Jeanine Gauthier, 'The Ways and Nature of the Zombi', *Journal of American Folklore*, CIV (1991), pp. 466–91

Agamben, Giorgio, *Remnants of Auschwitz: The Witness and the Archive*, trans. D. Heller-Roazen (New York, 1999)

Blanchard, Pascal, et al., eds, *Human Zoos: Science and Spectacle in the Age of Colonial Empires* (Liverpool, 2008)

Boluk, S., and W. Lenz, eds, *Generation Zombie: Essays on the Living Dead in Modern Culture* (Jefferson, NC, 2011)

Bonsal, Stephen, *The American Mediterranean* (London, 1913)

Bourguignon, Erika, 'The Persistence of Folk Belief: Some Notes on Cannibalism and Zombis in Haiti', *Journal of American Folklore*, LXXII (1959), pp. 36–46

Boyer, Paul, *By the Bomb's Early Light: American Thought and Culture at the Dawn of the Atomic Age* (New York, 1985)

Césaire, Aimé, *Discourse on Colonialism*, trans. J. Pinkham (New York, 2000)

Comaroff, Jean, and John Comaroff, 'Alien-nation: Zombies, Immigrants, and Millennial Capitalism', *South Atlantic Quarterly*, CI/4 (2002), pp. 779–805

Consentino, D. J., ed., *Sacred Acts of Haitian Vodou* (Los Angeles, CA, 1995)

Dash, J. Michael, *Haiti and the United States: National Stereotypes and the Literary Imagination* (London, 1997)

Diederich, Bernard, and Al Burt, *Papa Doc: Haiti and its Dictator* (Harmondsworth, 1972)

Docherty, Thomas, *Pre-code Hollywood: Sex, Immorality, and Insurrection in American Cinema, 1930–1934* (New York, 1999)

Clute, John, *The Darkening Garden: A Short Lexicon of Horror* (Cauheegan, WI, 2006)

Craige, John Houston, *Cannibal Cousins* (London, 1935)

Emery, Amy Fass, 'The Zombie in/as the Text: Zora Neale Hurston's *Tell My Horse*', *African American Review*, XXXIX/3 (2005), pp. 327–36

Fanon, Frantz, *The Wretched of the Earth*, trans. Constance Farrington (Harmondsworth, 1985)

Farmer, Paul, AIDS *and Accusation: Haiti and the Geography of Blame* (Berkeley, CA, 1992)

Fujiwara, Chris, *Jacques Tourneur: The Cinema of Nightfall* (Jefferson, NC, 2011)

Gilroy, Paul, *The Black Atlantic: Modernity and Double Consciousness* (London, 1993)

Glissant, Édouard, *Caribbean Discourse: Selected Essays*, trans. J. M. Dash (Charlottesville, VA, 1989)

Haining, Peter, ed., *Zombie: Stories of the Walking Dead* (London, 1985)

Hearn, Lafcadio, *Inventing New Orleans: Writings of Lafcadio Hearn*, ed. S. Frederick Starr (New Orleans, LA, 2001)

—, *Martinique Sketches* [1938], in *American Writings* (New York, 2009)

Herskovits, Melville, *Life in a Haitian Valley* (New York, 1937)

Hervey, Ben, *Night of the Living Dead* (London, 2008)

Hesketh-Prichard, H., *Where Black Rules White: A Journey Across and About Hayti* (London, 1911)

Hulme, Peter, *Colonial Encounters: Europe and the Native Caribbean, 1492–1797* (London, 1986)

Hurston, Zora Neale, 'Hoodoo in America', *Journal of American Folklore*, XLIV (1931), pp. 317–417

—, *Tell My Horse* (New York, 1938)

Jones, Robert Kenneth, *The Shudder Pulps: A History of the Weird Menace Magazines of the 1930s* (West Linn, OR, 1975)

Karr, Lee, *The Making of George A. Romero's 'The Day of the Dead'* (London, 2014)

Korsmeyer, Carolyn, *Savoring Disgust: The Foul and the Fair in Aesthetics* (Oxford, 2011)

Loederer, Richard A., *Voodoo Fire in Haiti*, trans. D. Vesey (New York, 1935)

Lovecraft, H. P., *Supernatural Horror in Literature* (New York, 1973)

McNally, David, *Monsters of the Market: Zombies, Vampires and Global Capitalism* (Chicago, IL, 2012)

Mars, Louis P., 'The Story of Zombi in Haiti', *Man*, XLV (March–April 1945), pp. 38–40

Mathijs, E., and X. Mendik, eds, *Alternative Europe: Eurotrash and Exploitation Cinema since 1945* (London, 2004)

Mbembe, Achille, 'Necropolitics', *Public Culture*, XV/1 (2003), pp. 11–40

Memmi, Albert, *Decolonization and the Decolonized*, trans. R. Bononno (Minneapolis, MN, 2006)

Moreman, C., and C. Rushton, eds., *Zombies Are Us: Essays on the Humanity of the Walking Dead* (Jefferson, NC, 2011)

Newman, Kim, *Nightmare Movies: Horror on Screen since the 1960s*, 2nd edn (London, 2011)

Obeyesekere, Gananath, '"British Cannibals": Contemplation of an Event in the Death and Resurrection of James Cook, Explorer', *Critical Inquiry*, XVIII (1992), pp. 630–54

Olney, Ian, *Euro Horror: Classic European Horror Cinema in Contemporary American Culture* (Bloomington, IN, 2013)

Parsons, Elsie Clews, *Folk-lore of the Antilles, French and English*, 3 vols (New York, 1933–43)

Patterson, Orlando, *Slavery and Social Death: A Comparative Study* (Cambridge, 1982)

Peirse, Alison, *After 'Dracula': The 1930s Horror Film* (London, 2013)

Penzler, Otto, ed., *Zombies! Zombies! Zombies!* (New York, 2011)

Perron, B, ed., *Horror Video Games: Essays on the Fusion of Fear and Play* (Jefferson, NC, 2009)

Possendorf, Hans, *Damballa Calls: A Love Story of Haiti*, trans. L. A. Hudson (London, 1936)

Price-Mars, Jean, *So Spoke the Uncle: Ethnographic Essays*, trans. M. Shannon (Washington, DC, 1983)

Ramsey, Kate, *The Spirits and the Law: Vodou and Power in Haiti* (Chicago, IL, 2011)

Renda, Mary, *Taking Haiti: Military Occupation and the Culture of U.S. Imperialism* (Chapel Hill, NC, 2001)

Rhodes, Gary, *White Zombie: Anatomy of a Horror Film* (London, 2001)

Roscoe, Theodore, *Z is for Zombie* (Mercer Island, WA, 1989)

Rosenberg, Bernard, and D. Manning White, eds, *Mass Culture: The Popular Arts in America* (Glencoe, IL, 1957)

Rutherford, Jennifer, *Zombies* (London, 2013)

Ryn, Zdzisław Jan and Stanisław Kłodziński, 'Between Life and Death: Experiences of the Concentration Camp Musulmen', in *Auschwitz Survivors: Clinical Psychiatric Studies*, trans. E. Jarosz and P. Mizia, ed. Z. J. Ryn (Krakow, 2005), pp. 111–24

St John, Spenser, *Hayti; or, The Black Republic* (London, 1884)

Schaefer, Eric, *Bold! Daring! Shocking! True! A History of the Exploitation Film, 1919–59* (Durham, NC, 1999)

Seabrook, William, *Jungle Ways* (London, 1931)

——, *No Place to Hide: An Autobiography* (Philadelphia, PA, 1942)

——, *The Voodoo Island* (London, 1966)

——, *Witchcraft: Its Power in the World Today* (London, 1941)

Seed, David, *Brainwashing: The Fictions of Mind Control: A Study of Novels and Films since World War II* (Kent, OH, 2004)

Shaviro, Steven, *The Cinematic Body* (Minneapolis, MN, 1993)

Siegel, Joel E., *Val Lewton: The Reality of Terror* (London, 1972)

Slater, Jay, ed., *Eaten Alive! Italian Cannibal and Horror Movies* (London, 2002)

Smith, Frederick, *Caribbean Rum: A Social and Economic History* (Gainesville, FL, 2005)

Stein, Elliott, 'Night of the Living Dead', *Sight and Sound*, XXXIX (Spring 1970), p. 105

Stephens, John Richard, ed., *The Book of the Living Dead* (New York, 2010).

Teresi, Dick, *The Undead: How Medicine is Blurring the Boundary between Life and Death* (New York, 2012)

Thacker, Eugene, *Horror of Philosophy*, vol 1: *In the Dust of this Planet* (Winchester, 2011)

Trombetta, Jim, ed., *The Horror! The Horror! Comic Books the Government Didn't Want You to Read!* (New York, 2010)

Turner, George E., and Michael H. Price, *Forgotten Horrors: The Definitive Edition* (Baltimore, MD, 1999)

Wald, Priscilla, *Contagious: Cultures, Carriers, and the Outbreak Narrative* (Durham, NC, 2008)

Wertham, Frederic, *Seduction of the Innocent* (London, 1955)

Whitehead, Henry S., *Voodoo Tales: The Ghost Stories of Henry S. Whitehead* (London, 2012)

Williams, Tony, *The Cinema of George A. Romero: Knight of the Living Dead* (London, 2003)

Wood, Robin, *Hollywood from Vietnam to Reagan* (New York, 1986)

Yoe, C., and S. Barnes, *Zombies: The Chilling Archives of Horror Comics* (San Diego, CA, 2012)

Zieger, Susan, 'The Case of William Seabrook: *Documents*, Haiti, and the Working Dead', *Modernism/Modernity*, XIX/4 (2013), pp. 737–54

Acknowledgements

For advice, help, clues and tips, book and DVD loans, invitations to speak and conversation, thanks are due to Andrew Abbott, Stacey Abbott (an extra big shout-out for reading the last draft and offering very useful suggestions), Simon Barraclough, James Bell, Mark Blacklock, M. Keith Booker, Mark Bould, Joe Brooker, Gerry Canavan, Julie Crofts, Barry Curtis, Robert Eaglestone, David Edgar, Justin Edwards, William Fowler, Paweł Frelik, Grace Halden, Stephen Hughes, Timothy Jarvis, Joe Kerr, James Kneale, John Kraniauskas, Mary Luckhurst, Tom McCarthy, James Machin, Dawn Mellor, William Mitchell-Reid, Glyn Morgan, Mpalive Msiska, Victoria Nelson, Kim Newman, Chris Pak, Adam Roberts, Laura Thomas, Tony Venezia, Sherryl Vint and Marina Warner. Thanks to my editor Ben Hayes and to Reaktion Books for commissioning this book.

This is for Julie, as always, even though she won't watch splatter horror and particularly not zombie films and so remains sadly unaware that the knitting needle is actually the ideal weapon for close fighting during the zombie apocalypse.

Photo Acknowledgements

The author and publishers wish to express their thanks to the below sources of illustrative material and/or permission to reproduce it:

Beinecke Rare Book and Manuscript Library, Yale University: pp. 42–3, 102; Library of Congress, Prints and Photographs Collection, Washington, DC: pp. 98, 107; image courtesy of HarperCollins: p. 105; Österreichische Nationalbibliothek, Vienna, Pf 25.322:B(1): p 27.

Eneas, the copyright holder of the image on p. 168, has published this online under conditions imposed by a Creative Commons Attribution 2.0 Generic license.

Readers are free:

> to share – to copy, distribute and transmit these images alone
> to remix – to adapt these images alone

Under the following conditions:

> attribution – readers must attribute any image in the manner specified by the author or licensor (but not in any way that suggests that these parties endorse them or their use of the work).

Index